3D GAME PROGRAMMING WITH DIRECTX 8.0

LIMITED WARRANTY AND DISCLAIMER OF LIABILITY

THE CD WHICH ACCOMPANIES THE BOOK MAY BE USED ON A SINGLE PC ONLY. THE LICENSE DOES NOT PERMIT THE USE ON A NETWORK (OF ANY KIND). YOU FURTHER AGREE THAT THIS LICENSE GRANTS PERMISSION TO USE THE PRODUCTS CONTAINED HEREIN, BUT DOES NOT GIVE YOU RIGHT OF OWNERSHIP TO ANY OF THE CONTENT OR PRODUCT CONTAINED ON THIS CD. USE OF THIRD PARTY SOFTWARE CONTAINED ON THIS CD IS LIMITED TO AND SUBJECT TO LICENSING TERMS FOR THE RESPECTIVE PRODUCTS.

CHARLES RIVER MEDIA, INC. ("CRM") AND/OR ANYONE WHO HAS BEEN INVOLVED IN THE WRITING, CREATION OR PRODUCTION OF THE ACCOMPANYING CODE ("THE SOFTWARE") OR THE THIRD PARTY PRODUCTS CONTAINED ON THE CD OR TEXTUAL MATERIAL IN THE BOOK, CANNOT AND DO NOT WARRANT THE PERFORMANCE OR RESULTS THAT MAY BE OBTAINED BY USING THE SOFTWARE OR CONTENTS OF THE BOOK. THE AUTHOR AND PUBLISHER HAVE USED THEIR BEST EFFORTS TO ENSURE THE ACCURACY AND FUNCTIONALITY OF THE TEXTUAL MATERIAL AND PROGRAMS CONTAINED HEREIN; WE, HOWEVER, MAKE NO WARRANTY OF ANY KIND, EXPRESS OR IMPLIED, REGARDING THE PERFORMANCE OF THESE PROGRAMS OR CONTENTS. THE SOFTWARE IS SOLD "AS IS " WITHOUT WARRANTY (EXCEPT FOR DEFECTIVE MATERIALS USED IN MANUFACTURING THE DISK OR DUE TO FAULTY WORKMANSHIP);

THE AUTHOR, THE PUBLISHER, DEVELOPERS OF THIRD PARTY SOFTWARE, AND ANYONE INVOLVED IN THE PRODUCTION AND MANUFACTURING OF THIS WORK SHALL NOT BE LIABLE FOR DAMAGES OF ANY KIND ARISING OUT OF THE USE OF(OR THE INABILITY TO USE) THE PROGRAMS, SOURCE CODE, OR TEXTUAL MATERIAL CONTAINED IN THIS PUBLICATION. THIS INCLUDES , BUT IS NOT LIMITED TO, LOSS OF REVENUE OR PROFIT, OR OTHER INCIDENTAL OR CONSEQUENTIAL DAMAGES ARISING OUT OF THE USE OF THE PRODUCT.

THE SOLE REMEDY IN THE EVENT OF A CLAIM OF ANY KIND IS EXPRESSLY LIMITED TO REPLACEMENT OF THE BOOK AND/OR CD-ROM, AND ONLY AT THE DISCRETION OF CRM.

THE USE OF "IMPLIED WARRANTY" AND CERTAIN "EXCLUSIONS" VARY FROM STATE TO STATE, AND MAY NOT APPLY TO THE PURCHASER OF THIS PRODUCT.

3D GAME PROGRAMMING WITH DIRECTX 8.0

Clayton E. Crooks II

CHARLES RIVER MEDIA, INC.
Hingham, Massachusetts

Copyright 2002 by CHARLES RIVER MEDIA, INC.
All rights reserved.

No part of this publication may be reproduced in any way, stored in a retrieval system of any type, or transmitted by any means or media, electronic or mechanical, including, but not limited to, photocopy, recording, or scanning, *without prior permission in writing* from the publisher.

Production: ElectroPublishing, Inc.
Cover Design: The Printed Image

CHARLES RIVER MEDIA, INC.
20 Downer Avenue, Suite 3
Hingham, Massachusetts 02043
781-740-0400
781-740-8816 (FAX)
info@charlesriver.com
www.charlesriver.com

This book is printed on acid-free paper.

Clayton E. Crooks II. *3D Game Programming with DirectX 8.0*.
ISBN: 1-58450-086-7

All brand names and product names mentioned in this book are trademarks or service marks of their respective companies. Any omission or misuse (of any kind) of service marks or trademarks should not be regarded as intent to infringe on the property of others. The publisher recognizes and respects all marks used by companies, manufacturers, and developers as a means to distinguish their products.

Library of Congress Cataloging-in-Publication Data

Crooks, Clayton E.
 3d game programming with DirectX 8.0 / Clayton E. Crooks II.
 p. cm.
 ISBN 1-58450-086-7
 1. Computer games--Programming. 2. DirectX. I. Title.
 QA76.76.C672 C76 2002
 794.8'15268--dc21
 2001006184

Printed in the United States of America
01 02 7 6 5 4 3 2 First Edition

CHARLES RIVER MEDIA titles are available for site license or bulk purchase by institutions, user groups, corporations, etc. For additional information, please contact the Special Sales Department at 781-740-0400.

Requests for replacement of a defective CD must be accompanied by the original disc, your mailing address, telephone number, date of purchase and purchase price. Please state the nature of the problem, and send the information to CHARLES RIVER MEDIA, INC., 20 Downer Avenue, Suite 3, Hingham, Massachusetts 02043. CRM's sole obligation to the purchaser is to replace the disc, based on defective materials or faulty workmanship, but not on the operation or functionality of the product.

Acknowledgments

A number of people are involved with the development of a project of this nature. This book would not exist without their support, encouragement, ideas, and hard work. With that in mind, I would like to begin by thanking Dave Pallai, President of Charles River Media, and the entire staff for their help.

I would also like to thank the TrueVision team, including Sylvain Dupont, Christopher D. Parker, Sigurd De Keyser, and Dave Sherlock for their excellent work on the TrueVision 3D engine (www.truevision3dsdk.com) that we used in the book.

Lastly, I would like to thank my family for their patience during the writing of this book. These types of projects take a great deal of time, and without your understanding, this would not have been possible. Thank you.

Dedication

I dedicate this book to my son, Clayton III.

"Of all nature's gifts to the human race, what is sweeter to a man than his children?"

—Marcus Tullius Cicero

Contents

CHAPTER ONE: TIPS AND TECHNIQUES LIST 1
 GAME PROGRAMMING OVERVIEW 2
 THE KEY POSITIONS IN A DEVELOPMENT TEAM 2
 DESIGNER 2
 PROGRAMMER 3
 AUDIO-RELATED POSITIONS 4
 MUSICIAN 4
 SOUND EFFECTS 4
 ARTIST 4
 CHARACTER ARTISTS 5
 3D MODELER 5
 TEXTURE ARTIST 6
 PRODUCER 6
 SECONDARY POSITIONS 6
 BETA TESTER 6
 PLAY TESTERS 6
 CHAPTER REVIEW 7

CHAPTER TWO: THE DESIGN DOCUMENT 9
 THE DESIGN DOCUMENT 10
 WHAT IS A DESIGN DOCUMENT 10
 IMPORTANCE TO TEAM MEMBERS 11

THINGS TO INCLUDE	11
GAME OVERVIEW (STORYLINE)	12
LEVELS	12
HEROS AND ENEMIES	13
MENU NAVIGATION	15
USER INTERFACE	16
MUSIC AND SOUND EFFECTS	16
SINGLE OR MULTIPLAYER	17
MISCELLANEOUS AND APPENDIX	18
WRAPPING IT UP	19
GAME PROPOSALS	19
GAME MARKET	20
TECHNICAL INFORMATION AND ASSOCIATED RISKS	20
REQUIRED RESOURCES AND SCHEDULING	21
CHAPTER REVIEW	
CHAPTER THREE: WHAT LANGUAGE SHOULD YOU USE	**23**
WHAT LANGUAGE SHOULD YOU USE?	24
ASSEMBLY	24
C	25
C++	26
VISUAL BASIC	27
DELPHI	29
JAVA	29
CHAPTER REVIEW	30
CHAPTER FOUR: INTRODUCTION TO MILKSHAPE 3D	**31**
INTRODUCTION TO MILKSHAPE 3D	32
INSTALLATION	33
MILKSHAPE 3D INTERFACE	38
VIEWPORT CONTROLS	41
BASIC MODELING FUNCTIONS	42
PRIMITIVE OBJECTS	42
SPHERE	43
GEO-SPHERE	43
BOX	44
CYLINDER	44

Contents

Mesh Editing tools	**46**
Vertices and Faces	46
Select Tool	47
Move	49
Scale	50
Rotate	51
Extrude	51
Animation Tools	**52**
Joints	52
Menus	53
File	53
Edit	54
Vertex	55
Faces	55
Others	55
Chapter Review	**56**

Chapter Five: Introduction to PaintShop Pro	**57**
PaintShop Pro	**58**
Installation	**58**
User Interface	**63**
The Toolbar	64
Tool Palette	64
Tool Options Palette	65
Color Palette	66
Style and Texture	66
Painting Tools	**66**
Paintbrush	66
Eraser	66
Airbrush	67
Picture Tube	67
Flood Fill Tool	68
Vector Drawing Tools	**70**
Vector Versus Raster	70
Layers	70
Draw Tool	72
Chapter Review	**72**

Chapter Six: Creating Low-Polygon Models with MilkShape 3D — 73

- Beginning the Process — 74
 - 2D Sketch — 74
 - MilkShape 3D — 74
 - Gun Stock — 75
 - Creating a Barrel — 81
 - The Clip — 84
 - A Trigger — 85
- Adjusting the Model — 90
 - The Stock — 90
 - Barrel — 94
 - Smoothing — 94
- Chapter Review — 96

Chapter Seven: Texturing Models — 97

- Creating the Textures — 98
 - Groups — 99
- Creating Textures — 100
 - Barrel — 100
- Assigning the Texture in MilkShape — 105
- Creating a Wood Texture — 107
- Apply in MilkShape — 109
- Trigger and Clip2 — 110
- Chapter Review — 112

Chapter Eight: Introduction to ACID — 113

- Introduction to Sonic Foundry ACID — 114
- Installation — 114
- Acid Specifics — 121
 - The Interface — 121
 - Altering the Interface — 122
 - The Media Explorer — 123
 - The Track View — 123
 - Beat Ruler — 124
 - Time Ruler — 124
 - Scroll Bars — 125
 - Zoom Controls — 125
 - Track List — 125

Contents

Properties Tab	128
Chapter Review	**129**

Chapter Nine: Syntrillium's Cool Edit 2000 — 131

Installation	132
The Interface	139
Toolbars	140
Display Range Bar	141
Amplitude Ruler	141
Waveform Display	142
Time Display Fields	142
Level Meters	143
Time	143
Status Bar	143
Transport	144
Zoom	144
Chapter Review	144

Chapter Ten: Creating Music and Sound Effects — 145

Why It Is Important	146
Basic Ideas	146
ACID Loops	147
Creating the Music	148
Creating SFX	153
Recording Sounds	153
How to Record	154
Using a PDA	155
Using a Recording Device	155
Chapter Review	162

Chapter Eleven: Half-Life Model — 163

Getting Started	164
Creating the Upper Body	166
Creating Legs	176
The Foot	180
Mirroring the Leg and Foot	183
Creating Arms	186
Creating the Head	193

TEXTURING THE MODEL	198
CREATING A TEMPLATE	200
PAINTING THE TEMPLATE	203
IMPORTING INTO MILKSHAPE	205
BASICS OF ANIMATION	210
COMPILING THE MODEL	212
CHAPTER REVIEW	212

CHAPTER TWELVE: INTRODUCTION TO THE DIRECTX 8 SDK — 213

INSTALLING THE SDK	214
BASICS OF DIRECTX 8	220
BASIC FRAMEWORK	221
CREATING A NEW PROJECT	221
MAIN LOOP	224
FULL-SCREEN MODE	226
DISPLAY DEVICE, ADAPTER, AND RESOLUTION ENUMERATION	228
CHAPTER REVIEW	229

CHAPTER THIRTEEN: INTRODUCTION TO DIRECTX GRAPHICS AND VB — 231

BASIC 2D/3D THEORY	232
WRITING SOME CODE	233
FORM_LOAD	235
EXPANDING THE PROGRAM USING THE WORLD TRANSFORMATION MATRIX	239
CHAPTER REVIEW	242

CHAPTER FOURTEEN: A DIRECTX MODEL VIEWER — 243

WHAT IS DIRECT3D?	244
ADVANTAGES OF DIRECT3D	244
THE SDK	244
DIRECT3D COORDINATE SYSTEM	245
DIRECT3D MODES	246
3D VOCABULARY	246
PROJECT FRAMEWORK	247
DECLARATIONS	247
FORM_LOAD EVENT	248
INITIALIZE DIRECTDRAW AND DIRECT3D	248
CREATING THE SCENE	250

The Main Loop	251
Closing the Application	252
Chapter Review	254

Chapter Fifteen: BSP and SkyBox Designs — 255

BSP	256
Outdoor Levels	258
Creating a Heightmap	258
Chapter Review	261

Chapter Sixteen: Introduction to the TrueVision 3D Engine — 263

Beginning TV3D	265
Installation	265
Referencing the Engine	265
Using TV3D in a Window or Full Screen	266
Window	267
Full Screen	267
Other TV3D Options	269
Transformation and Lighting	269
Display Frames Per Second	269
Loading Console	270
Full-Screen Title	270
Error Messages	271
Creating a Scene	271
Dithering	271
Rendering Modes	272
Lighting Modes	274
Texture Filtering	276
TrueVision Feature List	277
Main Features	277
Terrain Features	277
File Types Support	278
Graphics Formats	278
Render Scene	278
Shaders	279
Lights	279
Texture Factory	279
Compressed Textures	279

MESHES	280
PARTICLES	280
CAMERA	281
2D SCREEN	281
USER INTERFACE	281
INPUT FEATURES	281
INTERNAL OBJECTS	282
MISCELLANEOUS	282
CHAPTER REVIEW	282

CHAPTER SEVENTEEN: RENDERING BSP LEVELS — 283

GETTING STARTED	284
WRITING SOME CODE	286
BSP RENDERING	288
RENDERING LOOP	289
CHAPTER REVIEW	292

CHAPTER EIGHTEEN: HALF-LIFE MODEL VIEWER — 293

GETTING STARTED	295
WRITING SOME CODE	297
CHAPTER REVIEW	303

CHAPTER NINETEEN: TERRAIN RENDERING AND FPS SHOOTER — 305

GETTING STARTED	307
CREATING THE TEXTURES	312
DIRECTSOUND AND MOVEMENTS	315
CHAPTER REVIEW	320

CHAPTER TWENTY: ALTERNATIVE DEVELOPMENT ENVIRONMENTS — 321

MACROMEDIA DIRECTOR	322
MULTIMEDIA FUSION/JAMAGIC	322
3D GAME STUDIO	324
3D RAD	325
DarkBASIC/3D GAME MAKER	326
BlitzBasic3D	327
CHAPTER REVIEW	327

Contents

Appendix A: Design Document — 329

Appendix B: Half-Life Model Specifications — 335

Appendix C: Introduction to Visual Basic — 343

Appendix D: Links to Game Programming Sites — 365

Appendix E: About the CD — 371

Index — 375

Preface

Developing games is one of the most challenging and rewarding fields in computer science, and like every aspect of computing, it is constantly evolving. It is a challenge to attempt to stay caught up in the field if you are already well versed, and this says nothing about the difficulties a beginner will encounter. That is where this book comes in. Although the focus is on programming with DirectX 8, it provides a complete understanding of the game development process including the creation of 3D models, textures, music, and sound effects.

With the exception of a compiler (the book uses Visual Basic for the examples, but they could be converted rather easily to C# or C++7), this book and CD-ROM contain everything you need to complete the projects. The following list of topics will help you understand what you will find in this book:

- We use Cool Edit with several objects you have lying around the house to create custom sound effects.
- We create several full-screen and windowed mode DirectX 8 programs.
- We create texture and heightmaps using PaintShop Pro.
- Using MilkShape 3D, we create an animated model and a gun.
- We use ACID to create the music for our final project.
- We construct a Half-Life MDL viewer for testing the models we create. Additionally, we reuse the code for displaying an MDL file on a terrain.
- We build an application that renders BSP files, allowing us to move freely within it.
- Our final project uses most of the earlier components and combines them into a First Person Shooter (FPS). We use DirectSound for playing back the sound effects; we use the Half-Life MDL we created in MilkShape as an enemy in the game; and we use the textures and heightmap to create a virtual environment.

CHAPTER 1
Tips and Techniques List

GAME PROGRAMMING OVERVIEW

The development of a computer game is a unique production combining a wide range of elements into what is hopefully an enjoyable experience for the end user. A typical game project involves programmers, artists, musicians, designers, and countless other positions that are necessary components for a successful venture. The first chapter of this book guides you through the various positions, helping you to understand why each is an integral part in the development process.

In Chapter 2, "The Design Document," we discuss the creation of a design document. Subsequent chapters begin the process of creating a first person shooter (FPS) and the various elements that are required for its construction. Each chapter focuses on a specific topic where we create the key components that will ultimately make up our final project.

THE KEY POSITIONS IN A DEVELOPMENT TEAM

As previously mentioned, several key positions comprise a development project, which without any of these would not be successful. That being said, depending on the size of your team, a single individual might be forced to wear many hats, or in the case of the lone developer, all of the hats. That is, although all of the positions are required, a single individual might fill one or all of them.

Because the game industry is still in its infancy, it is sometimes difficult to discuss the positions that comprise a team. The type of game being produced definitely has a profound effect on the required personnel. Each development project is arranged differently, and as the industry matures, there will certainly become more standard types of arrangements. However, until that occurs, we need to attempt to explain most of the potential positions.

DESIGNER

Many development projects have a lead game designer who is responsible for creating the game script. The designer can be one of the most misunderstood of any of the key positions, and is often left completely off the team. This leaves room for everyone from the producer to a programmer clamoring for the title.

The designer makes many of the decisions related to the creation of important elements, such as puzzles or the levels in an FPS. Like a screenwriter for a movie, the designer is responsible for the overall feel of the game. Communication is a very important aspect of the designer's job, as they work with the other team members throughout the project.

In the beginning stages of a game, designers spends most of their time writing short scripts and working on the beginning storyboard sketches. A typical storyboard is a rough sketch of the action of a game that will later be transformed into the game itself. Depending on the basic talents of the designers, they might use simple stick figures and basic shapes to convey their messages.

After deciding on the game concepts, the designer begins working on a blueprint for the game, called a *design document*. The design document is discussed thoroughly in the next chapter as we begin working on our FPS. Simply put, the document details every aspect of a game and will evolve as the game develops.

PROGRAMMER

Game programmers are software developers who take the ideas, art, and music and combine them into a software project. Programmers obviously write the code for the game, but might also have several additional responsibilities. For example, if an artist is designing graphics for the game, the lead programmer could be responsible for the development of a custom set of tools for creating the graphics. It is also their job to keep everything running smoothly and to figure out a way to satisfy everyone, from the producer to the artists. Unlike the stereotype portrayed on many Web sites, in books, or even in movies, programmers usually do not stroll into work at noon, work for a few hours, and then leave. The truth is, they often arrive earlier and leave later than anyone else on the development team.

Programmers are responsible for taking the vast number of elements and combining them to form the executable program. They decide how fast a player can run, and how high it can jump. They are responsible for accounting for everything inside the virtual world. While doing all of this, programmers often try to create software that can be reused for other projects, and spend a great deal of time optimizing the code to make it as fast as possible.

Sometimes, a given project might have several programmers who specialize in one key area, such as graphics, sound, or artificial intelligence (AI). The following list details the various types of programmers and their primary responsibilities:

- **Engine or graphics programmers** Engine or graphics programmers create the software that controls how graphics and animations are stored and ultimately displayed on the screen.
- **AI programmers** AI programmers create a series of rules that determine how enemies or characters react to game situations and attempt to make them act as realistically as possible.
- **Sound programmers** A sound programmer works with the audio personnel to create a realistically sounding environment.

- **Tool programmers** As previously mentioned, programmers often write software for artists, designers, and sound designers to use within the development studio.

AUDIO-RELATED POSITIONS

High quality music and sound effects are integral parts of any gaming project, and is an area that many teams simply cannot afford to throw a great deal of money at. Having superb audio components such as music, sound, and voice can greatly enhance the total experience for the consumer. The opposite is also true, however, and music that is done poorly can be enough to keep people away from your product regardless of its other qualities. There are several individual positions that are usually filled with key audio personnel, or perhaps a programmer or other team member will fill in as needed.

Musician

When compared with the stress and long hours of the programmers, musicians are often at the other end of the workload. They have what amounts to the least amount of work of any of the positions on the team. That is not to imply that they do not work hard, it is just that there is not as much for them to do. They usually are responsible only for the music for a game, and while it is an important job, it does not typically take a great deal of time when compared with the other team member's jobs. Because of the relatively short production times, musicians often have secondary work outside of the gaming industry.

Sound Effects

Depending on the makeup of a team, musicians could be involved with the creation of the sound effects in a game. This can often make up for the lack of work they have and help to keep the budgets down. Another route that many teams choose to follow is the purchase of preexisting sound effects. Many sound effects companies distribute their work on CD-ROMS or the Internet, and many teams choose to alter these to their liking.

ARTIST

The artists are responsible for the creation of the graphics elements that comprise a project. They often specialize in one area within a project, such as 3D graphics or 2D artwork-like textures. The artists usually have a set of specifications given to them by the programmer for the creation of the graphics. Unfortunately, artists and programmers often have many disagreements on these specifications. For example, an artist might want to increase the polygon counts on a 3D model so that their work will look better, while a programmer might want to decrease these same counts to make the program run more smoothly.

Game artists have a variety of technical constraints imposed by the limitations of the hardware for which they are creating. Although hardware continues to increase in speed and decrease in cost, there is never enough power to satisfy a development project. Therefore, the artists are often given the responsibility to create objects that work within the constraints.

Depending on the development team, there are three basic types of artists. A character artist, or animators as some prefer to be called, 3D modelers, and texture artists.

Character Artists

Character artists have one of the most demanding jobs on the team. They create all of the moveable objects in a game, such as the main character, a space ship, or a vehicle. It is their job to turn the preliminary sketches that are often discussed by the entire team into a believable object on a computer screen.

Using 3D modeling tools such as 3D Studio Max (also known as 3ds max), TrueSpace, Maya, or LightWave, the character artists use basic shapes and combine them to form the character. If you have never used a 3D-modeling program, you can think of it as a type of digital clay. Once created, the character is then skinned with a 2D graphic image that is made in another program.

The character artists are also responsible for the animation of the objects. They might be required to animate a horse, a human being, or a creature that previously existed in someone's mind. Character artists often look at real-world examples to get their ideas on how a character should move in certain situations. Depending on the type of game, they might have to create facial expressions or emotion as well.

It is often the responsibility of a character artist to implement cut scenes in a game as well. Many artists enjoy the creation of the cut screens even more than the characters in the game. They have much greater freedom and are not restricted as to the number of polygons a certain object can have or the size of the object.

3D Modeler

The 3D modeler usually works on the settings in which a game takes place, such as a basketball arena or a Wild West wasteland. Background artists work hand in hand with the designer to create believable environments that work within the constraints of a game. Like character artists, they use a wide range of tools for their jobs, including both 2D and 3D graphics tools, although they usually only model static objects.

Texture Artist

Texture artists might be the best friends of the other artists. It is their job to take the work created by the modeler or character artist and add detail to it. For example, they could create a brick texture that, when added to a 3D box created by the modeler, creates the illusion of a pile of bricks, or they could create a texture that looks like cheese, turning this same box into a block of cheese.

PRODUCER

A producer oversees the entire project and attempts to keep everything moving along as smoothly as possible. The producer often acts as an arbitrator to help resolve any problems between team members. For example, if an artist wants to increase the color palette and a programmer wants to decrease it, the producer often makes the final decision on these types of key issues.

SECONDARY POSITIONS

There are several secondary positions that can be important to the development cycle as well. Depending on the budget, these positions might or might not exist, or could be filled by other members of the team.

BETA TESTER

Beta testers test the playability of a game and look for bugs that might occur when the game is executed. This is one of the most undervalued of the positions and should never be completed by the person responsible for programming the game. In reality, because of tight budgets and deadlines, this is also one of the steps that is often cut before it is completed, as due dates will unfortunately take precedence over most decisions. If adequate beta testing is performed, a development team can save a tremendous amount of time and resources without having to produce unnecessary patches later.

PLAY TESTERS

The play testers are often confused with beta testers, although play testers actually only test the playability of a game and critique areas such as movement or graphic elements. Again, these positions are often filled with individuals who perform other tasks on the team. Unlike beta testers, the play testers do not actually attempt to find or report bugs.

CHAPTER REVIEW

A development team is comprised of a variety of individuals who create the necessary components for a successful venture. Contrary to popular perception, game development is not always about fun and games, and because of budget concerns, team members will often spend many hours on the job working in a variety of positions. Often, a team will lose a key member and the others will be required to take up the slack, as hiring a new member might not be an option with the time constraints that are a part of the process.

CHAPTER 2
The Design Document

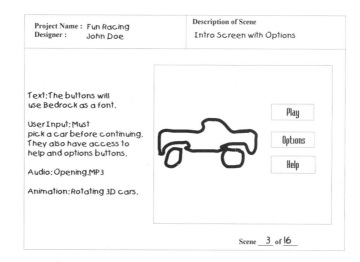

The Design Document

Now that you have an idea of the positions that make up a game team and their respective responsibilities, it is time to move on to the creation of a 3D First Person Shooter (FPS). Instead of jumping right into the technical aspects of the game such as creating the levels or writing some code, it's important to begin with the creation of a design document.

This chapter will serve as a complete overview of the design document. If you would like to follow along with an actual design document, Appendix A, "Design Document," contains the complete version for the game project that we are going to be working on in this book. Additionally, you can use this as a basic template for creating your own design documents.

ON THE CD

The companion CD-ROM contains the design document/template in word format for you to use.

What Is a Design Document?

A design document is often overlooked in the rush and excitement of a game idea. After all, if you have a unique idea that could conceivably be a great game, why would you want to waste your time working on something that does not really get you any closer to the end product?

Many times, even relatively large development teams do not spend the time to create a fully functional design document. Most game developers will try to stay away from unnecessary work, but the long hours spent creating a thorough design document will actually save countless hours later down the development road. You might be lucky enough to create a very good quality game without a design document, but the key word in this is *luck*. Most often, a game that begins without a properly developed design document will be delayed for months or might not even be finished.

The creation of a design document is similar to the creation of a movie script. In it, you will write details of an exact story (if you have one—for example, racing games would probably not have a story), an overview of the characters or opponents you are intending to create, detailed descriptions of every level, and so on. If this is the first time you have ever considered creating a design document, you should be aware of a few things.

First, the design document is not chiseled in stone. That is, it can and should evolve as the game does, but it shouldn't be drastically altered. The design document will serve as a sort of road map to how the project will develop, and should be as complete as possible. That being said, it can be changed when necessary to include a new character or a slight change in the plot. Design

documents are team oriented and therefore should include as many contributions as possible from the individuals who make up a team.

IMPORTANCE TO TEAM MEMBERS

A design document is important for a number of reasons. To a potential publisher, it details the game and gives them a vision of what you are actually hoping to accomplish. The purpose of a design document to a team is rather simple; it lays out the responsibilities of everyone involved. Depending on the team member, a design document will mean different things.

It is the document from which producers will base their estimates, while programmers might look at the design document as a series of instructions for completing their role. Artists will use the document to help them visualize the characters they need to create. Designers often take things from the document, such as the mood for a level. Audio personnel require some sort of a basis for the development of sound effects and music, and the design document might be the only place they can truly acquire the appropriate knowledge.

TIP

While the design document is very important, it does not take the place of meetings that a development team should conduct. Getting the thoughts of team members at regular intervals is also very important. Again, these meetings do not have to be formal, and can be in person or over some electronic medium such as a discussion board. Like most things, it is not important how they occur, it is only important that they actually do.

THINGS TO INCLUDE

Now that you have a basic understanding of design documents, we need to look at the individual components or ideas that make it up. Many teams will include information such as legalities, target audience, and market analysis for a game in their design document. While this works, it would make sense to include those types of "business" related materials in a game proposal to a publisher, which we look at in more detail later in this chapter. It is counterproductive to have team members scrolling through pages of information they really do not need to review.

GAME OVERVIEW (STORYLINE)

This might be the most important piece of the entire document puzzle. Without a solid story or game overview, the later steps will be much more difficult to create. Be very thorough with the game overview. If you leave something out, go back and fix it immediately. Sometimes, the smallest details can make a big difference in a large project.

Because you do not know exactly who will read this, make sure to use as many details as possible, as you would if you were creating a good storybook. You would be surprised at the number of simple spelling errors that are present in most design documents. While everyone misses a word every now and then, you should try your best to keep grammar and spelling mistakes to minimum. This is not directly important to you, but again, you do not know who might end up reading it.

Many teams place background information in its own category, but because it relates to the story, it can be placed within the game overview category. Some genres, such as a sports simulation, would not have a background section and can therefore be passed over.

LEVELS

The next item you need to address is the levels that make up a game. If you do a thorough job in the preceding step, this one is very easy. You compile a list of levels in the order in which they will be encountered in your game, adding any details you deem necessary. Some optional materials include ideas such as the layout, a general description, or the placement of enemies, to name a few. Creating a mood for a level at this time can be a big bonus, as a designer or artist can simply browse this area to get a feel for what needs to be created.

The creation of a set of maps for the levels is helpful to the members of the team, especially the programmers and level designers. They can be very detailed pictures, but more likely will be a set of simple lines, circles, and squares that form a rough layout of the levels. An example of this is shown in Figure 2.1.

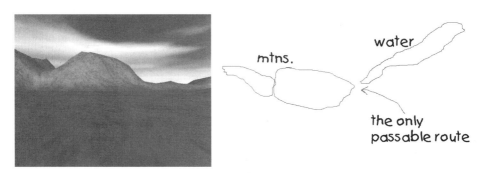

FIGURE 2.1 *A level with a map.*

Chapter 2 The Design Document

Heroes and Enemies

The next section of the design document deals with the characters that will be included in your game. Like the level area of the document, the character section should basically fall into place if the game overview is meticulous.

There are two basic types of characters in most games: a hero, and enemies. You can include details of the hero, such as any background information or some rough sketches. These ideas will again help team members to understand what is trying to be accomplished. A list and description of animations should be included with every hero as well. Depending on their role in the story, you can also include descriptive ideas of their intelligence level and strength, and basic information about how they react to the rest of the characters. Again, this information will be beneficial to the team when they are working with them.

Once you finish with the heroes, you need to create a specific section for enemies you will encounter. This could include anything that will attack a player. For instance, in an FPS, you might include a dinosaur, or in a space combat game, you could include an asteroid. You can follow the same basic procedures as the characters, making sure to include similar details and sketches where appropriate. For reference, Figures 2.2 through 2.4 are sketches of the raptor that we are using in our game project.

FIGURE 2.2 *A rough sketch of a raptor.*

FIGURE 2.3 *The raptor with some color.*

FIGURE 2.4 *A 3D rendering of the raptor.*

Finally, you need to include information about the types of weapons to which the characters will have access. You should include detailed descriptions of every weapon that can be accessed by either type of character. Sketches can be valuable for everyone on the team. You should create a list that describes the damage that the weapon will create, along with the type and amount of ammunition (see Figure 2.5).

Chapter 2 The Design Document

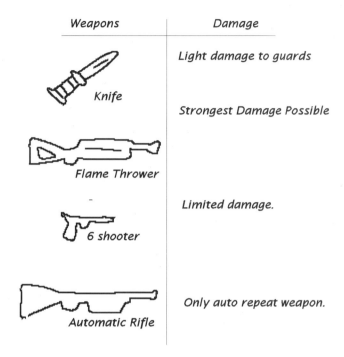

FIGURE 2.5 List of weapons and damages.

Notice the very simplistic sketches in Figure 2.5. You can make them as detailed or as simple as you need for your particular project. Often, it is more important to get them drawn than worry about how great they look. You can always go back and clean them up later.

Menu Navigation

A list that details menu navigation is very important. It helps you to keep track of the way that the game is linked to other parts, and is very important to the programmers involved. You should create the main menu and a simple illustration of how the screens will be linked together. Nothing fancy is necessary, but all of the menus should be included. For example, you could use something like Figure 2.6 to display information about the opening screen of a racing game.

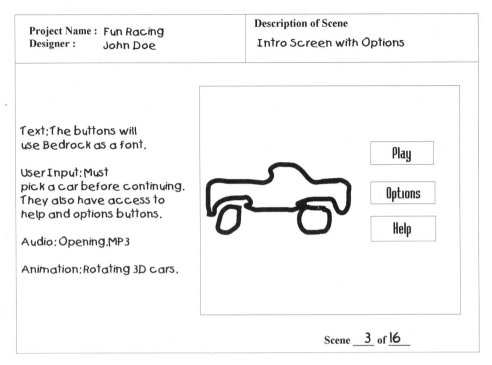

FIGURE 2.6 *A fictitious racing game opening screen.*

USER INTERFACE

The user interface goes hand in hand with the menu navigation system. For convenience, you could place them under the same category, as they deal with many of the same ideas. The information for this category can be text-based information about what you are planning to do, but ideally, some type of sketch works best. Like most of the design document, they do not have to be fancy, but details are important (see Figure 2.7).

MUSIC AND SOUND EFFECTS

This section is important to the audio personnel on the team and the programmers who will try to use their sounds in the game. You can discuss the possibilities of tools that you plan to employ, the types of sound effects that you have in mind for some of the game, and possibly detail the music you might have in the levels that you listed earlier in the process.

The most important step in the first draft of the document is to include what formats and sound API (application programming interface) you are planning to use, and what types of music and sound effects. For example, you should decide if you are going to use MIDI, WAV, or MP3 files for the music, and if you

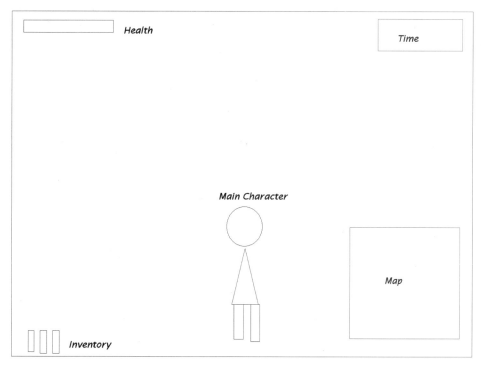

FIGURE 2.7 *A user interface example.*

will need sound effects such as explosions or footsteps. You should also list the genres of music you will be planning; for example, rock or pop. This keeps the programmers and audio personnel thinking the same way so that they are not surprised two months into the project.

SINGLE OR MULTIPLAYER

The next step focuses on the game play itself. If you worked hard on the game overview, you might have already covered this. If you have, this section is much easier. If not, you should begin by determining if it will be a game that implements single player, multiplayer, or both. For example, if you are planning an FPS clone like *Quake*, you might decide that it is single player only. If you are doing a sports game like basketball, you'll probably want to have multiple player support. Sometimes, the information in this area of the document is discussed in other areas, but you should not worry about duplication of ideas. This is especially true on a first draft, as you can always change the document after a later inspection.

If it is a single player game, you can describe the game experience in a few sentences and perhaps break down some of the key elements of the single-player game. For example, if it's a *Quake* clone, you could begin by setting up the location of the game. Next, you could detail the types of enemies you will be facing and the route to complete the game; for example, you have to finish 10 levels before the game is over. You could also list how the game ends; For example, if the player does not complete the level on time. Another idea that you can include is a projection on the number of hours the game is going to take before a player finishes, and how the player ultimately wins the game. A single player game is usually easier to design, and discuss in the design document.

A multiplayer game description begins the same way as a single player. You can take a few sentences to describe the basics of the game play. The basketball game we mentioned earlier could begin be mentioning the type of game; for example, street ball type of game, college, professional, or international rules game. You can also decide what types of options you will have, such as franchise mode for a professional game, or what types of parks you will include for a street ball game. Now is a good time to decide how many players will be allowed to play simultaneously and how you plan to implement the client-server or peer-to-peer system. For example, do you plan to use something like DirectPlay or another API, and how many individuals do you plan to allow to play against one another. In our basketball example, you need to decide how many people you will allow to play on the same team or against one another on different teams. You do not need to have complete technical details, but at a minimum, you should discuss the possibility of the protocol you plan to use. It would be even better to begin looking at potential pitfalls that are common in multiplayer games.

MISCELLANEOUS AND APPENDIX

The final area of the document is for miscellaneous information that might be specific to a certain type of genre or does not fit neatly into another category. You can name this category anything that works well for you. For example, suppose you decide to do a basketball street game and you want to include information about the way the basketball players will dress so that you can keep track of players from both teams. You could have one team play in white shirts and another in red shirts, for example. If you have multiple additions, you should split them up into multiple categories to keep everything easy to read and follow. The appendices are a good place to put items such as sketches or concept drawings. This way, you can refer the reader to an appendix instead of cluttering up your text.

WRAPPING IT UP

Once the design document is finished and everyone on the team has had a chance to read it and make changes, you should print a copy for everyone and keep the original in a safe place where it will not be altered unless the necessary parties agree. If you leave the document on a server where everyone can access it, team members might decide to alter it to their liking, which would ultimately defeat the entire purpose.

GAME PROPOSALS

The game proposal is a much more formal document than the design document is. It will be used to approach a publisher for possible funding for a project. If you are planning to develop the project with your own money, a game proposal is probably unnecessary.

A game proposal takes the design document to another level. It involves several issues that should not be included in a design document. After the design document has been thoroughly digested by the lead programmers or the senior members of the team, it should be included with the game proposal. Additional information should be included, such as technical specifications, marketing, financial, and legal matters. We will not break these down into detail, but the major sections are included. For a quick overview, refer to Figure 2.8.

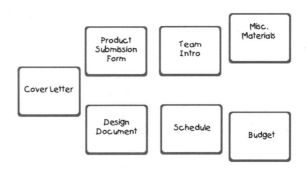

FIGURE 2.8 *Basic parts of a game proposal.*

Game Market

The game market is a good place to begin. You can determine a market simply by looking at titles that are similar to the one you are developing. By looking at sales figures, you can deduce what size of market a particular style or genre has and your potential for sales. An excellent source of game market data can be found at www.pcdata.com. You can search information on PC sales, Mac sales, and even home education sales. An example of the data available at PCData is shown in Figure 2.9. If you are planning a game to run on multiple platforms, you should try to break this information down among them.

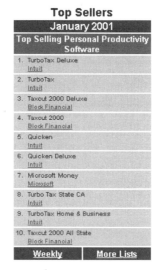

FIGURE 2.9 *Example from PCData showing market sales for February 2001. Source: www.pcdata.com ©2001. NPD Intelect Market Tracking. All rights reserved.*

Technical Information and Associated Risks

The most important things you should list in this area include the team's development experiences in developing a game similar to the one you are working on. For example, if the lead programmer has developed 3D engines in the past, you should mention that the 3D engine would be similar to the one they created before. On the other hand, if this is your first 3D engine, you should also convey this as well. If you are using third-party software such as a code library or sound effects, they should be listed as well.

There are technical risks in any project, so try to provide the possibility of a workaround if you encounter one. For example, you could purchase a 3D engine from company XYZ if the engine you are developing does not work out.

Required Resources and Scheduling

The final area that you should be sure to include is the required resources and scheduling information. The schedule should include an estimate as to the completion of a final project, along with specific steps along the way, such as an alpha or beta product. The required resources should include all financial-related estimates, such as the cost of employees, hardware, and software.

Chapter Review

Although we have gone over this process in some detail, we are only really scratching the surface. There are entire volumes of books written on much of the information we have briefly looked at. That being said, with the material from this chapter, you should not have a problem creating a functional design document for yourself or for a team. Be careful not to become offended if someone suggests that you change or alter something in the document. Input from others is important to the process, and the information you receive is usually invaluable. It is important to look at the creation of this document as an inexact science.

Feel free to alter the layout of the document as you deem necessary for any projects you are working on. You should definitely look over the appendices to this book to get a better feel for the process.

CHAPTER 3

What Language Should You Use?

WHAT LANGUAGE SHOULD YOU USE?

Although the book is DirectX 8 based, it is important to understand that there are many languages that you can use to program DirectX content. While many issues are debated in programming, the ones that get the most attention and are the most heated are those related to the choice of programming languages. Game programming is certainly not immune to the argument, and depending on whom you are talking to at any given time, you will receive a completely different answer to the same question. Therefore, rather than try to direct you to a specific language or development environment, we'll look at several of the most popular, discuss their strengths and weaknesses, and let you decide which language is best for you. This book is slanted toward Visual Basic, although the vast majority of concepts will work with any modern programming language. This chapter takes a well-rounded approach to the topic of programming languages.

One of the most important things to remember is that a good game design can often overcome a slower language and bad programming practices. This is not to say that programming is not important; it is obviously the largest focal point of any project. It is just to serve as a reminder that everything in game development, including programming languages and environments, is not as important as becoming comfortable with the tools you choose. Additionally, although the samples in the book are written in VB 6 (it also works with .NET or version 5), they would be very easy to convert to C# or Visual C++.

ASSEMBLY

Assembly was the first computer language and is a representation of the actual instructions that a computer processor runs. It has a very bad reputation that is hard to overcome. Many programmers feel that there are not enough benefits in using a language such as Assembly. This line of thinking is becoming more prevalent as the speed and storage capacity of computers continue to rise at a seemingly exponential pace.

The most often complaint of Assembly language is that it is difficult to learn. While this is true, it is probably not much more difficult that any other programming language, especially when you consider that most programs would not be based on Assembly alone.

Historically, many games have used Assembly in places where it could benefit the most. For example, most 3D engines have been written in C or C++, but many of them have a few bits of code that were coded in Assembly to improve performance. Most often, these routines are used for displaying information to the screen and are called thousands of times in the execution of a program.

Chapter 3 What Language Should You Use?

- **Advantages** A programmer who is well versed in Assembly can be a huge asset to a programming team. While most will use other languages such as C to do some of their programming, they will use the speed of Assembly in the routines that need it. Thousands of games have used Assembly to optimize performance.
- **Disadvantages** Assembly is not portable in any way, since it is designed for a single processor. It has been given such a bad name in programming circles that many are afraid of attempting to learn it. It also takes a little longer to program a sequence in Assembly than in any of the high level languages.
- **Additional information** If you are planning to write for a specific platform, you should check out the Web sites of the hardware manufacturers for that particular platform. For example, for X86 machines, check out Intel and AMD, as they are the two biggest producers of processors for PCs.

C

Dennis Ritchie created C in the 1970s. It original intention was for writing system-level programs such as operating systems, while trying to become a language that anyone could use and learn. Before its introduction, operating systems were coded in Assembly language, an arduous task even under the best of circumstances. Because of its initially intended uses, it interfaces well with Assembly language, which, as mentioned in the previous section, can be an advantage when you are trying to squeeze everything you can out of system.

- **Advantages** C is at its best when writing small and very fast programs. As previously mentioned, it can be interfaced with Assembly very easily. It has also been very standardized, so platform changes are not nearly as noticeable with C when compared to other languages. Many aspects of the language are platform independent, although you are generally required to write user interfaces for every platform you intend to use. It is not too difficult a process, which makes C a popular choice for multiple platforms.
- **Disadvantages** The syntax of the C language takes some time to get used to, and might not be the best choice for beginning programmers. It does not lend itself to object-oriented techniques, which can be problematic for individuals who are used to object-oriented programming (OOP).
- **Additional information** There are so many books and documentation available for the C language that it could conceivably take an entire chapter just to list them. With that in mind, you can check out discussion groups (see the appendices for links) for information about many of the popular books.

C++

C++ is an object-oriented successor to C, and is probably the most used programming language for games. If you are unfamiliar with the concept of OOP, it simply means that the programs are built from objects that can be used repeatedly. This type of programming allows you to theoretically create an application with libraries designed by yourself or others, piecing them together as needed. There are countless libraries available for C++, covering everything from sound to graphics and databases. It's often a much easier solution for programming; however, many game developers do not embrace C++, as it often adds performance overhead to a game—obviously, not what most game programmers would be looking for.

As mentioned previously, the advocates of a particular language or environment are very quick to point out the weaknesses in other development environments. The C versus C++ argument is probably going on right now in a discussion group or online chat room. You will usually find individuals who are on one side or the other, although you will occasionally find someone who likes both and understands the strengths and weaknesses of each. The independent members of the discussions usually will point out that C++ is much easier to use, and the extra overhead associated with it is more than worth it.

A smaller problem within this much larger one is that many individuals try to decide which language they should learn first, C or C++. Again, this is not easy to determine. Although C is probably easier for a beginning programmer to learn, you will not learn object-oriented approaches and will therefore be required to relearn a new way of programming if you want to use most of the newer programming languages.

- **Advantages** With its object-oriented approach, C++ is much easier to use, and some people like the enormous amount of available libraries. It is probably easier than C to manage programs, too, especially when they can become extremely large and complicated, as games tend to do. C++ slightly more portable than C, and the vast majority of commercial games are probably written in C or C++. In addition, there exists tremendous IDEs for C++, such as Visual C++ (see Figure 3.1) or C++ Builder.
- **Disadvantages** Depending on the situation, it C++ might be slower than its C counterpart. It can also take some time to get used to if you are unfamiliar with structured programming.
- **Additional information** Like C, there are too many resources to limit this to only a list. Check you favorite bookstore to determine which books are best for the version of C++ you are using. There are also many good programming classes at your local college that might be helpful to a new programmer.

CHAPTER 3 WHAT LANGUAGE SHOULD YOU USE?

FIGURE 3.1 *The Visual C++ IDE is an advantage for developers.*

VISUAL BASIC

The Basic language has been around for some time now, and Microsoft has clearly captured the market with their version, called Visual Basic, undoubtedly one of the most popular languages for development of business applications. It is the most widely used language in the world because it is often easier for beginners to learn and use. One of the problems with Visual Basic has been its lack of support for heavy-duty multimedia work, although this problem has quickly disappeared with many third-party 3D engines and tools written exclusively for the VB programmer. Moreover, DirectX has had support for VB since version 7.

Visual Basic's strength lies in its ease of use. It is nearly impossible to write an application in C or C++ and do it as quickly as you can in VB. Most of its users are corporate programmers developing databases with VB on a daily basis.

However, because it is the most popular language in the world, it was only a matter of time before support was available for multimedia and games. During the past several years, third parties released countless ActiveX controls and add-ons that allow VB programmers to take advantage of DirectX and OpenGL. The controls allow VB programmers to do things previously impossible. Now that Microsoft is supporting VB with DirectX, the language is becoming more popular for game programmers, and with the impending .NET release, it appears that VB is poised to become a serious contender for game developers.

- **Advantages** VB is the most popular language in the world and has a tremendous user base and support system. The VB IDE (see Figure 3.2) is excellent, and even a novice programmer can pick it up and use it rather easily. Visual Basic can use DirectX, which enables it to compete with historically more popular game programming languages such as C or C++. Over the next few years, we are certain to see more commercial games written entirely in Visual Basic.

FIGURE 3.2 *The VB IDE is easy for beginners to learn.*

- **Disadvantages** The biggest disadvantage of VB is that it is a proprietary language. That is, a program developed in VB can only run on the Windows platform. That being said, many games are written only for Windows anyway, since it is by far the most popular operating system on computers today. Additionally, the .NET framework might change all of this.
- **Additional information** There are countless users groups and training materials for Visual Basic, and like C and C++, it would be impossible to list even a fraction of them. Most colleges offer low-cost courses in Visual Basic. For beginning programmers, check out the book *Learning Visual Basic with Applications* (Charles River Media). It is a good beginner and intermediate programmers' book with complete instructions on building many types of applications, ranging from games to an MP3 player to a paint program.

DELPHI

Delphi is very similar to Visual Basic in that its ease of use and IDE are its most important features. Like VB, Delphi has had tremendous support from the large user base, including complete 3D engines and third-party controls for accessing DirectX. We will not get into the VB versus Delphi argument in this book as it is very heated, with programmers from both sides defending their favorite environment.

Delphi has been a Windows-only product, although a recently released program called Kylix is essentially Delphi for Linux. This could be a big plus for those out there looking for an easy way to develop applications for Linux. There are several books available for Delphi as it relates to game programming, along with several user groups and message boards on the Internet.

JAVA

Java is a portable language developed by Sun to compete with C++. It borrowed many aspects of the C++ language, although it seems to be a little easier to learn for beginning programmers. The programs you develop can be platform independent, and most can run embedded in Web pages. The language became popular seemingly overnight with thousands of developers rushing to learn the new offering. There are thousands of Web sites, newsgroups, and message boards for Java programmers. Add to this the large number of books and learning resources, and you have a relatively easy-to-learn language with a tremendous number of resources.

Similar to Visual Basic, Java uses a runtime engine called a *Virtual Machine* to execute Java programs. This makes applications slower than truly compiled programs, but new technologies like Just In Time compilers have greatly enhanced the speed at which Java programs execute. It is very portable, but

user interface elements often have to be rewritten to work on different platforms. There are not many commercial games written in Java, but this will probably change in the future, as many developers become better acquainted with the language, and speed improvements continue to unfold.

Chapter Review

Now that we've looked at the many languages and several authoring tools, you are probably wanting an answer to "which language or tool should I use?" Unfortunately, there is not a single solution that will work in every instance.

Assembly is by far the fastest language available, but it is probably not a good solution for a complete game. C and C++ are the most common languages used by game programmers, although they might not be the best choice for beginners. Visual Basic is definitely a language that is making headway as a game development solution, but it is currently limited to the Windows OS. Finally, there are Java and Delphi to consider, each with its own strengths and weaknesses.

With all of this information in mind, you are probably in a better position to determine the language or authoring tool that will best suit your needs. For example, C++ might be a great choice for a heavily used multi-user 3D game, but not the best choice for a card game such as Poker. Therefore, it is often easiest to determine which language best fits the type of game you are working on, rather than the other way around.

CHAPTER 4

Introduction to MilkShape 3D

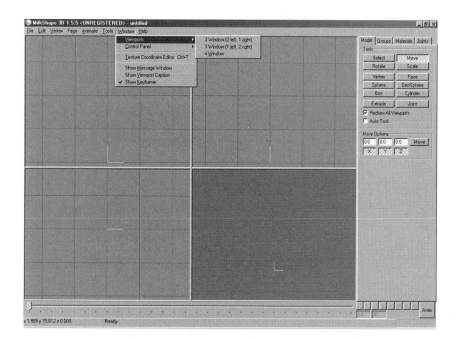

Before we move on to DirectX programming, let us look at several tools that we'll use to construct the various elements that will make up the final game project. These software packages include Sonic Foundry's ACID for loop-based music, MilkShape 3D for the creation of 3D models, PaintShop Pro for bitmaps and textures, and Cool Edit 2000 for sound effects recording and editing. We will begin by looking at the basics of these applications, and then move forward to use them for our project.

There are many good 3D modelers on the market today, but you would be hard pressed to find an application as inexpensive as MilkShape 3D. Obviously, price isn't the only factor in choosing tools, and fortunately, MilkShape offers everything you need for the type of low-polygon modeling necessary for real-time game development.

We will use the terms MilkShape, MS3D, and MilkShape 3D interchangeably throughout the text, although they are in fact the same product.

INTRODUCTION TO MILKSHAPE 3D

MilkShape 3D is a low-polygon modeler initially designed by Mete Ciragan for the creation of Half-Life models. During the development of the product, Mete has added many file formats to the package, including the most common game formats.

MilkShape 3D offers a full set of basic modeling operations such as select, move, rotate, scale, extrude, and turn edge, to name a few, and allows low-level editing with the Vertex and Face tool. MilkShape also includes a set of primitives such as spheres, boxes, and cylinders.

The most important feature of MilkShape is the ability to do skeletal animation. This allows you to export to morph target animations such as those offered by the *Quake* model formats, or to export to skeletal animations like Half-Life or Genesis3d. For our gaming project, we will use the Half-Life model format, as it offers one of the easiest and most powerful game formats.

Chapter 4 Introduction to MilkShape 3D

Installation

ON THE CD

Before we can begin using MilkShape, we first need to install it.

MilkShape located on the companion CD-ROM in the Applications\MS3D155 directory. Otherwise, you can download the latest version from www.swissquake.ch/chumbalum-soft/.

Once you have acquired the software, the next step is to run the setup.exe file. It will begin the installation process, where you will be presented with a screen that looks similar to Figure 4.1.

FIGURE 4.1 *The installation program begins with this screen.*

Click Next to continue the installation. From the next window, which appears in Figure 4.2, you should enter an installation directory or use the default value of C:\Program Files\MilkShape 3D 1.5.5.

The default installation directory contains version information. Therefore, it might be different depending on the version you have.

FIGURE 4.2 *Set the appropriate installation directory for MilkShape.*

You need to click Start from a window that looks similar to Figure 4.3 to copy the files to the hard drive.

FIGURE 4.3 *Click Start to copy files to the hard drive.*

The last step in the process is to click Exit in the window shown in Figure 4.4.

FIGURE 4.4 *The final step in the installation process.*

Once you have finished the installation, you can run MilkShape by clicking the shortcut that was created in the installation. When you open MilkShape for the first time, a window will appear similar to Figure 4.5. This window will be displayed only when it is executed the first time, and it is very important. As you will notice, it displays your current system date and time.

You need to make sure the information is accurate, as MilkShape allows you to use their software for only 30 days without registering it. If the information is incorrect, you need to correct it before you click Yes. Otherwise, if you attempt to correct it at a later time, the software will not function unless you register it. Take the 30 days to try MilkShape and if you like it, consider registering it. It is currently only $20, a small price for a modeler with so many features.

Once you have determined the date is correct, click Yes, which will display the standard MilkShape interface that appears in Figure 4.6.

Chapter 4 Introduction to MilkShape 3D

FIGURE 4.5 *Make sure the system date and time are accurate before you click Yes.*

FIGURE 4.6 *The standard MilkShape 3D interface.*

MilkShape 3D Interface

Before we begin looking at the modeling features of MilkShape, you first need to understand some of the basics of the MilkShape interface. Like the vast majority of modeling tools, you have the ability to alter the view windows. First, you can customize any individual window by right-clicking on it and selecting from the available options. The available commands are shown in Figure 4.7.

FIGURE 4.7 *You have many options available for the individual view windows.*

Along with options for changing the individual viewports, you can also display the viewports in several types of sets. To change the viewports, click on the Window | Viewports menu option shown in Figure 4.8.

Depending on your personal preference, the viewports can be displayed in several ways. First, you can display four viewports, which is the standard view (see Figure 4.9). Otherwise, you can display the viewpoints in three window views, with two windows on the left (Figure 4.10) or two windows on the right (Figure 4.11).

Chapter 4 Introduction to MilkShape 3D

FIGURE 4.8 *You can change the viewports to your liking.*

FIGURE 4.9 *Viewports in standard four-window setup.*

FIGURE 4.10 *The viewports with three windows, two on the left and one on the right.*

FIGURE 4.11 *The viewports with three windows, one on the left and two on the right.*

CHAPTER 4 INTRODUCTION TO MILKSHAPE 3D

You can further customize the individual viewports by displaying captions in them. This allows you to enter parameters, and change the viewports from a drop-down list. Figure 4.12 shows these options.

FIGURE 4.12 *Displaying captions in the viewports can be a big time saver.*

VIEWPORT CONTROLS

Now that you have a basic understanding of the user interface, we will move on to the basic functions of the viewports. A viewport can be zoomed by holding down the Shift key and the left mouse button, and dragging the mouse vertically. It is important to note that zooming will not work if the Select button under the Model tab is selected. If the viewport is 3D, holding down the Shift key and the left mouse button will rotate it in a 360-degree arc. The viewport can also be panned by holding down the Ctrl key when the left mouse button is selected and dragged.

BASIC MODELING FUNCTIONS

In Chapter 6, "Creating Low-Polygon Models with MilkShape 3D," we'll use MilkShape 3D to construct models for the project we are creating in this book, but first, you need to be accustomed to many of the basic features that Milk-Shape offers.

PRIMITIVE OBJECTS

To create models in MilkShape, you use the built-in primitive objects that Milk-Shape offers. They are located in the upper-right corner of the interface under the Model tab and can be seen in Figure 4.13. The vast majority of 3-D programs provide geometric primitives, such as spheres, boxes, and cones to use as building blocks.

FIGURE 4.13 *The primitives are used to construct models.*

SPHERE

To draw a sphere, you need to place the pointer on the screen where you want the sphere's center point, and then click and hold down the left mouse button while dragging the pointer to create the radius of the sphere. You'll see the sphere drawn as you drag the mouse. Once finished, simply release the button and the sphere will be placed in the available views. A sample sphere is shown in Figure 4.14.

FIGURE 4.14 *A sample sphere displayed in a four-window viewport.*

GEO-SPHERE

A geo-sphere is another form of sphere, but it is very smooth compared to the standard sphere. Creating the geo-sphere is similar to the standard version; you click and hold the left mouse button at the desired center point of the geo-sphere, and then drag the mouse to the desired radius of the sphere. The geo-sphere, a sample of which is shown in Figure 4.15, will be displayed as you drag the mouse.

FIGURE 4.15 *The geo-sphere is smooth compared to a standard sphere.*

Box

Just as it sounds, a box is a six-sided cube. You draw it in much the same way as a sphere. However, instead of placing the mouse where you want the center, place it where you want the initial corner. Next, click and hold the left mouse button while dragging the mouse until you reach the point where you would like the opposite corner placed. You'll see the box being drawn as you move the mouse. A sample box is shown in Figure 4.16.

Cylinder

A cylinder is created as the other primitives are, but will always be drawn with the ends facing up and down. For example, in the vertical views (which are front, back, left, right), you position the pointer where you want the cylinder to begin, and then hold down the left mouse button and drag the pointer. The

Chapter 4 Introduction to MilkShape 3D

FIGURE 4.16 *Boxes are drawn in a similar manner as the spheres.*

cylinder will be drawn as you drag the mouse. The diameter of the cylinder is scaled uniformly as you drag left or right, and the height is set by the distance you drag vertically. In the vertical views, it appears that you are drawing a rectangle, but you can verify that you are drawing a cylinder in the 3D view.

If you draw a cylinder in the top or bottom view, click and drag the mouse similarly to the vertical views. However, notice that when you drag the mouse, you'll actually see a circle being drawn that scales uniformly. Again, you can verify that you are actually drawing a cylinder by looking at the 3D view. Figure 4.17 shows a sample cylinder.

FIGURE 4.17 *Depending on the viewport, a cylinder might look like a circle or a rectangle.*

MESH EDITING TOOLS

Along with the modeling tools, MilkShape provides several tools for moving, scaling, extruding, and rotating your selected vertices or faces. Like the modeling tools, the mesh tools are located in the Model tab, shown in Figure 4.18.

The mesh editing tools that follow only work on a selected vertex or face, and will not work in a 3D view.

TIP

VERTICES AND FACES

Before we look at the mesh editing tools, let us look at two of the basic components of MilkShape and 3D modeling in general: vertices and faces. A vertex (or vertices for more than one vertex) is simply a point in 3D space. You can combine them to form faces, which are a series of vertices that define a plane in 3D space.

FIGURE 4.18 *Mesh editing tools are available in the Model tab.*

You create a vertex by selecting the Vertex button and clicking inside a viewport. Once you have placed the vertex, you will see a red dot that represents it. To create a face, you need to have a minimum of three vertices, which are then clicked on in a counter-clockwise manner to create a face. Do not spend too much time worrying about this right now; we will cover it in more depth when we create some actual models.

SELECT TOOL

Now that you understand vertices and faces, we will look at the mesh editing tools. The Select tool is used to select a vertex, vertices, or faces. This is the first step before you move on to the other tools, which only work if a vertex or face is selected. You can select them in several ways, but one of the easiest is by drawing a selection box around the vertices or faces that you want to select.

Drawing the selection box in MilkShape (see Figure 4.19) works like most other graphics applications. You click in a viewport to set your initial corner, and while holding down the left mouse button, you drag the mouse. You will see the box being resized as you move the mouse, and when you release the button, the selected vertices or faces will turn red to show that they are selected. The selected faces are shown in Figure 4.20.

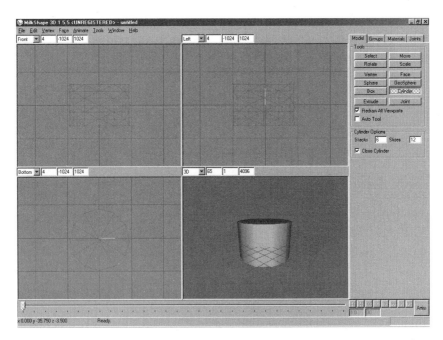

FIGURE 4.19 *The selection box allows you to select multiple faces or vertices at a single time.*

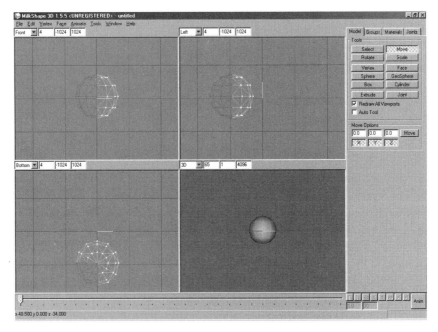

FIGURE 4.20 *The faces or vertices that are selected will be red to distinguish them from the others.*

You might have already noticed the additional options available for the Selection tool. Using these options and clicking on vertices or faces, you can select faces individually.

Depending on your accuracy when using either selection option, you will probably select unwanted faces or vertices. In this case, you should hold down the left mouse button and deselect any face or vertex that you do not want selected. They will return to their normal white color when you deselect them, which allows you to determine the remaining selected items. The last two selection options allow you to select an entire mesh group or a joint, although we will not discuss them at this time.

The next step is to look over the mesh editing tools: move, scale, and rotate.

Move

The Move tool works as you would expect. When you click on selected vertices or faces and drag them while the Move tool is selected, they will move in the direction you are dragging. There are several options available when the Move tool is selected. First, you can restrict movement of the faces or vertices by deactivating any of the X, Y, or Z buttons.

X, Y, and Z coordinates refer to the directions in 3D space. X is the horizontal dimension (left to right); Y is the vertical direction (up and down); and Z is the 3D dimension (back and forth).

Besides having the ability to move the vertices and faces by dragging the mouse, you can also enter exact amounts in the boxes, as shown in Figure 4.21.

FIGURE 4.21 *The faces have been moved −3 in all directions using the input boxes.*

SCALE

Scale is used to resize the selected faces by dragging the mouse or using the input boxes. It works similarly to the Move tool in this respect. You can also restrict the movement as you can with the Move tool.

There are additional options for the Scale tool: Center of Mass, Origin, and User Point. Center of Mass means that the faces will be scaled from the center point of the selected faces. The origin of MilkShape 3D can be seen at the center of a viewport; it is the two lines shown in Figure 4.22. If you select the Origin button and then scale a face, the scale will be based on the origin point. The final option, User Point, makes the scale radiate from the original position of the mouse when you click the button.

Chapter 4 Introduction to MilkShape 3D

Figure 4.22 *The origin of MilkShape.*

Rotate

Rotate works similarly to the others with a click-and-drag operation used to rotate the selected vertices or faces. The direction of rotation depends on the view you are in. As with the other tools, you can restrict the direction of rotation and you can manually input rotations into input boxes. It also has the same type of center point options that scale offers, including Center of Mass, Origin, and User Point.

Extrude

The Extrude tool obviously allows you to extrude a face in a certain direction. You cannot extrude vertices, and if you attempt to do so, some very strange things will happen. It becomes very unpredictable, so do not even attempt to do it. The Extrude tool has similar options that the other mesh editing tools offer, including the ability to enter exact values into X, Y, and Z input boxes. Figure 4.23 shows a face that has been extruded.

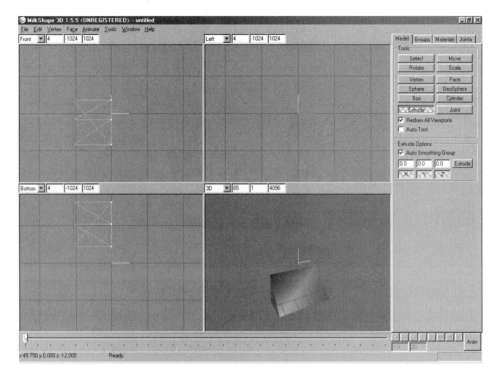

FIGURE 4.23 *A triangular face that has been extruded.*

ANIMATION TOOLS

The animation tools that are available in MilkShape are one of its most impressive features. In this section, we'll look at the ideas and menu options that you'll need to become familiar with.

JOINTS

You can create joints for models with the Joint tool. You use it similarly to many of the MilkShape tools, with one exception. Instead of clicking and dragging to create bones, you first click a single time, which creates the first part of a bone, and then move your mouse and click again to create the second part. A sample bone is shown in Figure 4.24.

Chapter 4 Introduction to MilkShape 3D

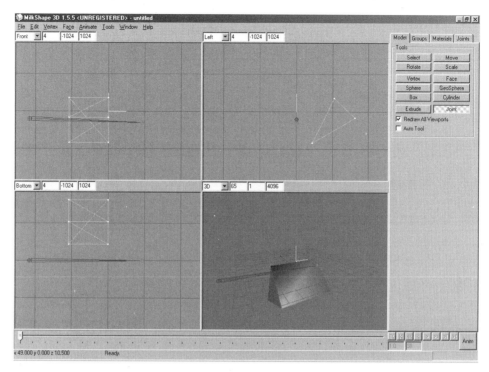

FIGURE 4.24 *Creating joints and bones in MilkShape is a very easy process.*

MilkShape uses keyframes to create animation sequences. We will look at this further when we do a step-by step-tutorial later in the book.

Menus

There are only a few menus that we need to concentrate on for animation: File, Edit, Vertex, and Faces.

File

The last thing we will look at in this introduction to MilkShape is the File menu, shown in Figure 4.25. There really isn't much to discuss with this menu. It contains all of the standard file operations, such as Open, Close, and Save. Most of the items in the File menu are self-explanatory, with the exception of Merge, which does just what its name implies—it merges two 3D files together.

FIGURE *MilkShape has a standard Windows menu.*
4.25

Finally, the import and export options offer a great deal of functionality for game developers. Perhaps the most important aspect of any modeler is the file formats it offers. MilkShape excels in this area. Depending on your needs, Milk-Shape can export models to many popular game formats, including the following:

- Half-Life SMD
- Quake I MDL
- Quake II MD2
- Quake III Arena MD3
- Vampire t:MR NOD
- Lithtech ABC v11, v12
- Genesis3D BDY 1.0
- Genesis3D MOT 1.0
- Unreal/UT 3D
- Nebula Engine
- Wavefront OBJ
- 3dstudio ASC
- LightWave LWO
- AutoCAD DXF
- POV-Ray INC
- VRML1 WRL
- Autodesk 3DS
- MilkShape 3D
- ASCII RAW
- Renderman RIB

EDIT

The Edit menu is missing several of the normal features you might expect in a Windows application. It does not offer the standard Cut, Copy, and Paste commands. Instead, you can use Duplicate Selection, which will copy any faces you currently have selected. It will not copy vertices. In addition, the duplicated section will be placed in the exact location as the original, so you might not see it at first glance.

Vertex

The Vertex menu offers several options all related to vertices. First, you can snap two vertices together with Snap Together. You can also snap a vertex to the grid or weld them together, which you always do after you snap them together. Flatten allows you to flatten all of the vertices to a particular plane. Finally, the Mirror commands are particularly useful when you have duplicated an object.

Faces

This menu offers options for faces in MilkShape. The first menu option, Reverse Vertex Order, will make a visible face invisible, or an invisible face visible. It does this because a face only has one visible side. You can just think of it as a type of toggle, which allows a face to be on or off. Subdivide 3 and 4 subdivide a face into three or four parts, respectively.

Figure 4.26 shows a square with two faces selected. If you click on Faces | Turn Edge, the edge will turn and will now appear like Figure 4.27. The last command we will look at is Face to Front, which works opposite of Reverse Vertex Order.

Others

The remaining menus can be covered very quickly. The Animate menu contains everything related to animation. We will look at it in greater detail in Chapter 11. The Tools menu contains information specific to individual model formats, such as Half-Life and Quake III Arena. If you are planning to use MilkShape for a specific type of file format, you might want to invest a little time to work through this menu. The last menu, Window, was already looked at earlier in the chapter. It gave us the option to arrange our viewpoints in specific ways.

FIGURE 4.26 *A square with two faces selected.*

FIGURE 4.27 *The edge turned between two faces.*

CHAPTER REVIEW

While there are several great 3D modelers on the market that cost thousands of dollars, MilkShape provides some of their functionality at only $20. It would be difficult to find such a bargain in another software package. Not only is the program inexpensive, it also offers everything you need for the type of low-polygon modeling necessary for real-time game development. With the basic information you have gained in this chapter, it will be possible to move on to creating simple game models with MilkShape, and ultimately creating animated characters.

CHAPTER

Introduction to PaintShop Pro

PAINTSHOP PRO

PaintShop Pro is an excellent graphics editor and is a great choice for game developers. Currently in its seventh release, PaintShop Pro offers a tremendous number of features in a low-cost product. It supports both bitmap and vector objects, which allows you to have access to both types of graphics without purchasing another tool. For game designs and texture creation, PaintShop Pro offers everything you need in one easy-to-use package.

INSTALLATION

Before we begin discussing specifics of PaintShop Pro, we need to install it.

ON THE CD

PaintShop Pro is located on the companion CD-ROM in the Applications directory and is called PSP702ev.exe. If you prefer, you can download the latest version from www.jasc.com.

The first step in the installation process is running the executable file. It will begin the installation process where you will be presented with a screen that looks similar to Figure 5.1. You can leave the directory as it is listed; it's only a temporary directory for the installation files.

FIGURE 5.1 *The installation program begins with this screen.*

Chapter 5 Introduction to PaintShop Pro

Click Next to continue the installation. It will take a few moments before the next window appears, which should look similar to Figure 5.2. You need to click Next at this window.

Figure 5.2 *Click Next to continue the installation.*

The next window is a license window, which is shown in Figure 5.3. It displays the PaintShop Pro license agreement that you should read. In order to continue the installation, you need to accept the terms of the license.

Figure 5.3 *You need to accept the license agreement before you can continue.*

After you agree to the terms of the license, click Next. A window, shown in Figure 5.4, appears that allows you to select a complete installation or a custom installation. Leave the installation set at Complete, and click Next.

FIGURE 5.4 *Choose a Complete installation from this window.*

The last step is to click Install from the window as shown in Figure 5.5.

FIGURE 5.5 *The final step in the installation process.*

Chapter 5 Introduction to PaintShop Pro

Once you have finished the installation, the Installshield Wizard will display a window that looks something like Figure 5.6. You should choose to create a shortcut on the desktop from this window, and click Next. From the last window, click Finish.

FIGURE 5.6 *Click Finish to end the installation process.*

Once the installation is finished, you will find a shortcut to PaintShop Pro on your desktop. Double-click it. When it is first started, a window will be displayed that looks like Figure 5.7. If you would like to purchase PaintShop Pro, you can do so by clicking the Order button. It will give you details on how to purchase PaintShop Pro. If you do not choose to purchase it, you can use PaintShop Pro freely for 30 days by clicking Start to move on.

 PaintShop Pro will function correctly for only 30 days unless you purchase it.

CAUTION

FIGURE 5.7 *This window allows you to purchase PaintShop Pro, or use it in trial mode for 30 days.*

Another window appears, asking you to pick your file associations. File associations allow a program like PaintShop Pro to be opened simply by double-clicking a file with which it is associated. Unless you have some specific files in mind, you should leave the standard files selected, some of which are shown in Figure 5.8.

FIGURE 5.8 *You can select certain files to be associated with PaintShop Pro.*

Once you have determined the correct files, click OK to display the standard PaintShop Pro user interface.

CHAPTER 5 INTRODUCTION TO PAINTSHOP PRO

USER INTERFACE

Now, let us look at the basics of the user interface and a few of the most important tools that are available in PaintShop Pro. In Chapter 7, we'll use PaintShop Pro to design textures and a user interface for the First Person Shooter (FPS) we are going to create.

The PaintShop Pro user interface is shown in Figure 5.9. It is a very good design for a user interface, as it provides excellent functionality and is very easy to learn.

FIGURE 5.9 *PaintShop Pro has an interface very similar to most Windows applications.*

Figure 5.10 includes basic descriptions for all of the user interface elements.

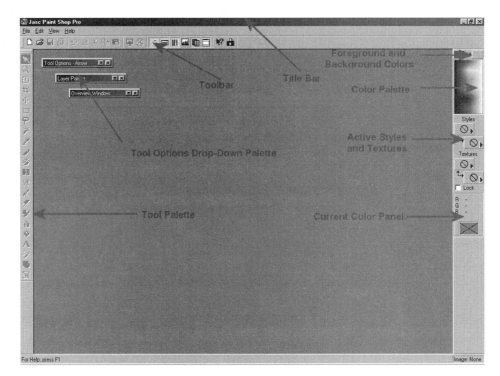

FIGURE 5.10 *The PaintShop Pro interface with everything labeled.*

Next, let's look at several of the labeled entries in more detail.

THE TOOLBAR
The Toolbar contains options for doing many routine tasks, such as opening, closing, saving, and copying or pasting. The Toolbar displays buttons corresponding to the menu commands. It is much easier to click the Toolbar button instead of looking through the menu for the corresponding option. If a command is available, you can click on it. Otherwise, it will appear to be "grayed out" and will be unavailable for selection.

TOOL PALETTE
The Tool palette contains the painting, drawing, and retouching tools (see Figure 5.11).

CHAPTER 5 INTRODUCTION TO PAINTSHOP PRO

- Arrow Tool
- Zoom Tool
- Deformation Tool
- Crop Tool
- Mover Tool
- Selection Tool
- Freehand Tool
- Magic Wand Tool
- Dropper Tool
- Paint Brushes
- Clone Brush
- Color Replacer Tool
- Retouch Tool
- Scratch Remover Tool
- Eraser Tool
- Picture Tube Tool
- Airbrush
- Flood Fill Tool
- Text Tool
- Drawing Tool
- Presets Shape Tool
- Object Selector Tool

FIGURE 5.11 *The Tool palette contains a variety of drawing, painting, and retouching tools.*

TOOL OPTIONS PALETTE

When you click a Tool palette button, the Tool Options palette displays the options associated with the tool, and the Status Bar displays a short description of its use. Depending on the current tool, you can select from a single tab of options to multiple tabs. The palette has a permanent tab that allows you to modify the appearance of the cursor and the settings for a pressure-sensitive tablet.

Color Palette

You use the Color palette to select the colors, gradients, patterns, and textures that you want to apply to an image. When you move the cursor over the available Colors panel, it changes to the Dropper tool. A single click will change the foreground color, and a right-click will change the background color. Directly above the available colors, you will see the currently selected foreground and background colors.

Style and Texture

The Style and Texture tools are useful for determining if you want to paint with a solid color, a texture, or a pattern. The upper boxes display the foreground and stroke styles, and the lower boxes display fill and background styles.

Painting Tools

PaintShop Pro provides several tools that you can use for painting. The Painting tools, which are available on the Tool palette, can only be used on raster layers, while the Drawing tools, which are also available on the Tool palette, can be used on either raster or vector layers. We will look at several of the most important features of the tools.

Paintbrush

The Paintbrush is useful for painting freehand, much like you would with a regular paintbrush. You simply select the Paintbrush tool, and click and drag the cursor while holding a mouse button. If you want to apply the current foreground and stroke style, use the left mouse button; the right button applies the background and fill style. Releasing either button ends your current painting. If you want to create straight lines, hold down the Shift key and click the beginning point. Then, move to where you would like the line to end, and click again. Figure 5.12 shows the differences between freehand drawing and using a mouse and holding down the Shift key to drawn straight lines.

Eraser

You can use the Eraser to remove colors from an image, replacing them with the background color or transparency. Although you should be careful when using the Eraser, you can easily undo a mistake by pressing Ctrl-Z or selecting Undo from the Edit menu.

FIGURE 5.12 *Painting freehand with the mouse.*

AIRBRUSH

The Airbrush works in much the same was as the standard Paintbrush tool but instead of a solid color, it simulates an airbrush or spray can. You can use it to draw freehand, or by holding the Shift key, you can force it to draw straight lines. Figure 5.13 shows a sample of painting comparing the standard paintbrush and the airbrush.

FIGURE 5.13 *The airbrush works similarly to the standard paintbrush.*

PICTURE TUBE

PaintShop Pro's picture tubes, some of which can be seen in Figure 5.14, are one of its best features, as it allows you to paint with a variety of pre-existing objects. You can add everything from raindrops to flowers to an image very quickly. There are hundreds of picture tubes available on the Internet, or you can use the ones that come with the program. You can even design your own with PaintShop Pro.

FIGURE 5.14 *Picture tubes are available freely on the Internet.*

You can quickly see the power of the picture tubes by looking at Figure 5.15. Every object in it was added with the Picture Tube tool, and the entire image was created in less than 30 seconds.

FLOOD FILL TOOL

The last tool we will look at is the Flood Fill tool. It fills an area with a color, pattern, or gradient. Use this to quickly add patterns or solid colors to the entire background of an image, or fill only a selection using the Selection tool.

There are many more tools available in PaintShop Pro, and we encourage you to spend time going through its help file. This chapter is here to introduce you to some of the concepts of PaintShop Pro. When we later use it for creating graphics and textures, we will do everything in a step-by-step manner.

FIGURE *You can quickly create entire scenes with picture tubes.*
5.15

Vector Drawing Tools

One of the newest trends in raster editing tools such as PaintShop Pro is to add vector drawing and editing tools. PaintShop Pro has added several tools that allow you to use raster and vector graphics in a single application, which makes your job much easier.

Vector versus Raster

Before we move on to look at the vector drawing tools, it is important that you have a basic understanding of the difference between vector and raster formats. A raster file is composed of units of light, each of which is called a *pixel*. By grouping these pixels, a raster image can be created. The pixels can be blended to create smooth transitions for objects, which makes it good for gaming. Raster images are resolution dependent. That is, you specify the resolution and pixel dimensions when you create the image, and if you later decide to increase or decrease the image, it can have a negative impact on its quality.

Vector images are not comprised of pixels. Instead, they are composed of mathematical instructions that draw an image. This has several advantages over pixel-based images. First, every object is stored as a separate item in an image. This information stores data such as position, width, height, and color, to name a few. Vector-based images are resolution independent; that is, they can be freely resized without losing image quality. You might wonder how a monitor, which uses pixels, can display these mathematical computations in a manner we understand. The vector images go through a process so that the monitor can see them. The rasterized images can then be displayed on the screen.

Layers

Default PaintShop Pro images consist of a single layer, the background layer, which is comparable to a canvas you would paint on in the real world. You can create additional layers, stacking them on top of one another. PaintShop Pro supports up to 100 layers per image, although the number might be smaller depending on your computer memory.

The Layer palette allows you to switch between the various layers in an image with a single mouse click. As you can see in Figure 5.16, it lists details about each layer. By clicking on the layer visibility toggle (looks like glasses), you can display or hide any layer in the image. If you save your image to the internal PaintShop Pro file format (PSP), the layers will be saved with the image. Otherwise, the image will be flattened when the image is saved in another format.

Chapter 5 Introduction to PaintShop Pro

FIGURE 5.16 *The Layer palette allows you to quickly view layer information.*

You can create three types of layers in PaintShop Pro: raster, vector, and adjustment layers. Raster layers, like raster graphics, contain pixel-based information. Vector layers are mathematical instructions for drawing vector lines, shapes, and text. Adjustment layers contain color correction information that is used to alter layers placed beneath them. It is easy to distinguish between vector and raster layers in the Layer palette. The Layer palette displays the vector icon, and when the layer contains vector objects, a plus sign appears next to the icon (see Figure 5.17). If you click the plus sign, the individual objects that are on the vector layer can be seen.

FIGURE 5.17 *Vector and raster layers are distinguishable in the Layer palette.*

You cannot place vector objects on raster layers. Likewise, you cannot place raster objects on vector layers.

DRAW TOOL

The Draw tool might be the most powerful tool available in PaintShop Pro. You can use the Draw tool for both raster and vector drawing, depending on the type of layer you are working on. It can draw straight lines, freehand lines, or even Bezier curves. Vector-drawn objects can be moved, deformed, and edited after they are created without affecting anything else in the image.

CHAPTER REVIEW

PaintShop Pro offers a tremendous number of features and is easy for beginners to learn, as the user interface can be mastered with relatively little effort. We merely touched on the absolute basics of this software here, and will later use PaintShop Pro to create textures and 2D graphics for our game project.

CHAPTER 6

Creating Low-Polygon Models with MilkShape 3D

Now that we have learned some of PaintShop Pro's basic functions, we will begin using it with MilkShape 3D. In this chapter, we'll design a gun that could potentially be used for our game.

BEGINNING THE PROCESS

We could begin this process in several ways, but starting with some type of very basic sketch seems like a good idea.

2D SKETCH

We will begin our model by creating a basic sketch in PaintShop Pro. The sketch will serve as a basic outline for our model. Once it is complete, we will import it into MilkShape as a background, and then remove it when we are done. You need to open PaintShop Pro if you have not already done so, and select New from the File menu. A window will open and prompt you for several items. For a width and height, you can use 144. The resolution can remain at the default, and the background color should be set to white.

The next step is to create a new vector layer by selecting New Vector Layer from within the Layer menu. Now, using the Drawing tool, we will sketch a gun similar in appearance to Figure 6.1.

FIGURE 6.1 *A basic sketch of the 3D model we will be creating.*

The next step is to save the image as a PaintShop Pro file so that you can edit the file later. After doing so, also save it as a BMP format. MilkShape 3D needs it in BMP so that it can be imported as a background picture.

MILKSHAPE 3D

We can import the image into MilkShape 3D once it is in BMP format. First, open MilkShape and right-click on the Right viewport. If you do not have a Right viewport, change the Upper-Right viewport to Right with the drop-down box. Next, select Choose Background Image from the pop-up menu. It will then prompt you for the location of the file. Choose the filename and location in which you saved the sketch.

Gun Stock

After importing the image, draw a square in the same viewport. Your screen should appear similar to Figure 6.2.

FIGURE 6.2 *The first step in creating the 3D model.*

Notice that the square model was resized in the previous step; the width is much smaller than the default size. You do this by selecting Scale from the Model tab, and then clicking and dragging your mouse in the appropriate viewport.

This square will serve as the stock for our gun, so we need to shape it accordingly. Choose Select from the Model tab, and then choose Vertex from Select Options. Next, draw a line around the vertices that are on the far right of the model. They should then appear to be red. Choose Scale, and then click and drag the mouse down in the Right viewport. You'll see the object being resized. Continue to resize it until it appears something like Figure 6.3.

FIGURE 6.3 *Resizing the stock in MilkShape.*

Once the object is in place, choose Extrude from the Model tab. This will allow you to create an extrusion with the already selected vertices. Click and drag your mouse in the Right viewport to the right until the object has reached a size similar to Figure 6.4.

The next step is to select only the upper two vertices on the right side of the newly extruded piece. Once selected, you can move the vertices until they reach a point similar to Figure 6.5.

TIP *Remember the Undo feature in the Edit menu if you make a mistake. It will allow you to recover from most mistakes you make along the way.*

Chapter 6 Creating Low-Polygon Models with MilkShape 3D

FIGURE 6.4 *The extrusion will eventually be used for the middle parts of the gun.*

FIGURE 6.5 *The vertices are being moved to create the angle.*

Once in position, you need to select the entire face that was extruded (see Figure 6.6). Also notice that the 3D view is constantly being changed, which allows you to see details you otherwise would not have seen.

FIGURE 6.6 *The extrusion with faces selected.*

The face is then extruded again to look like Figure 6.7. As you follow along, we will attempt to roughly approximate the sketch we created earlier, although we might, from time to time, alter the model for convenience or looks.

You can then use the Selection tool to individually move sets of vertices so that the new extrusion now looks like Figure 6.8.

Chapter 6 Creating Low-Polygon Models with MilkShape 3D

FIGURE 6.7 *The Extrusion tool is used several times in this tutorial.*

FIGURE 6.8 *Extruded objects are very easy to manipulate.*

The next step is to create another box like the one shown in Figure 6.9. Resize the box and position it in a manner consistent with Figure 6.10.

FIGURE 6.9 *Creating another box in MilkShape.*

FIGURE 6.10 *The objects need to be sized and positioned appropriately.*

CHAPTER 6 CREATING LOW-POLYGON MODELS WITH MILKSHAPE 3D

CREATING A BARREL

In order to create a barrel for our gun, we must first decide what primitive object to use. The only one that makes sense for a barrel is a cylinder, so our next step is to create a cylinder that is approximately the size of the one shown in Figure 6.11.

FIGURE 6.11 *The first step in creating a barrel.*

While the cylinder is still selected, click on Rotate in the Right viewport, and click and drag the mouse to the left or right to rotate it. You can rotate it so that the back view appears similar to Figure 6.12.

FIGURE 6.12 *Rotate the barrel so that it looks like this.*

Chapter 6 Creating Low-Polygon Models with MilkShape 3D

The last step in creating the barrel is to position it with the rest of the pieces of the gun so that it appears on top of the gunstock. Use the 3D viewport when attempting to align the barrel to see the gun from several different directions. Your gun should now look similar to Figure 6.13.

FIGURE 6.13 *The barrel is now finished and in its final place.*

If you need to zoom in or out of a viewport, simply hold down the Shift key, and click and drag with the left mouse button. You can also pan the viewport by using the Ctrl key in place of the Shift key.

THE CLIP

In our hand drawing, notice that we have to create another box to use as the gun clip. Like most of this project, we'll use a box as the basis for this part of the model. First, create the box similar to Figure 6.14.

FIGURE 6.14 *Creating the clip requires several steps.*

Next, we need to select the vertices at the top of the box on both corners, which means that we will have four of them selected. Now, we can use the Scale button to move the corners so that they are angled as in our drawing. We also need to resize the width of the box so that it is smaller than the rest of the gun. Finally, we need to move the box so that it rests in a location similar to Figure 6.15 which shows all the changes made to the box.

CHAPTER 6 CREATING LOW-POLYGON MODELS WITH MILKSHAPE 3D

FIGURE 6.15 *The gun clip is finished.*

A TRIGGER

There are countless ways you could go about designing the entire gun. This is true of everything including a trigger. With most guns, in both the virtual and real worlds, there is an opening for your hand with the trigger inside of it. This gun will have the opening, but we will skip creating an actual trigger, although we will actually call the entire assembly a *trigger*.

To create the opening, begin with a box sized similar to Figure 6.16.

Next, we need to resize the width, making it smaller than the rest of the gun, and rotate it so that it looks something like Figure 6.17.

FIGURE 6.16 *The first step for the trigger opening.*

FIGURE 6.17 *Rotating and resizing the box makes our opening begin to take form.*

Chapter 6 Creating Low-Polygon Models with MilkShape 3D

We could create another entirely new box and continue working on the opening, but it is easier to use Duplicate Object from the Edit menu. Once you have duplicated it, the new object will appear exactly over the old one. You need to move it before you'll actually see it. Position it similar to Figure 6.18. Also notice that it is rotated so that it is perpendicular to the stock, while the old one remains angled.

Figure 6.18 *Duplicating objects instead of creating new ones can save a tremendous amount of time.*

With two parts of the trigger completed, we need to add a third one that will connect the other two. We'll again duplicate and rotate one of the other pieces so that the width remains constant. When it has been rotated correctly, it should look like Figure 6.19.

FIGURE 6.19 *The trigger is almost complete.*

The last step for creating the trigger is to zoom in and pan the 3D view so that the trigger appears very close. It allows us to resize the third piece of the trigger so that it fits perfectly. Figures 6.20 and 6.21 show examples of this.

Congratulations, we now have a complete gun! In the next steps, we will make slight changes to the overall shape of the model so that you see how quick and easy it is to fine-tune a MilkShape model.

Chapter 6 Creating Low-Polygon Models with MilkShape 3D

FIGURE 6.20 *The 3D view is perfect for finely positioning and resizing objects.*

FIGURE 6.21 *Our trigger opening is completed.*

ADJUSTING THE MODEL

The model is finished and could probably be left alone and the texturing process could begin. However, it is very easy to make small or large adjustments to the model, which we will do in the following steps that will hopefully make changes to benefit the model. Save the model at this time, so that if we make changes we do not like, we can always revert to the original.

THE STOCK

The first area that could use some attention is the stock. Like any form of artwork, modeling is often very objective, and often you simply go by how you feel. The angle on the stock, which can be seen clearly in Figure 6.22, is a little drastic. We can change this by moving the vertices at the end of the angle to form a larger angle like the one shown in Figure 6.23.

FIGURE 6.22 *The short angle could be a source of concern.*

FIGURE 6.23 *The stock looks much better after lengthening the angle.*

It seems that the end of the stock could also use some changes. We can lengthen the stock slightly and also reduce the angles. Figures 6.24 and 6.25 show the before and after views.

FIGURE 6.24 *The end of the stock needs some adjustment.*

FIGURE 6.25 *Reducing the angles on the stock and lengthening it give it a much better look.*

CHAPTER 6 CREATING LOW-POLYGON MODELS WITH MILKSHAPE 3D

After making the changes, it is apparent that the bottom vertices also need to be moved in order to make the end of the stock a straight edge. Figure 6.26 shows the necessary change.

FIGURE 6.26 *The stock is now at a 90-degree angle relative to the barrel of the gun.*

BARREL

With the stock being elongated, it now appears that the barrel could use a little lengthening as well. We can select the vertices at the end of the barrel and simply move them in a manner consistent with Figure 6.27.

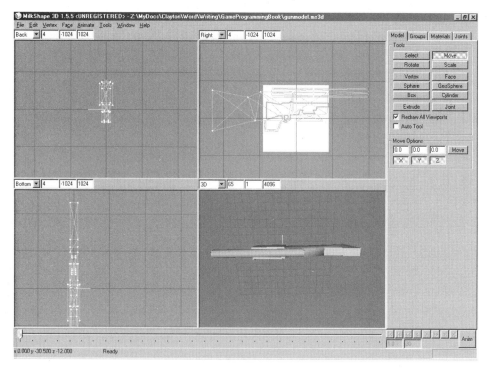

FIGURE 6.27 *The barrel is resized and is now in a better size relation to the stock.*

SMOOTHING

The final step in this chapter is to use the Groups tab to select every part of the model. We will then assign a smoothing group to all of the items that will make them appear much better after the refinements we have made.

The first step is the select the models in the Group tab. Regardless of the names of your objects, begin by clicking on the top group, which in Figure 6.28 is Box 01. When it is highlighted, click the Select button that is located in this same tab directly beneath the highlighted groups. The individual box should now be colored red in the viewports. Continue doing this for all items until everything is selected as shown in Figure 6.28.

CHAPTER 6 CREATING LOW-POLYGON MODELS WITH MILKSHAPE 3D

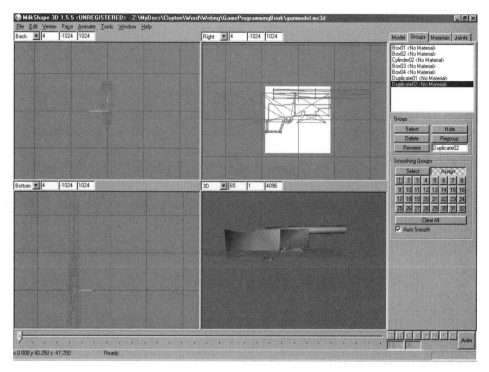

FIGURE 6.28 *Every group is selected.*

There is one final step to smooth all of the objects. Click the Assign button, followed by number 1. The object will appear much smoother, and is particularly evident in Figure 6.29 in the 3D viewport.

FIGURE 6.29 *The 3D viewport allows you to see changes more clearly.*

Chapter Review

In this chapter, we modeled a complete 3D gun in MilkShape. We used many of the tools that MilkShape offers, including several different primitive objects, and moving, rotating, and scaling. The next step is the creation of textures for the model, which can be done in PaintShop Pro and then imported into MilkShape. The next chapter details this aspect of modeling.

CHAPTER 7
Texturing Models

This chapter continues with the gun model we created in the previous chapter. We will use PaintShop Pro to create a couple of textures for it, and then apply the texture from within MilkShape 3D. We'll also look at the capability of MilkShape to create shading attributes that work well if you are quickly prototyping a model, or creating a model that doesn't need a great deal of detail.

CREATING THE TEXTURES

As you saw in Chapter 4, "Introduction to MilkShape 3D," PaintShop Pro has many features, but is relatively easy to use. Designing textures with it is actually a very simple process. We will begin by looking at the model, which can be seen in Figure 7.1, to determine which areas need textures, and then we will focus on how we will go about creating them.

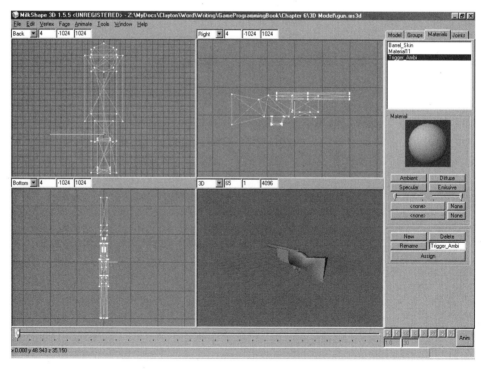

FIGURE *The finished gun model without any textures applied.*
7.1

GROUPS

Although the gun model is simple enough that we probably would not have to, it is best to rename the appropriate components of a model so they are easier to identify. To do this, click on the Group tab, which is the same tab we used late in the last chapter to smooth the objects. The Group tab should look something like Figure 7.2.

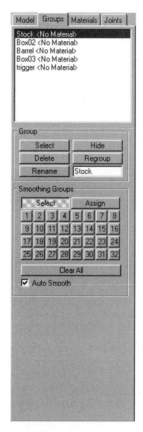

FIGURE 7.2 *MilkShape's Group tab allows you to assign names to objects.*

The Group tab that is displayed is probably a little different from the one you see on your screen. This is because some of these objects were renamed to allow for easier identification. For example, box 1 has been renamed to stock. To rename the objects, first click on the top item in your list. Next, click the Select button and you will see it highlighted in red in the viewports. Once you

find the object, type the name in the text box that is available, and click Rename. Next, click the Select button again to deselect the object, and move to the next one in your list. Continue until you have named each object is named in a manner that allows you to easily distinguish them. Figure 7.3 lists some example names.

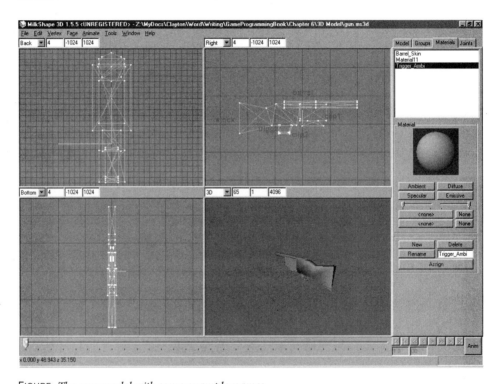

FIGURE 7.3 *The gun model with some example names.*

CREATING TEXTURES

Now that we have organized the objects into recognizable names, we can begin the process of making the textures. We will begin with the barrel object.

BARREL

The gun barrel will need to have a metallic look to it. To begin, open PaintShop Pro and click select New in the File menu, which will display a window similar to Figure 7.4. Set the width and height to 256 pixels.

FIGURE 7.4 *Begin by creating a new file that is 256 pixels in width and height.*

We could go about creating a metallic look in several ways. First, we could download a texture from one of many free sites on the Internet. Ensure that you have the right to use anything you download, as you could be violating copyright laws. Here, we are going to create our own texture. You could use one of the built-in textures in PaintShop Pro, but again, we want to design our own. Therefore, we will begin by using the Fill tool to paint the entire background with a gray color (see Figure 7.5).

FIGURE 7.5 *Begin by filling the background with gray.*

The next step is to add some noise to the texture to give it a metallic type of appearance. From the Effects menu, select Noise and then Add (see Figure 7.6).

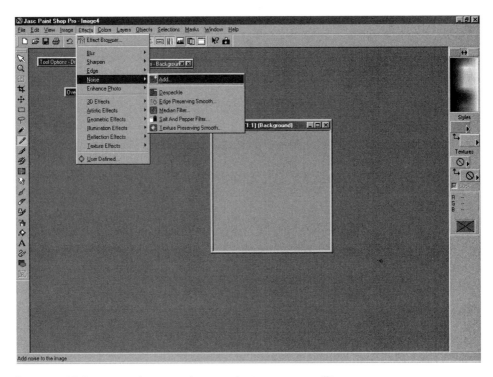

FIGURE 7.6 *Adding noise to the gray color to make it appear metallic.*

CHAPTER 7 TEXTURING MODELS

From the Add Noise window, watch the preview to see how the changes are affecting the image. After trying different options, it appears that 15 is an appropriate amount. The options we used are shown in Figure 7.7.

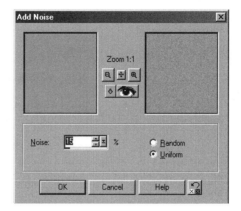

FIGURE 7.7 *The preview pane allows you to see how your changes are affecting the final result.*

Click OK after you have the noise where you want it. Your image should now look like Figure 7.8.

FIGURE 7.8 *The metal texture is beginning to take shape.*

It would be fine to use the texture as is, but we are going to add a little extra detail in the form of a couple of lines that will appear at the front and back of the barrel. To accomplish this, create a new vector layer by clicking the Layer menu and then selecting New Vector Layer. A window should appear similar to Figure 7.9.

FIGURE 7.9 *Creating a vector layer will allow us to add a few details to our texture.*

You can rename the layer to "lines," and then click OK. The next step is to use the Line tool to draw two black lines near the top and bottom as in Figure 7.10.

FIGURE 7.10 *The black lines add detail to our drawing.*

Chapter 7 Texturing Models

You can save the drawing in PaintShop Pro (PSP) format so that you can later come back and remove the lines, or add additional lines without altering the rest of the texture. After saving it in PSP format, save it in BMP format that MilkShape uses. If you save the texture in BMP format only, it will lose the layer settings, so if you later want to make any drastic changes to the file, you will have to recreate it.

Assigning the Texture in MilkShape

Now that we have a texture for the barrel, we need to assign it to the appropriate group from within MilkShape. Select the Groups tab, click on the barrel object, and then click the Select button (see Figure 7.11).

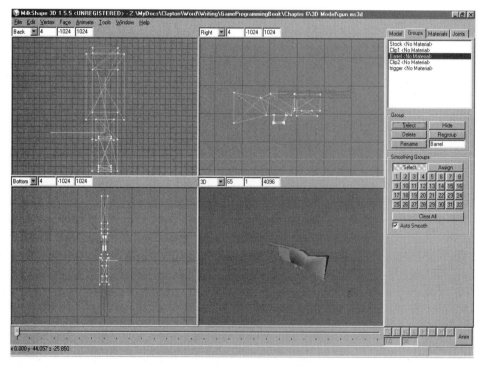

FIGURE 7.11 *Applying the texture begins by selecting the correct group.*

Next, click on the Material tab and once inside, click New. A material is created with some abstract name; change it to something like "barrel_skin" before moving on. After changing the name, click Assign. Now, any changes you make will be updated with the model. Next, we can import our texture by clicking on the <none> button; there are actually two buttons, and you should select the top one.

A dialog box will appear that looks similar to Figure 7.12. Choose the appropriate image file in BMP format from within this dialog box. If you make any changes to the texture, simply repeat this step to apply the new version.

FIGURE 7.12 *The standard dialog box allows you to choose an image file.*

Once you apply the image, turn on the texture viewing in the 3D viewport. This will allow you to see how the texture looks on the model. Right-click on the 3D viewport and select Textured from the pop-up menu. You should now see your texture, which should look similar to Figure 7.13.

Chapter 7 Texturing Models

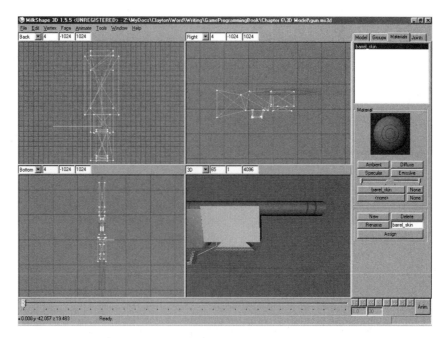

FIGURE 7.13 *Previewing the texture in the 3D viewport.*

Creating a Wood Texture

The next step is to create a wood texture for the stock of the gun. This texture will be created in a few simple steps similar to the metal texture. First, create a new 256 x 256 image in PaintShop Pro, and fill it with a color that is near to brown. It should look something like Figure 7.14.

FIGURE 7.14 *The first step is to create a new image.*

The next step is to use the Add Noise filter so that it looks similar to Figure 7.15.

FIGURE 7.15 *Adding noise to the image.*

Now, select everything within the image by holding the Ctrl key and pressing A. A selection box should appear around the image as shown in Figure 7.16.

FIGURE 7.16 *Selecting everything in the image.*

The next step is use the motion blur filter to create an image that looks like Figure 7.17.

FIGURE 1.3 *The motion blur filter finishes the texture.*

APPLY IN MILKSHAPE

The texture is finished, so save it as you did the previous one. It is applied in MilkShape using the same set of steps. However, since we have to apply it to both the Clip1 group and the Stock group, we have a few extra steps.

First, click on the Clip1 group, and then click the Select button. Next, click on the Stock group, and click the Select button. Now you can apply the texture and material as we discussed earlier. When done, the model should look like Figure 7.18.

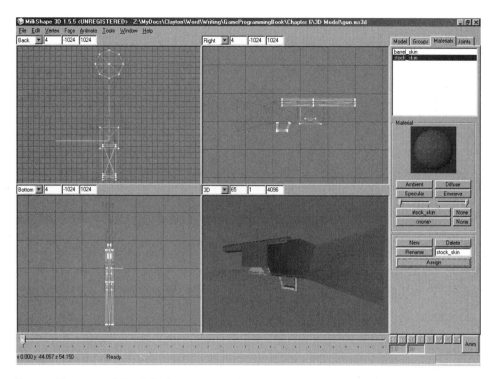

FIGURE 7.18 *The 3D model with both textures applied.*

TRIGGER AND CLIP2

Not every group in an object needs to have textures applied to look believable. The model that we have been working on has two groups that still do not have a texture: the trigger and clip2. We are going to use the built-in shaders available in MilkShape to apply a metallic-looking color.

The first step is to create a new material by clicking on the Materials tab, and clicking New. Rename the material to something like metal_shdr. Next, click on the Group tab and select only the trigger and clip2 groups. Assign the new material by selecting the Materials tab, and then click Assign.

The final step is to click the Diffuse button. A color palette, similar to Figure 7.19, will be displayed from which you can choose a color that represents a metallic finish. The color you choose will be displayed in the 3D viewport.

Chapter 7 Texturing Models

FIGURE 7.19 *A Color palette appears from which you can pick a color.*

The model is now complete and should look something like Figure 7.20.

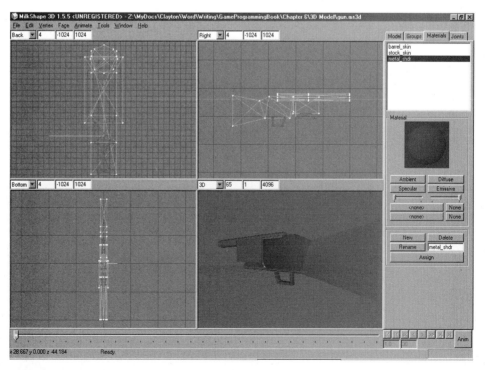

FIGURE 7.20 *The final 3D model.*

CHAPTER REVIEW

Creating textures for MilkShape is very easy with PaintShop Pro. Using a variety of standard drawing tools and built-in filters, it is possible to develop almost any type of texture in PaintShop Pro. The textures are created inside PaintShop Pro and then applied within MilkShape with a few simple steps.

CHAPTER 8
Introduction to ACID

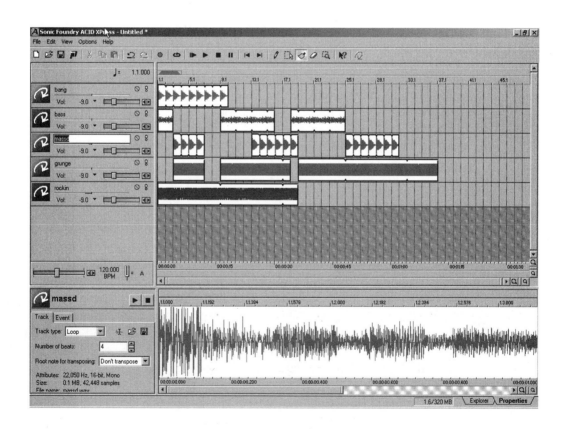

Although having a good concept for your game and good graphics are very important components in the game development process, they are not enough in a competitive marketplace. To have a completely successful game, music and sound effects have very important supporting roles. Music and sound effects should convey information that helps set up a level without overwhelming a player.

In this chapter, we will be introduced to Sonic Foundry ACID and Syntrillium's Cool Edit 2000. We will use Sonic Foundry ACID to create the music loops for our game, and use Cool Edit 2000 for recording and editing the sound effects.

INTRODUCTION TO SONIC FOUNDRY ACID

Sonic Foundry ACID is perhaps the easiest-to-use loop-based music creation tool ever created, and can be used in many game development projects. Before we begin using the software, let us look at the installation process and the user interface. Then, we will make a simple loop for our project.

INSTALLATION

Before we begin discussing specifics of Sonic Foundry ACID, we need to install it.

ON THE CD

Sonic Foundry ACID is on the companion CD-ROM in the Applications directory, and is called ACID20d_enu.exe. If you prefer, you can download the latest version from www.sonicfoundry.com.

The first step in the installation process is running the executable file. It will begin the installation process where you will be presented with a screen that looks similar to Figure 8.1. This screen displays the Sonic Foundry license agreement. To continue the installation, read the agreement and click Yes to agree to the terms of the agreement.

From the next screen (see Figure 8.2), click Next.

Chapter 8 Introduction to ACID

FIGURE 8.1 *The installation program begins with this screen.*

FIGURE 8.2 *Click Next to continue the installation.*

The next step is to enter your information in the registration screen that should look something like Figure 8.3. After doing so, click Next to continue.

FIGURE 8.3 *Registration information that ACID will use.*

At the next screen, which appears in Figure 8.4, you can leave the directory as it is listed, or change it as you need. Then, click Next to continue the installation.

Click Next on the screen shown in Figure 8.5. The files will then begin to be copied and a window that looks like Figure 8.6 will appear.

CHAPTER 8 INTRODUCTION TO ACID

FIGURE 8.4 *Click Next after changing the installation directory.*

FIGURE 8.5 *The Ready to Install window should look similar to this.*

FIGURE 8.6 *A window similar to this will appear when the files are copied to the installation directory.*

When the files have finished copying, you will be presented with a window similar to Figure 8.7.

FIGURE 8.7 *The final step in the installation process.*

If you click Finish, the installation program will close and ACID will open. The first screen that you will see will be a serial number entry screen similar to Figure 8.8. If you have purchased a serial number, enter it now. Otherwise, click Next.

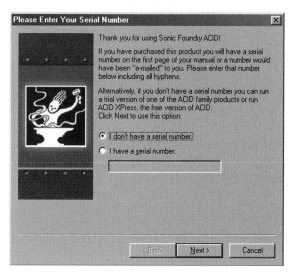

FIGURE 8.8 *If you do not have a serial number, click Next.*

If you did not have a serial number in the previous step, you will be presented with a window similar to Figure 8.9. From this window, select the option button next to "I Would Like to Use ACID XPress." This will give you an unlimited-use version of ACID, but without all of the features of the full version. Unfortunately, the XPress version limits the types of files you can export, so we will be forced to deal with this limitation. If you have a serial number, follow the instructions as they are given.

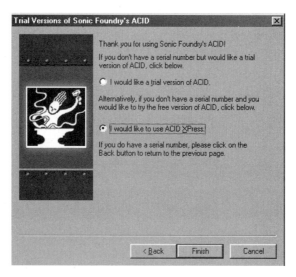

FIGURE 8.9 *Unless you have a serial number, we will set up ACID as ACID XPress.*

Click Finish to run ACID for the first time. You should see a window similar to Figure 8.10.

FIGURE 8.10 *The ACID interface appears.*

ACID SPECIFICS

One of the greatest attributes of ACID is the interface, which is easy to learn and very easy to master. It's a great choice for game development, especially for individuals with graphics or programming experience who have been given the task of developing music for their game. For those with a music background, ACID becomes another extremely powerful tool in their arsenal of choices, and for those without any music background, Sonic Foundry offers royalty-free loops that you can use to create your music.

THE INTERFACE

To begin, let us look at the screen and identify the various elements that make up the ACID window (see Figure 8.11). At the top of the window is a familiar Windows title and menu bar. Below that is a toolbar that gives you quick access to the most commonly used commands. These tools can be used to edit, play back, and save your composition. We will look at these tools in more depth later in this chapter.

FIGURE 8.11 *The interface offers standard Windows menu bars.*

Looking at Figure 8.11, you can see that the rest of the screen is divided into three main areas. In the upper-left portion of the screen is the ACID Track List. To its right is the Track View, and at the bottom is the Multi-Function area. The Multi-Function area contains the Media Explorer and Properties window (ACID Pro contains additional windows, but we will not discuss them here). Finally, along the bottom of the window is the Status bar, which displays useful information such as available system memory. Figure 8.12 shows the interface with labels so that it is easier to see the different areas of ACID's interface.

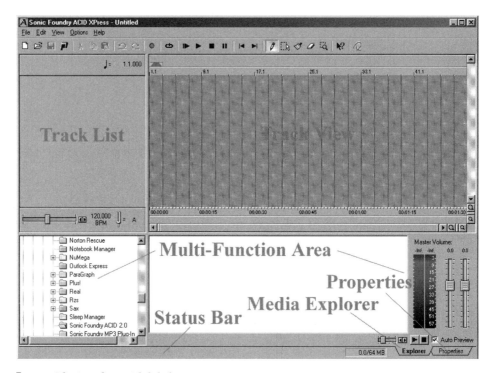

FIGURE 8.12 *The interface with labels.*

ALTERING THE INTERFACE

You can resize the main windows that make up the interface if you wish. For example, you can lengthen the Track List, Track View, or Multi-Function section. To try this, place your mouse over a border between the Track List and Multi-Function sections, and then click and drag to the top. You will see the windows changing. When you want to stop, simply end the click. Once you have the windows how you like them, ACID will automatically remember the settings every time you open it.

Chapter 8 Introduction to ACID

The Media Explorer

The Media Explorer is very much like the standard Windows Explorer with which you are probably already familiar. On the left is a directory view of the drives on your computer, and drives on the network if you are connected to a network. Clicking on a drive or a folder in a drive will display the contents on the right. Click on the plus (+) to the right of the C: drive icon to display the contents of your computer hard drive (see Figure 8.13).

Figure 8.13 *The Media Explorer works similarly to Windows Explorer.*

You use the Media Explorer to locate and find tracks that you would like to add to your project. After locating them, simply double-click them or drag them to the Track View or List.

The Track View

The Track View is used to compile the project. By "drawing" the tracks in the Track View, you are able to compose a track. Figure 8.14 is a labeled drawing for the Track View window.

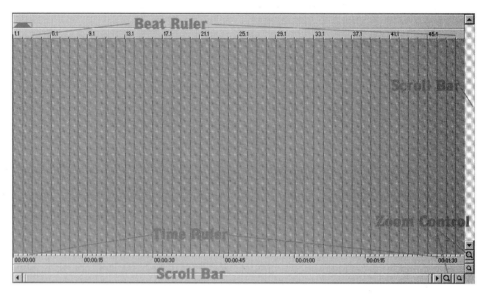

FIGURE 8.14 *The Track View is comprised of the space where you will draw events on each track.*

BEAT RULER

The Beat Ruler appears along the top of the Track View, and allows you to place events in reference to the musical time of bars and beats. The timeline is fixed length and will not change when you alter the tempo. In Figure 8.15, the 1.1 represents beat one of measure one, and each ruler mark represents one beat.

FIGURE 8.15 *Close-up of the Beat Ruler.*

TIME RULER

The Time Ruler appears along the bottom of the Track View. To change the format of the display, right-click on the timeline and choose an option from the shortcut menu. This timeline will change with tempo, since the number of bars and beats per second of real time will change with tempo (see Figure 8.16).

FIGURE 8.16 *Right-clicking the Time Ruler changes the format.*

SCROLL BARS

The horizontal scroll bar appears below the Time Ruler. Click and drag the scroll box to pan left or right through the project. The scroll box also functions as a zoom control. Click and drag the edges of the scroll box to zoom in and out, or double-click the scroll box to zoom out so that the entire length of the project will be displayed

The vertical scroll bar appears on the right side of Track View. Click and drag the scroll box to pan up and down through the project. Double-click the scroll box to zoom the project out so that as many tracks will be displayed as possible.

ZOOM CONTROLS

The magnifying glass icons shown at the ends of the scroll bars allow you to change the magnification level of your ACID project. The larger icon, seen in Figure 8.17, increases the track height zoom level, while the smaller icon decreases the level. You can also display a Zoom tool by clicking on the box located between the sets of Zoom tools.

FIGURE 8.17 *The zoom controls give you control over the entire area.*

TRACK LIST

The Track List contains the master controls for each track. From here, you can adjust the volume, mute the track, and reorder tracks. Figure 8.18 shows a sample Track List.

FIGURE 8.18 *The Track List gives you control over each track.*

There are a few areas within the Track List that we should look at further. The volume and pan drop-down control, shown in Figure 8.19, is very useful. It allows you to alter the volume and/or the pan of a track. By selecting Volume from the list, you can determine how loud a track is in the mix. A value of 0 dB means that the track is played with no boost or cut from ACID. Clicking and dragging the fader (which is directly to the right of the drop-down) to the left decreases the volume, while clicking and dragging to the right boosts the volume.

FIGURE 8.19 *The volume controls how loud a track is in a mix.*

Pan controls the position of a track in a stereo field. Clicking and dragging the fader to the left will place the track in the left speaker more than in the right, while moving the fader to the right will place the track in the right speaker.

The Track List is also used for the placement of tracks. They can be moved around to create logical groupings at any time during a project's creation. To do so, click on its icon in the Track List and drag it to a new location. While dragging it, a new location is indicated by a highlighted line separating the tracks, a sample of which is shown in Figure 8.20. You can move multiple tracks by using Shift or Ctrl to highlight them before dragging.

Finally, you can rename a track using the Track List by right-clicking the track label and choosing Rename from the shortcut menu (you can also double-click the track label). Renaming a track applies to the project only, and does not change the file associated with a track. Figure 8.21 shows a track being renamed.

Chapter 8 Introduction to ACID

FIGURE 8.20 *The highlighted line indicates the new position for a track.*

FIGURE 8.21 *The track is being renamed within the project.*

Properties Tab

The Properties tab, which is located at the bottom of the ACID window and shown in Figure 8.22, contains options to modify the behavior of entire tracks or events on a track. From this tab, you can ACIDize files, modify a track's stretching properties, or edit the start point and pitch of a specific event.

ACIDizing a file involves adding extra information to the audio file that is ACID specific. This is information such as stretching properties, root note, and number of beats or tempo of the file. This information is then used by ACID to time-stretch and pitch-shift the file for you automatically when you open it. You can alter a file and then save it, or you can simply save the ACID-specific information for a given project.

User the Properties tab to adjust the properties that are saved when a file is ACIDized. Figure 8.23 shows the track properties that determine how a file behaves in ACID.

FIGURE 8.22 *The Properties tab.*

FIGURE 8.23 *The Properties tab is one of the most powerful features offered in ACID.*

CHAPTER REVIEW

As you have seen, there are a tremendous number of features in ACID that make it an extremely useful program for game developers. It is one of the easiest programs that you will ever use, and one that you will undoubtedly make a spot for in your toolbox. In the next chapter, we'll look at Syntrillium's Cool Edit 2000, the software that we'll use to create sound effects and edit individual tracks for use in ACID. Later, we will use ACID to create the music for our game.

CHAPTER 9

Syntrillium's Cool Edit 2000

In the last chapter, we looked at ACID, which is going to be our application of choice for creating music for our game. In this chapter, we are going to look at Syntrillium's (www.syntrillium.com) Cool Edit 2000, a program that we will use for recording and editing sound effects for our game.

ON THE CD

A shareware version of Cool Edit 2000 is located on the CD-ROM in the Applications subdirectory and is named CE2kmain.exe.

INSTALLATION

Before we begin discussing specifics of Cool Edit 2000 (we might refer to it as Cool Edit in the text, but it is the same product), we need to install it. If you do not have the CD-ROM that came with the book, you can visit the Syntrillium Web site at www.syntrillium.com to download the latest version available.

The first step in the installation process is to run the executable file. It will begin the installation process where you will be presented with a screen that looks similar to Figure 9.1. To continue the installation, click Next.

FIGURE 9.1 *The installation program begins with this screen.*

CHAPTER 9 SYNTRILLIUM'S COOL EDIT 2000 133

From the next screen, shown in Figure 9.2, you need to choose an installation directory. You can leave the directory as it is listed, or change it as you need. After you decide, click Next to continue the installation.

FIGURE 9.2 *Click Next after selecting an installation directory.*

At the next screen, which appears in Figure 9.3, you can choose to set Cool Edit as the default editor for specific types of audio files. This process is known as setting up *file associations* in Windows. If you have other editors, you can choose Cool Edit as the default application for only specific types of files, or simply leave it as the default. It's important to realize that you can deselect every item and still use Cool Edit to open them. To do so, open the files manually using the File | Open menu, rather than double-clicking them in Windows Explorer.

From the screen shown in Figure 9.4, you can choose to have an icon placed on your desktop, or you can move forward without one. Click Next to continue.

FIGURE 9.3 *Setting up default file associations.*

FIGURE 9.4 *You have the option to create an icon on your desktop.*

CHAPTER 9 SYNTRILLIUM'S COOL EDIT 2000 135

Your ready-to-install window should look similar to Figure 9.5. Click Next to continue.

FIGURE *You are now ready to install.*
9.5

FIGURE *The Syntrillium license agreement is next.*
9.6

Figure 9.6 displays the Cool Edit license agreement. Read through the document, and then click OK to continue.

FIGURE 9.6 *The Syntrillium license agreement is next.*

When you click OK, it will begin copying files and will look similar to Figure 9.7.

When the installation finishes, the screen shown in Figure 9.8 is displayed. It asks you to choose the location of your temporary files. Unless you have particular issues with hard drives on your system, it's probably best to let it pick the appropriate locations. Choose the location of the temp files, and click Yes to continue.

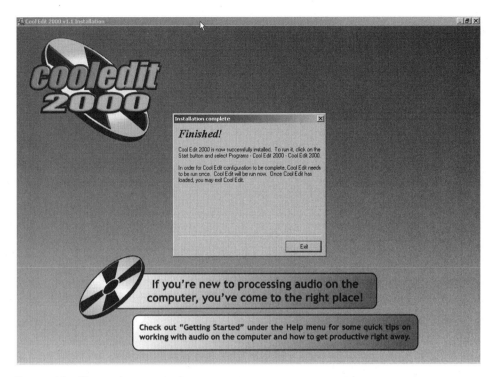

FIGURE 9.7 *The files are being copied to your computer.*

FIGURE 9.8 *The next step is to choose the location for temporary directories.*

The actual installation process is now complete, although the program will execute automatically at this time, displaying Figures 9.9 and 9.10. These figures will actually occur every time you execute the program, but will automatically open this first time.

Cool Edit is both feature limited and time limited unless you register it.

FIGURE 9.9 *A warning details the trial version options.*

FIGURE 9.10 *When it starts, Cool Edit asks you if you would like to check for updates on the Internet.*

Chapter 9 Syntrillium's Cool Edit 2000

The Interface

Like ACID in the previous chapter, we will now look at the user interface and some basic operations of Cool Edit. In the next chapter, we will use it to record and edit sound effects for our game.

To begin, let us look at the screen and identify the various elements that make up the Cool Edit interface, which can be seen in Figure 9.11. At the top of the window you will see a familiar Windows title and menu bars. Below that is a toolbar that gives you quick access to the most commonly used commands. These tools can be used to edit, play back, and save your composition.

FIGURE 9.11 *The interface offers standard Windows menu bars.*

Along with the standard toolbars, there are also several interface items unique to Cool Edit, including the Time Window, Transport, and Horizontal Zoom, to name a few. Figure 9.12 has been altered to reflect these areas that we will look at in more detail.

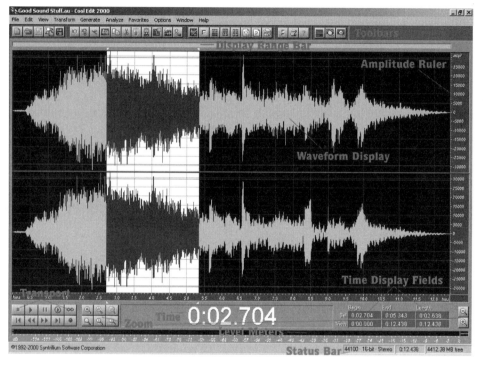

FIGURE 9.12 *The areas of Cool Edit's interface are clearly marked in this figure.*

TOOLBARS

The Cool Edit toolbars, some of which are shown in Figure 9.13, contain button shortcuts to functions, and are grouped into menus. Each grouping has a specific background color. The toolbar groupings can be displayed or hidden through the File Menu Options | Toolbars. Most of the functions you will use are available in the menus that offer ToolTips for individual buttons when you leave your mouse pointer over them for a moment. If you want to add or remove toolbars, you can right- click on the toolbar, and a list will appear from which you can choose.

FIGURE *The toolbars contain shortcuts to common functions.*
9.13

DISPLAY RANGE BAR

The Display Range Bar is shown in Figure 9.14 and indicates which part of the waveform is currently being viewed in the Waveform Display. When you zoom in or out, this bar will become smaller or larger to reflect the portion currently being viewed. You can left-click and drag the bar to scroll forward or back without affecting the zoom level. If you right-click it, your mouse changes to a magnifying glass, and dragging it left or right will zoom in or out, respectively. Finally, you can double-click on the Display Range Bar to bring up the Viewing Range dialog. This dialog box allows you to enter values for the viewable area.

FIGURE *The Display Range Bar indicates the part of the waveform currently in view.*
9.14

AMPLITUDE RULER

The Amplitude Ruler measures the volume of audio data. In Waveform View, the ruler's display format can be set to Samples (exact sample value of the data), a percentage (from –100% to 100%, where 100% is 0dB), or as a normalized value (–1 to 1). Left-click and drag on the Amplitude Ruler to scroll the waveform display vertically. As with the Display Range Bar, you can right-click and drag to zoom (see Figure 9.15).

FIGURE *Cool Edit's Amplitude Ruler measures*
9.15 *the relative amount of audio data.*

WAVEFORM DISPLAY

The Waveform Display is the area in which you view your audio material in the form of a waveform (see Figure 9.16). You can use your mouse in the Waveform Display to select data in several ways:

- Left-click anywhere in the display to position a playback cursor.
- If you are using stereo files, you can disable or enable either channel by positioning the mouse in either channel and clicking. That way, you can edit only one of the channels if you need to.
- A left-click and drag will create a selection in the waveform.
- A right-click and drag will increase or decrease a selection.

FIGURE 9.16 *The Waveform Display area is where you view the audio materials.*

TIME DISPLAY FIELDS

These fields display beginning, end, and length information for the visible portion of the current waveform, and for the currently selected range. The top row relates to selection times, and the bottom row to the viewing range. The format that is used for the display is the currently selected format you specify in the File menu View | Display Time Format. You can left-click in any of the Time Display Fields and enter a value to adjust either the selection or viewing range (see Figure 9.17).

FIGURE 9.17 *These fields display various time elements related to the current waveform.*

LEVEL METERS

Cool Edit 2000's level meters are used to monitor the volume of incoming and outgoing signals (see Figure 9.18). The signal is represented as the peak amplitude in decibels. A level of 0dB is the absolute maximum before clipping occurs. Yellow peak indicators will remain for about 1.5 seconds before resetting to allow for reading of the peak amplitude. When displaying stereo audio, the top meter represents the left channel, and the bottom, the right. To access the Level Meters configuration menu, right-click in the meter area.

FIGURE 9.18 *Level meters are used to monitor volumes of incoming and outgoing sounds.*

TIME

The time readout simply displays current cursor position of the file in Playback or Record mode (see Figure 9.19). You can change the format by selecting Edit | Display Time Format from the File menu. You can make the readout as large or as small as you like and the window floats, meaning it will stay on top of the rest of Cool Edit 2000 when open. You can open and close the Time window by choosing View | Time Window from the File menu.

FIGURE 9.19 *The Time window displays the current cursor position.*

STATUS BAR

The Status Bar can display a variety of information related to your computer and a file's properties (see Figure 9.20). It can be turned on or off by selecting View | Show Status Bar. You can right-click the Status Bar to alter its display options.

FIGURE 9.20 *The Status Bar displays various information related to the file.*

TRANSPORT

The Transport toolbar is the control center for functions such as play, stop, record, and so forth. It works very similarly to a standard VCR, except that you can right-click the Fast Forward and Rewind buttons to select varying speeds of advancement and rewind (see Figure 9.21).

FIGURE 9.21 *The Transport toolbar is the control center for rewind, stop, play, and so forth.*

ZOOM

The Vertical Zoom buttons increase or decrease the vertical scale in the amplitude ruler, while the Horizontal Zoom buttons allow you to get more or less detail on a waveform or session (see Figure 9.22).

FIGURE 9.22 *The Zoom buttons allow you to alter the vertical scale, or get more or less detail.*

CHAPTER REVIEW

In this chapter, we looked at many of the basics of Cool Edit. In addition to learning the basic features of the software, we also learned about many of the features and tools that make Cool Edit so popular. In the next chapter, we'll use this along with ACID to create music and sound effects for the game.

CHAPTER 10
Creating Music and Sound Effects

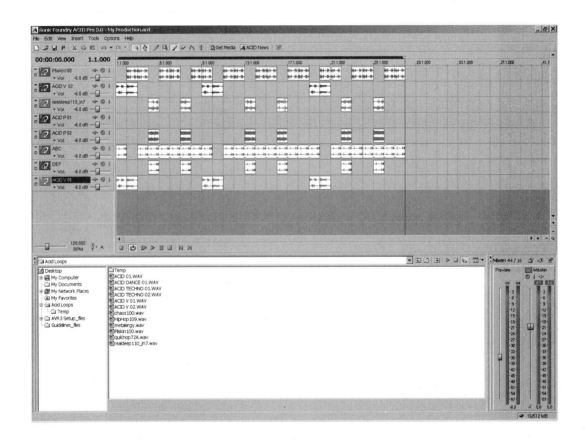

Of the many components that go into making a video game, perhaps none is given less attention than music and sound effects. The addition of quality music and sound effects are one of the best ways to add production value to your games. For single developers or small teams, there is now a tremendous array of software and low-cost hardware to aid in this process. With believable sound effects and music, the game player's emotional experience will be greatly enhanced.

WHY IT IS IMPORTANT

There are many parallels between making a movie and the development of a game. Hollywood has long realized the benefits of music and sound effects to the moviegoer. Over the past decade, there has been tremendous time and resources spent on improving these aspects of a movie, during which time we have seen the use of surround sound in both theatrical and home movie releases.

The long and varied history of the movie industry offers us a tremendous amount of guidance. While you will find very little documentation on the creation of music and sound effects for games, there is a plethora of information available for the movie maker, both professional and amateur. Countless books have been written over the years and vast resources are available at Web sites, not to mention the movies themselves, which can often provide inspiration and ideas.

Beginning with the 42nd Annual Grammy Awards, the video game industry has started to receive recognition for its work. The NARAS (National Academy of Recording Arts and Sciences) approved three new categories to include music written for "Other Visual Media," the term they are using to include the music from games.

BASIC IDEAS

When you are given the assignment to create music for a game, you usually begin with a basic understanding of the type of music being requested. For example, if you are creating music for a wrestling game, classical music is probably not going to be part of the piece. With this in mind, your research often begins with discussing the piece or watching a specific type of program. Looking at the wrestling sample, you might watch wrestling on television or perhaps visit a live match in person. This will allow you to get a very good understanding of the requirements in which the fans would be interested.

On the other hand, if you were writing music for a game that reenacted the Civil War, you might watch movies on the Civil War or even speak with music historians about the types of instruments or music that would have been popular during that period.

It is important to understand that you would not do this research so that you could simply copy the music, but would instead use this approach to discover what in the music makes it fit the time or era. Keep an open mind; you might come up with unique ideas, or perhaps you will find their work is adequate and choose to use their basic premise.

We are going to use ACID, a program we looked at previously in the book. This program offers several advantages to other applications. First, even if you do not have a music background, you can use ACID. Additionally, it comes with several samples that can be used in many ways. Several Web sites have clips readily available for download to use in the program.

ACID Loops

ACID is based on the ability to create music from loops, much like mainstream music being produced today. In the past 15 years, the vast majority of the music industry has used loops or samples in one aspect or another. This concept has drastically altered the music landscape, changing the way both amateur and professional producers create their music. A quick glance at many modern albums will disclose their use of samples.

The use of samples in many forms of music has brought about an entire industry that produces music especially for this purpose. There are literally thousands of CDs that contain materials that can be used for almost any purpose. Along with the CDs that are filled with music in standard CD audio format, there are also those that have been built with the file formats used by many leading music programs, including ACID.

There are two basic ways these CDs are distributed. First, is a royalty-based system where you are required to pay for every time the sample is used. The CDs are often free, but you pay as you use them. The other option usually involves paying a fee up front, but you then receive a royalty-free license that allows you to do almost anything with the loops. With either option, you usually cannot distribute the materials as a new collection of loops.

Recently, the Internet has offered a third solution for obtaining samples. Countless Web sites offer fee-based downloads, while others allow you to download their loops freely. Several sites offer free loops, but the first one we will look at specifically is the Sonic Foundry run ACIDPlanet.com. It has a freely available download every week called an 8Pack, which is essentially an ACID project file that includes eight loops arranged into a song. The 8Packs will help to teach you how to combine loops into a final project, and comes with tips and tricks that were used to put it together.

Another excellent site is PocketFuel.com. It offers the largest collection of files for ACID on the Internet, and they are royalty free. For the production in this book, files were downloaded from this site. If you register at the site, you can also download the same files that we use in the next section.

CREATING THE MUSIC

Because of licensing issues, the final project on the CD-ROM is in MP3 format to comply with the licensing information located at PocketFuel. You should thoroughly read through the licensing agreement before downloading anything from this Web site. To begin our composition, you should first locate and download several types of loops from the Web site; you do not need to duplicate this project exactly, as the files that were downloaded might no longer exist.

The screen shots in this chapter are from ACID Pro 3. They might look slightly different from the free version of ACID located on the CD-ROM. However, you should be able to follow along, as the project is limited in that it only uses the capabilities available in the free version.

When you open ACID, you will be presented with an empty project (see Figure 10.1).

Next, from the File menu choose Properties and set the information for your project, such as the title of the project and the copyright information. The Properties window is shown in Figure 10.2.

Next, add your first loop to the project. Double-click a file in the Explorer, or drag it to the Track List to add it to your ACID project. If you add a file that is longer than 30 seconds in length, ACID's Beatmapper Wizard will automatically be displayed. Right-click and drag a file to the Track View or Track List to specify the type of track that will be created. When you drop the file, a shortcut menu appears that allows you to choose whether the file will be treated as a loop, one-shot, Beatmapped track, or as an autodetected type. Your project should look something like Figure 10.3.

CHAPTER 10 CREATING MUSIC AND SOUND EFFECTS 149

FIGURE 10.1 *A blank project in ACID.*

FIGURE 10.2 *The project Properties window.*

FIGURE 10.3 *The project with a single loop added to it.*

Next, drag the time so that it ends at approximately 21 seconds. Your screen should now look like Figure 10.4. If for some reason your ruler has a different measure of time, you can change it by choosing View | Time Ruler, and then selecting the appropriate format.

Next, select the Paint tool. If you remember from Chapter 7, "Texturing Models ," the Paint tool is designed to paint events across multiple tracks. With the Paint tool selected, you can paint events across multiple tracks by clicking and dragging the mouse. This tool is also useful for inserting one-shot events evenly along the grid, which is basically how we will use it.

With the Paint tool, draw in the first location in the grid directly to the right of the filename that can be seen in the Track List. Your project should look like Figure 10.5.

Chapter 10 Creating Music and Sound Effects

FIGURE 10.4 *The time ruler with a time of approximately 21 seconds.*

FIGURE 10.5 *The first entry in the grid.*

You can click the Play button to test the project before moving on. If it plays correctly, give your project the name "MyFirstACIDProject."

The next step is to add the rest of your loops to the project. Once you have finished, you can begin creating your music by drawing with the Paint tool or Draw tool inside the grid next to the individual tracks. Figure 10.6 shows the finished project.

FIGURE 10.6 *The finished project.*

ON THE CD

If you have any problems with this project, take the time to download the 8Packs available at ACIDPlanet.com. They have preconstructed projects that will give you an idea of how to better put things together.

Once your project is complete, you need to save it in WAV format. The final project is in MP3 format, but the free version of ACID cannot export to MP3.

The final project can be found in several formats on the CD, including MP3, WAV, and RM. It is in the "Music and SFX" directory.

CREATING SFX

Sound is everywhere in our daily life so it is obvious why it would be so important to a gameplayer. Sound effects often take on meaning in a game. A dark alley with a strange noise coming from behind an overflowing dumpster delivers a message of fear more than the dark alley would by itself. People yelling loudly draw our attention to an area or might make us want to flee in the opposite direction. You can also use sound effects to establish a time and a place. For example, crickets in the background or waves beating a shore can add a great deal to a setting without visually displaying anything.

Sound effects can also convey actions, such as a gun being fired or a car colliding with a wall in a racing game. It is this part of sound effects, the part that adds emotion or action to a scene, in which game programmers are most interested.

Like the CDs that are available with loops, there are also sound effects libraries that can be purchased. For the vast majority of sound effects, there are probably CD libraries that contain something that will work or can be modified slightly to work.

For those sounds that are unique or for sounds you would prefer to do yourself, it is often a very simple process. If you have a PDA or a portable recorder of some sort, you can often visit a site to obtain sound recordings. For example, if you have a game with animals, a visit to a pet store or local zoo is often all you would need to add the appropriate noises. If you are creating a sports title, visiting a local sporting event will give you all of the crowd and background noises you ever need.

If you choose to visit local areas to record your noises, keep in mind that you often need more than you think you do. This is true for many reasons, such as the noises not being as good as you had thought, or, after editing, you are left with only minutes from a 10-minute recorded segment. Again, always try to get more material than you think you will need.

The other basic type of sound effect for a game is the effects that occur when some type of action occurs. The action types take a great deal of time to produce and might require a tremendous amount of specialized equipment. Fortunately, with a little effort and common items, you can use some very simple ideas to record these types of sound for our game.

RECORDING SOUNDS

It does not really matter what type of device you are using to record the sounds; ultimately, we have to get the data into the computer. For our setup, we will assume you are using a tape record, digital recorder, or a PDA to record your sounds. We will then connect these devices to the sound or microphone inputs on your sound card. We will then use Cool Edit to edit these noises after changing them into a digital form.

How to Record

The first step in this process is to create the recordings. We are going to create a basic 3D shooter, and with this in mind, we will need to create effects for gun shots, footsteps, and perhaps even noises of collision. These are actually quite easy to record.

The following table lists several types of actions that you can record easily with common household items. For our purposes, we need to record the footsteps and a body collision.

Sound Type	How to Record
Car Crash	Fill a box with scrap metal and chunks of wood. Shake vigorously while recording.
Fire	Take a piece of cellophane and crinkle it in your hands.
Door Slamming	You can use a real door and simply place the recording device near the hinges. You can slam the door, and then open and close the door slowly if you also need this type of noise.
Body-Type Collisions	You can use items such as a pumpkin or watermelon and strike them with a piece of wood or rubber mallet. Try various methods to get just the right sound. Watch out, though, this one can be very messy! Another method is to wrap wet towels around wood planks and then strike them together, or let them fall a small distance to a concrete or hardwood surface.
Rain	You can simply record rain on a roof or metal sheet, or if you are in a hurry, you can simulate the effect by taping together five plastic cups having cut the bottoms of the cups into different shapes such as a square, star or ellipse. After taping them together, you can pour uncooked rice into the top, and as it falls through, it will sound like rain falling.
Thunder	Thunder can be recorded during a storm, but like rain, it can be simulated using other methods. You can make up a simple "thunder sheet" by getting a piece of sheet metal cut approximately 18" x 50". Then, fit it with 1" x 2" boards on one end and multiple holes in the other to hang it from a ceiling or beam. You can shake the end with the handle to simulate the thunder. This can take some practice to master, so be patient if it does not sound realistic at first.
Footsteps	Depending on your needs, it is probably easiest to emulate footsteps by recording the real thing. You can record in gravel areas for outdoor simulations, or you could use a hardwood floor with a hard-heeled show for indoor areas. If you prefer, you can actually construct a wooden box that would be large enough to step into. It would need to be approximately 3' x 3', and once constructed, you can step in place.

Chapter 10 Creating Music and Sound Effects

	Additionally, you can flip it over for recording step noises, or you can fill it with things like straw or newspaper to vary the produced noises. To simulate walking in snow, you can use a shoe to press on an old strawberry container, or against a couch cushion or similar type of furniture. If you do this at the approximate stepping rhythm, it will simulate this very well. You can also simulate animal footsteps using similar methods. For example, you can simulate a horse by striking small squares of wood together or by striking together halves of a coconut with all of the pulp removed. You could use your box along with the coconut by adding some sand and then striking the halves with the box.
Machines	You should try to do your best to record the actual machine noises. For example, if you are creating a car racing game, you might get the best effects by visiting a race and recording the sounds yourself. Additional sounds that work well in games include saws, drills, and even hammers.
Gunshots Hitting Wood	You can cut plywood into thin strips and then break it while recording. It will sound as if the shots are splintering the wood.
Shots	Gunshots can be simulated by hitting a leather seat with a thin wooden stick such as a yardstick or ruler. For different types of sounds, you can experiment by hitting other materials with the wooden stick.

For practice, let us look at the last item in the table, a gunshot. Using a thin wooden stick, strike various objects with varying strengths to get used to the idea. Creating these types of sound effects is very much trial and error. As such, you should spend some time finding several objects that sound good and record all of them.

Using a PDA

The next step is to connect your recorder to the computer. If you are using a PocketPC or Windows CE-based PDA, you can simply connect it to the computer and transfer the recordings, which will already be in WAV format. If you are using this method, you can skip the next section *Using a Recording Device*. Depending on the sound quality of your PDA, the sounds will be of varying quality. If they are not of good quality, you will probably be forced to use another method to record your sounds.

Using a Recording Device

If you are using a tape recorder, mini-disc recorder, or other recording device, you will have to attach it to your computer's sound card. On most sound cards, there are four connectors: Line In, Line Out, Microphone, and a MIDI/Game Port. Figure 10.7 shows a diagram of a typical sound card.

Most modern sound cards also use diagrams to label the connections. A sample is shown in Figure 10.8.

FIGURE 10.7 *The layout of a typical sound card.*

FIGURE 10.8 *Sound cards often have labels.*

The following list details the various connectors:

- **MIDI/Game Port** This port is most commonly used to connect a game paddle and or Joystick to the computer. This port will also allow you to connect a device such as a MIDI keyboard to the computer.
- **Line In** A connector that allows you to connect a cassette tape, CD, or other recording device to the computer.
- **Line Out** This is used for speakers or headphones that can be connected to get sound from the sound card.
- **Microphone** Allows you to connect a microphone to the computer and record your own sound files. If necessary, you can also connect a recording device to this port.

Once you have located the Line In or Mic (microphone) connection, you should attach your device to the computer. Depending on the device, you might need different types of cables and connectors. The vast majority of sound cards use 1/8" (miniplug) jacks for Mic and Line In.

After connecting the device, the next step is to open the mixer panel of your sound card by double-clicking on the yellow speaker icon in your system tray, which is near the clock on your task bar. Figure 10.9 shows a standard sound card mixer.

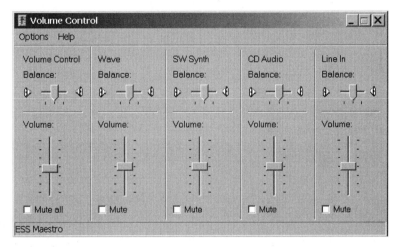

FIGURE 10.9 *The mixer panel allows you to choose options related to the sound card.*

When you first open the mixer, you will see all of the possible playback volumes. Make sure that wave is not muted, and that its volume slider and the master volume slider are both at least halfway up.

Next, set the sound card's recording devices by going to Options | Properties, and then select Recording. Each of the devices your sound card can record from will be listed in the window. The next step is to click OK, which will display the Recording Controls window. Make sure that the volume of the category you plan to use is halfway up. For example, if you are using the Line In, you should make sure that Line In is halfway up. Figure 10.10 shows the Line Ip as it should appear.

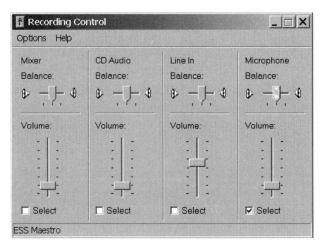

FIGURE 10.10 *Line In with the correct settings.*

The next step is to open Cool Edit, select Options | Settings, and then click on Devices. Make sure that the correct device is selected for both Waveform Playback and Waveform Record. Create a new file by clicking File | New. Choose the WAV file type, and click OK. Next, click the Record button in Cool Edit and start the playback of the device. When you have finished recording, press the Stop button. Depending on your sample, you should see something like Figure 10.11.

You should test the playback volume in Cool Edit before moving on. If the volume is too low, you can rewind or reset your device, increase or decrease its volume as necessary, and then record it again to a new file. Once it is in Cool Edit and the volume seems appropriate, we can save it and then begin editing it as needed. First, notice that there are basically three areas shown in Figure 10.11. These areas represent the three times that the stick was used to strike a leather chair in the sample recording. Our plan will be to alter this file such that there is a single "shot." Begin by selecting one of the first areas, and then choose Edit | Copy. Next, place your mouse at the end of the selection and then single click. If it appears that you have selected the area directly next to the first sample, choose Edit | Paste. The area should now look like Figure 10.12.

Chapter 10 Creating Music and Sound Effects

FIGURE 10.11 *Cool Edit displaying the recorded sample.*

FIGURE 10.12 *The newly pasted area.*

The next step is to select Transfer | Amplitude, and then Envelope. Drag the line down in the window so that it looks like Figure 10.13. Next, click OK.

FIGURE 10.13 *After applying the envelope.*

The tapered effect will act as a sort of echo to the gunshot. The next step is to highlight areas away from where the first gunshot and newly pasted are, and then press the Delete button. This will leave only the single gunshot and echo. Figure 10.14 shows the result.

You might notice that there is an area within the taper that actually begins to increase in volume before falling back down. This adds to the echo effect and is accomplished by selecting an area, choosing Transfer | Amplitude, and then Amplify. From this window, drag the Amplification to create a higher value. You can also use Amplify to increase or decrease the volume of the entire sample if the volume is too high or low.

CHAPTER 10 CREATING MUSIC AND SOUND EFFECTS 161

FIGURE 10.14 *The final version of the WAV file.*

That's all there is to a gunshot. You can follow this same basic process for creating the other sound effects using the methods we looked at previously in the chapter.

Chapter Review

It is easy to see why music and sound effects are so important to the development of a game. They can add so much to the experience of a game player by setting a mood or location. Well thought-out music and sound effects go hand in hand with the eye candy on which so many developers focus. It has become an integral part of the game development process.

In this chapter, we used two of the best tools available for game developers: ACID, with its easy-to-use interface to create a very simple song, and Cool Edit to record and edit sound effects for our final project. In the next chapter, we will look at modeling a 3D character in MilkShape 3D and, once finished, our focus will turn to level designs and programming. Finally, we will put everything together to create a First Person Shooter (FPS).

CHAPTER 11
Half-Life Model

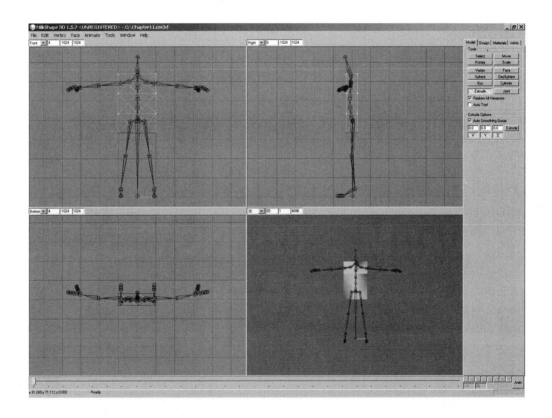

In this chapter, we will expand on our previous knowledge of MilkShape 3D in the creation of a Half-Life humanoid model. The model will be used as in the First Person Shooter (FPS) that we will ultimately construct. Although we could use DirectX, Quake, or any number of model formats, we will use the Half-Life format for a number of reasons. Its easy-to-use skeletal animation system is undoubtedly at the top of the list. The system allows us to create or customize an animation in a relatively easy manner. Additionally, MilkShape 3D supports the Half-Life model format and includes the ability to compile the animations.

ON THE CD

The creation of a model is a very involved process. If you prefer, you can use one of the ready-made models that are included on the CD-ROM instead of creating your own.

GETTING STARTED

This chapter involves the creation of a 3D humanoid model, and contains a large number of steps. To aid you in the process, this chapter includes figures for many of the steps, the benefits of which are twofold: it will be easier to follow along, and allow you to check your progress regularly.

The first step is to open MilkShape, at which time we are presented with a screen similar to Figure 11.1.

Because we are creating a humanoid Half-Life MDL, we are going to use a Valve created skeleton for our animations. Fortunately, MilkShape ships with the skeleton, which can be opened by choosing File | Open. From the Open dialog box, shown in Figure 11.2, choose "valve_skeleton.ms3d." We are going to display the skeleton early in the project to give us a sort of template to use when we model our human.

Chapter 11 Half-Life Model

FIGURE 11.1 *The MilkShape interface as displayed on startup.*

FIGURE 11.2 *The Open dialog is used to open the Valve skeleton.*

After the file opens, MilkShape should look something like Figure 11.3.

FIGURE 11.3 *We will use the Valve skeleton as a template.*

CREATING THE UPPER BODY

We will begin the modeling process by adding a Box to the scene. You should resize it so that it is similar to Figure 11.4.

 If you cannot remember the steps in basic modeling, refer to Chapter 6, "Creating Low-Polygon Models with MilkShape 3D."
TIP

The next step is to resize the model so that it is smaller from front to back. We can accomplish this by choosing Select from the Tools menu, and Vertex from the Options menu. Figure 11.5 shows the menu.

Chapter 11 Half-Life Model

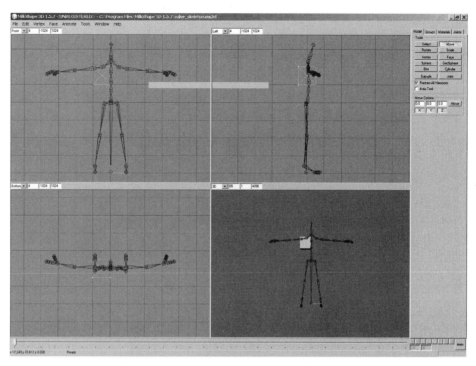

FIGURE 11.4 *A box is the first step in our model.*

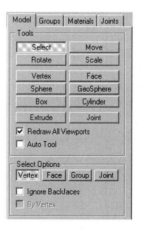

FIGURE 1.3 *Selecting the appropriate options.*

With the Selection tool, draw a box around the four vertices that are at the front of the model. Figure 11.6 shows the Selection tool being drawn around the appropriate areas.

FIGURE 11.6 *Use the Selection tool to select these vertices.*

Once you have selected the vertices, the next step is to select Moves from the Tools menu. You can then move the selected vertices closer to the front of the skeleton. You can see an approximation of this in Figure 11.7.

You need to repeat the previous steps for the four vertices on the backside of the model as well. This will alter the width of the box as shown in Figure 11.8. As you resize the elements that will make up this model, please keep in mind that the skeleton itself will not be visible when the model is compiled. We are using it at this time for a reference. With that in mind, you do not necessarily have to cover every part of the skeleton with a piece of the model.

It would be a good idea to save this model at this time, making sure to save it to a name other than valve_skeleton.ms3d.

TIP

Our next step will be to use the Extrude tool to add to our box. First, change the Upper-Right viewport to Right (see Figure 11.8).

CHAPTER 11 HALF-LIFE MODEL 169

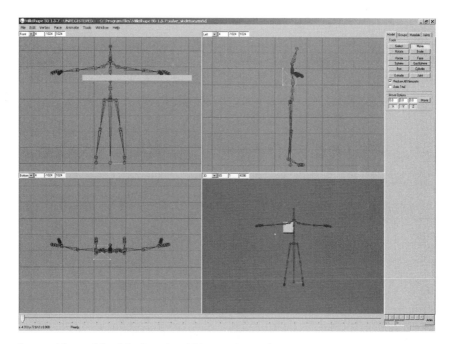

FIGURE 11.7 *The width of the box should be similar to this.*

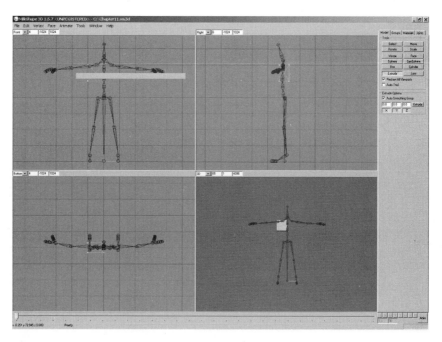

FIGURE 11.8 *The Upper-Right viewport has been changed to Right.*

Choose Select and Face from the Tools and Select Options menus, respectively. You also need to make sure that Ignore Backfaces is checked. Next, draw a selection box around the shoulder area of the skeleton (see Figure 11.9).

FIGURE 11.9 *Use the Selection tool to select the entire face.*

TIP
Make sure that you are selecting a face, because we plan to use the Extrude tool in later steps. MilkShape will do some strange things to your model if you try to extrude selected vertices.

Once you have selected the face (it should be highlighted in red), the next step is to use the Extrude tool to extend the box. Using the Front viewport, create an extrusion similar to Figure 11.10.

You will notice that the "shoulder" area of our model appears to be lying too low on the skeleton. We can use the Select tool (make sure Ignore Backfaces is unchecked) to select all vertices, and then use the Move tool to move the selection up on the model in a manner similar to Figure 11.11.

Chapter 11 Half-Life Model

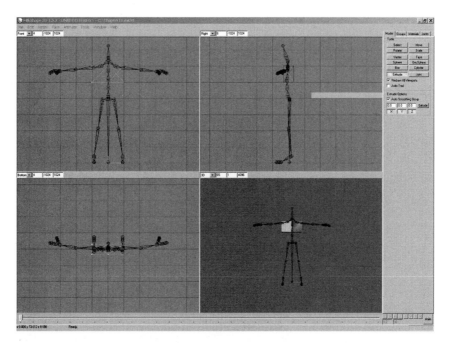

Figure 11.10 *Extrude the face so it looks something like this.*

Figure 11.11 *We need to move the selection to this area.*

The next step is to extrude the bottom edge of the area we have created. Choose Select and Face from their respective menus. Next, check the Ignore Backfaces option, and draw a selection box around the Bottom viewport as shown in Figure 11.12.

FIGURE 11.12 *The faces we are selecting will be extruded.*

You can now use the Extrude tool to create the extrusion so that the model now appears like Figure 11.13.

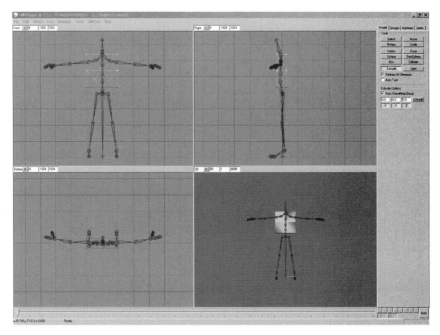

FIGURE 11.13 *After extrusion, our model looks something like this.*

Repeat the extrusion to create a "third row" of boxes (see Figure 11.14).

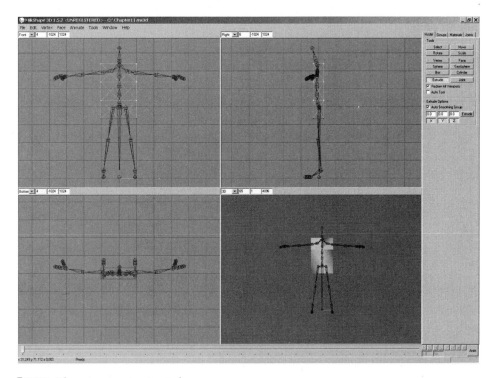

FIGURE *The extrusion is repeated.*
11.14

We will finish this part of the model by moving several vertices to take away the "square" look. We are not going to spend a great deal of time on this, but it is important that you understand how it can be accomplished. First, choose Select and Vertex from their menus, making sure that Ignore Backfaces is not selected.

Using the Front viewport, draw a selection rectangle around the lower-right portion of the model (see Figure 11.15).

FIGURE 11.15 *The selection should only be around the lower-right portion of the model.*

Once the vertices are selected, the next step is to choose Move. Again, using the Front viewport, move the vertices so that the model looks like Figure 11.16. Repeat the step for the opposite site to match Figure 11.17.

Chapter 11 Half-Life Model

FIGURE 11.16 *Your model should now look like this.*

FIGURE 11.17 *Moving the other side makes it symmetrical.*

CREATING LEGS

The next step in the creation of our model is to create the legs. Begin by choosing Select and Face from their menus. Ignore Backfaces should be checked. Using the Bottom viewport (lower-left of the MilkShape screen by default), hold down the Shift key and click the faces that are directly left of the center of the model. Figure 11.18 shows the areas highlighted in red.

FIGURE 11.18 *The highlighted area has been selected.*

Chapter 11 Half-Life Model

Next, choose the Extrude tool and then create an extrusion as in Figure 11.19.

FIGURE 11.19 *The beginning of our leg.*

Leaving the face selected, choose the Scale tool, and then rescale it to create a large upper leg area. You can see the change in Figure 11.20.

FIGURE 11.20 *The upper leg has been scaled.*

Using the same ideas, extrude and scale another portion of the leg down to where the knee would approximately be. Figure 11.21 displays the scaling and extrusion.

We will use the same steps to create two sections in the lower leg that will represent the increased size of the calf muscle and then the tapering down to the ankle. Figure 11.22 displays the model as it should appear after the step.

Chapter 11 Half-Life Model

Figure 11.21 *Scale and Extrude were used again.*

Figure 11.22 *The model now has a lower leg.*

THE FOOT

With the lower leg out of the way, we now need to create a foot. Continuing where we left off, we will use the Extrude tool to create the beginning area of a foot. Begin by extruding a straight segment down from the ankle (see Figure 11.23).

FIGURE 11.23 *A foot begins to take shape.*

Next, choose the Select and Face tools, and check the Ignore Backface option. Using the Front viewport, select the face that will be extruded to create a foot. Hold down the Shift key and click to select the two faces highlighted in Figure 11.24.

Our next step is to use the Extrude tool to create a length for the foot (see Figure 11.25).

Chapter 11 Half-Life Model

Figure 11.24 *The face is selected.*

Figure 11.25 *The foot has been extruded.*

Once the foot has been extruded, we need to choose Select and Vertex. You should uncheck the Ignore Backface option, and then draw a selection box around the upper-front area of the foot (see Figure 11.26).

FIGURE 11.26 *The vertices have been selected.*

The final step in the creation of the foot is to choose Move, and then move the vertices slightly downward to create a slight angle for the foot (see Figure 11.27).

Chapter 11 Half-Life Model

FIGURE 11.27 *The foot is now finished.*

Mirroring the Leg and Foot

We could repeat the steps to create another leg and foot, but because we are at approximately the center of the skeleton, we can use another option: mirroring. First, choose Select and Face from their respective menus. After making sure that the Ignore Backface option has been unchecked, you can draw a box around the leg to highlight it (see Figure 11.28).

FIGURE 11.28 *Selecting the entire leg is the first step toward mirroring it.*

From the Edit menu, select Duplicate Selection (see Figure 11.29).

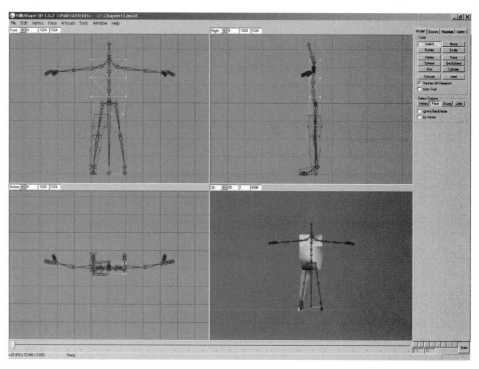

FIGURE 11.29 *Choose Edit | Duplicate Selection.*

Chapter 11 Half-Life Model

Strangely, nothing appears to have happened. However, if you now choose Mirror Left <——> Right from the Vertex menu, it will create an exact mirror. The menu option is shown in Figure 11.30.

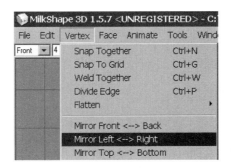

FIGURE 11.30 *The Mirror option is located in the Vertex menu.*

The mirrored leg, shown in Figure 11.31, will appear, at which time you can use the Move tool to move it left or right if necessary. This will only happen if you are slightly off center, and should only be for a very small distance.

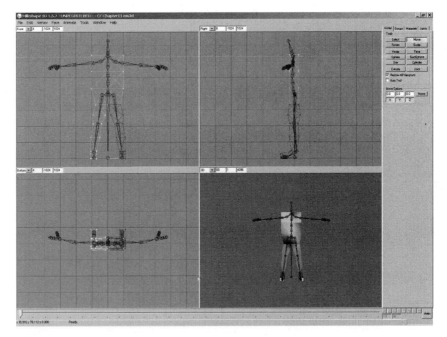

FIGURE 11.31 *The leg appears as a perfect match.*

You can move the 3D viewport at this time to see how the model is progressing (see Figure 11.32).

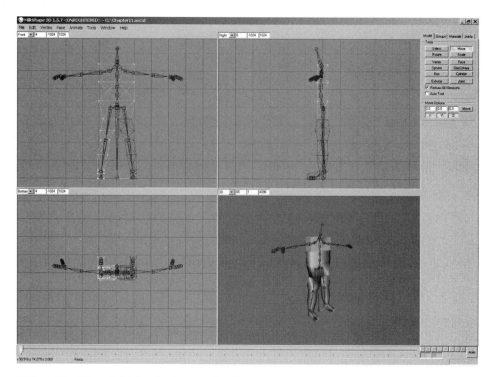

FIGURE 11.32 *The 3D model is beginning to take shape.*

Creating Arms

Now that the legs are finished, our next objective is to create a neck, arms, and shoulders for the model. We will use the same basic approach that we used in the previous steps; that is, we will use the Extrude, Scale, and Move tools.

We will begin by changing the Bottom view (in the lower left-hand corner) to a Top view (see Figure 11.33).

Choose the Select tool and Face for the Select Option. You should also select Ignore Backfaces. Select the faces at the upper side of the model using the Top viewport (see Figure 11.34).

CHAPTER 11 HALF-LIFE MODEL

FIGURE 11.33 *The Lower-Left viewport has been changed.*

FIGURE 11.34 *Select these faces.*

After selecting the faces, you need to use the Extrude tool to create a small area as shown in Figure 11.35.

FIGURE 11.35 *Extrusion is the next step.*

Use the Scale tool to resize the upper area so that the neck area is scaled as shown in Figure 11.36.

We will now create the left arm and then mirror it as we did with the leg. Select the left shoulder faces, and then extrude them so that you create a very small area as in Figure 11.37.

Chapter 11 Half-Life Model

189

FIGURE 11.36 *This very simple neck is now finished.*

FIGURE 11.37 *We create a small shoulder area in this step.*

Next, use the Scale tool and then create another extrusion. After the extrusion, which ends at the middle of the upper arm, use the Scale tool again to enlarge the area. These steps should appear similar to Figure 11.38.

FIGURE 11.38 *At this time, your model should look like this.*

Now that you have an idea of how the arm is going to take shape, we will create the rest of it down to the wrist by continuing to extrude and scale the areas. Figure 11.39 shows the arm as it will look when you have finished it to the wrist.

The creation of the hand will involve the same tasks. Extrude a section and then scale as necessary. We will not create fingers for this model, so two sections for a hand is all that we will need. Figure 11.40 shows the finished hand.

Chapter 11 Half-Life Model

FIGURE 11.39 *The arm should look like this.*

FIGURE 11.40 *The arm is now finished.*

You can now use the Select tool and draw a selection box around the entire arm. You can then duplicate and mirror as we did with the leg. Figures 11.41 and 11.42 show these steps.

FIGURE 11.41 *The arm has been selected and duplicated.*

CHAPTER 11 HALF-LIFE MODEL

FIGURE 11.42 *Mirroring the arm is completed.*

CREATING THE HEAD

While we could approach the creation of the head in several ways, it is probably easiest to continue using the same extrusion/resize methods. We will begin by selecting the faces at the top of neck (see Figure 11.43).

Extrude the selected faces so that the neck appears like Figure 11.44.

FIGURE 11.43 *The neck has been selected.*

FIGURE 11.44 *Extrude the faces.*

Create another extrusion about the same size, and then scale it so that it looks like Figure 11.45.

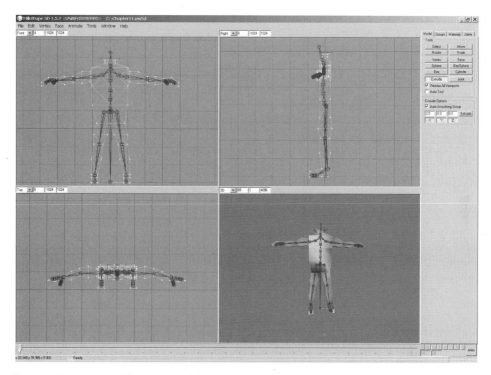

FIGURE 11.45 *The neck and lower part of the face are completed in this step.*

Next, extrude the neck to create a square head for the humanoid. Select the front face of the head so that we can extrude a small section. Figure 11.46 shows the figure after the two extrusions.

Scale the newest extrusion so that it creates a more rounded appearance as in Figure 11.47.

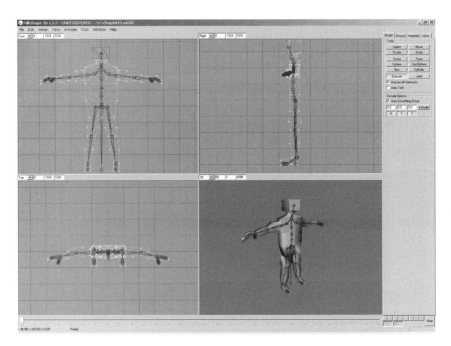

FIGURE 11.46 *The two extrusions make up the majority of the face and head.*

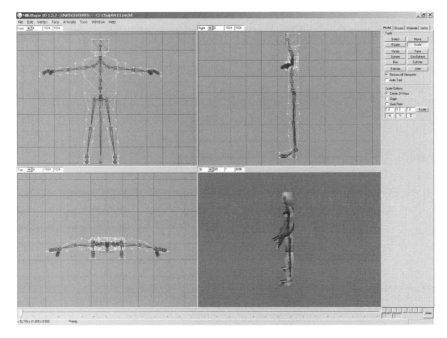

FIGURE 11.47 *Creating a more rounded appearance for the face.*

Our next step is to create another extrusion and then scale it so that we can create something similar to a nose (see Figure 11.48).

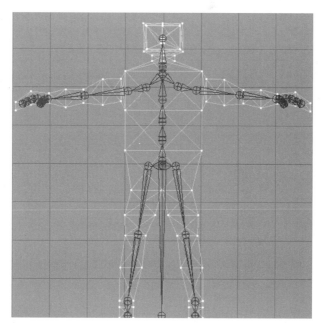

FIGURE 11.48 *The face is now complete.*

The last step for our head is to create a more rounded appearance for the rest of the head using the same procedures. The final version is shown in Figure 11.49.

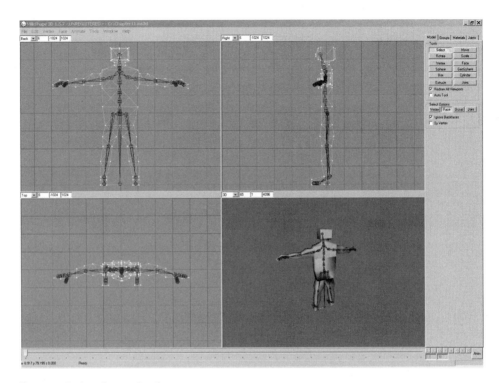

FIGURE 11.49 *The head in its final state.*

TEXTURING THE MODEL

The next step is to create a texture for the model. This is not too difficult to accomplish, as we will simply divide the model into two groups, a front and a back. The first step is to hide the skeleton so that it is easier to see the model. Select the Joints tab, and then deselect the Show Skeleton option. Next, select the Group Tab in MilkShape. You might have several names displayed as groups, but do not concern yourself with them.

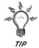

Save your model at this time with a new name, so that if you make a mistake, you can simply revert to the old model.

TIP

Chapter 11 Half-Life Model

Now, select Edit | Select All to select every face on the model, and click the Regroup button. Your screen should look something like Figure 11.50.

FIGURE 11.50 *The model has everything selected.*

The previously visible groups will be replaced with a single group. In the Upper-Left viewport, make sure that it is set to Front. Next, hold down the Shift key and the right mouse button, and then draw a selection box around the front view of the model. This will deselect the front faces (see Figure 11.51).

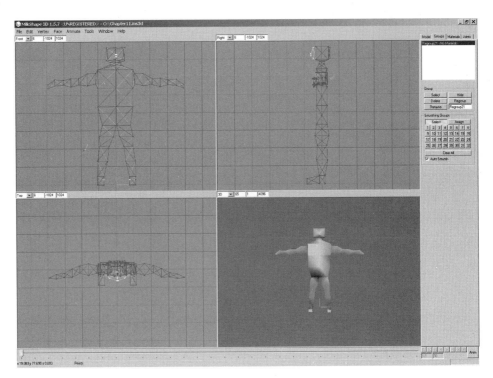

FIGURE 11.51 *The front faces have been deselected.*

Click the Regroup button. This will create a new group name. Select Edit | Select Invert. This will invert the selection, allowing you to group only the front faces. Click the Regroup button, which will now bring you to two distinct groups, a front and a back. You can rename the groups appropriately.

CREATING A TEMPLATE

The next step is to create a template we can use to draw our texture. Change the Upper-Right viewport to Back, and then click Print Screen. This will take a screen shot of the current image as shown in Figure 11.52.

Open PaintShop Pro, and then select Edit | Paste as New Image. Your image will be displayed in PaintShop Pro similar to Figure 11.53.

Chapter 11 Half-Life Model

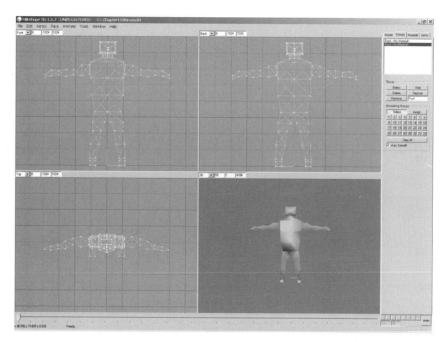

FIGURE 11.52 *The Upper-Left and Upper-Right viewports will be used for our template.*

FIGURE 11.53 *Paste the image into PaintShop Pro.*

Select Edit | Copy in PaintShop Pro to copy the selection to the Clipboard. Next, choose Edit | Paste as New Image. You will see the image, an example of which can be seen in Figure 11.54, in PaintShop Pro. It is this image that will eventually become the template for the first half of our model. Repeat the process for the Back view.

FIGURE 11.54 *The first template has been created.*

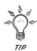 *Both sides of the template are virtually identical, so we could have used the same image for both sides.*

Before moving on, we will resize both images. Choose Image | Resize, and then type 256 into the Width. The Height will automatically be resized accordingly. Do the same for the other image, and then save both of them.

Choose Layer | New Raster Layer to create a new layer on the front and back templates. This will allow us to draw over them without actually editing the template. We now will begin to paint our skin.

PAINTING THE TEMPLATE

To begin painting, choose the Paintbrush from the toolbar. Next, choose a style such as Cement, and then a brown color that is a shade of gray. Paint the image so that you cover most of the areas. Figure 11.55 shows the way the figures should look at this time.

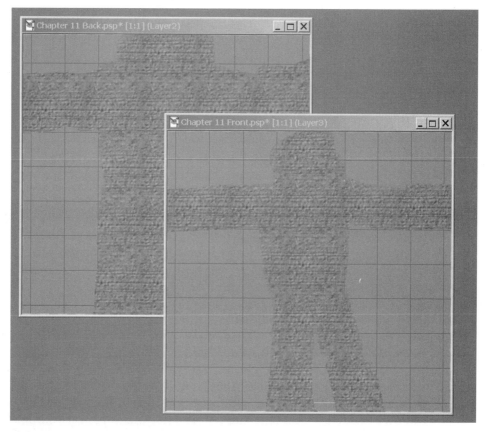

FIGURE 11.55 *The template begins to turn into a skin.*

Like the model, this is a very simple texture. You can add as little or as much detail to it as you like. For our purposes, we will simply add some green "eyes" and a different style to the hands and shoes.

To create the eyes, set the Paintbrush to a width of 30, a hardness of 100, and the style to "Green Emerald." Position the brush where you think the eyes would approximately be, and single-click in each position. The next step is to change the style to Light Streaks, and paint the hands and feet area of both images. Your templates should now look something like to Figure 11.56.

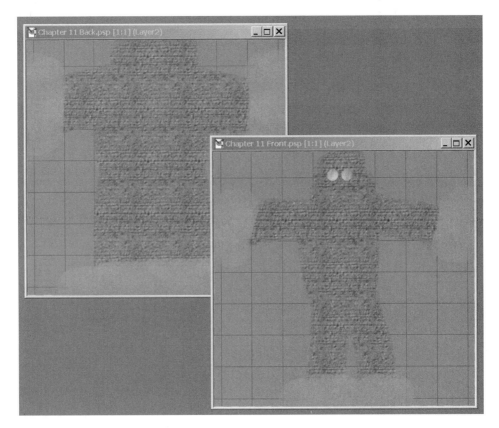

FIGURE 11.56 *The skins are nearly finished.*

Once you have the skins where you would like them to be, you can save them to a format MilkShape can use, such as JPG. This will convert the images to a single layer at the same time. Although it will not affect your final skin, you can remove the bottom layers before saving them to give a cleaner final skin.

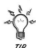

TIP

The Half-Life MDL format requires the skins to be saved in 8-bit format. You can change the number of colors in PaintShop Pro by choosing Color | Decrease Color Depth.

CHAPTER 11 HALF-LIFE MODEL

IMPORTING INTO MILKSHAPE

After saving the skins in JPG format, we can move back to MilkShape and import them onto the model. Begin by selecting the Groups tab. Make sure the Front group is highlighted, and then click Select. Your model should appear like Figure 11.57.

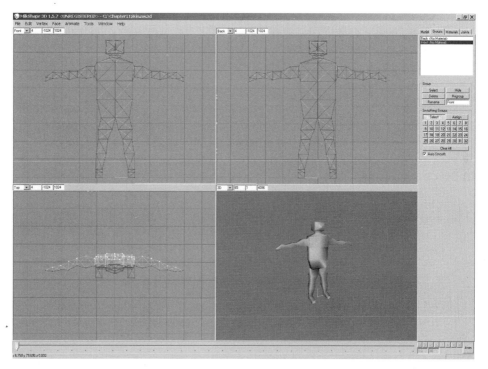

FIGURE 11.57 *Your model should look like this when you click Select.*

Next, click the Materials tab. Click New, and a material will automatically be created. Rename the material to Front, and then click the button labeled <None>. From the Open Image box, select the Front JPG image we created. Right-click the Lower-Right viewport, and make sure that it is set to Textured. Click Assign. You should see your imported skin appear very small inside the model, something like Figure 11.58.

FIGURE 11.58 *The material needs to be resized.*

Select Window | Texture Coordinate Editor. From both drop-down boxes, choose Front. Your window should look something like Figure 11.59.

Next, click the Remap button. The Texture Coordinate Editor should now display the outline of your model as shown in Figure 11.60. From here, you can accurately position the texture.

FIGURE 11.59 *The Texture Coordinate Editor allows you to position the texture.*

FIGURE 11.60 *Position your model so that the texture aligns properly.*

When you are finished, close the window. Your model should now look like Figure 11.61.

FIGURE 11.61 *The texture now appears on the front of the model.*

Repeat the entire process for the back of your model. When finished, the model will look like Figure 11.62.

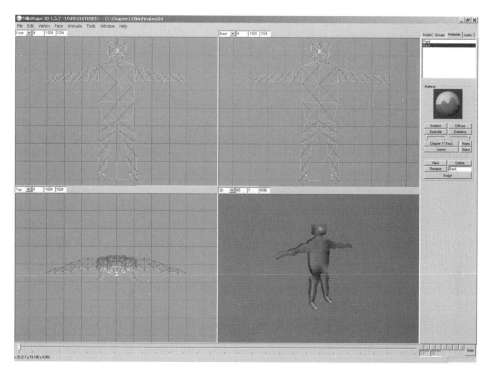

FIGURE 11.62 *The finished texture on the model.*

 If the texture did not line up properly or needs some adjusting, you can alter it and then repeat the steps as necessary.

TIP

BASICS OF ANIMATION

In order to animate a model in MilkShape we must first assign the bones to areas of the mesh model that we have created. For example, we need to assign the right calf area to the bone called Bip01 R Calf. We will assign each of the bones in the skeleton to areas of the mesh, and then use a series of animated files that have already been created to compile the model into a final MDL file.

To begin, click the Joints tab and display the skeleton that we had previously hidden. Once inside the Joints tab, click the Show Skeleton option, which will display the entire skeleton. You'll also notice that the tab displays a list of each of the bones contained in the skeleton. If you click one of the bones, it will select it so that we can assign it to the mesh. You will see the bone that has been selected, as it will change color from blue to green as shown in Figure 11.63.

FIGURE 11.63 *The skeleton displayed in the model with a selected bone.*

Chapter 11 Half-Life Model

Remember that our model is basically a bunch of simple blocks. Although we could have added a great deal of detail to it, we instead built it with simplicity in mind. Therefore, we have not added individual toes and fingers. With that in mind, we'll begin the assignment of our bones by selecting the bone named Bip 01 L Foot. This should select the left foot and all bones in it. Next, click the Model tab. You need to click the Select tool and the face option, making sure that Ignore Backfaces is not selected. Using the Front viewport, you need to draw a selection box around the left foot. After selecting the correct faces, go back to the Joints tab, and then click Assign. This will assign the selected faces to the bone.

We will now repeat the process moving up the leg to the Bip 01 L Calf bone. Draw your selection this time around the calf area, but do not include the areas you previously selected. Your model should look like Figure 11.64 after the assignment.

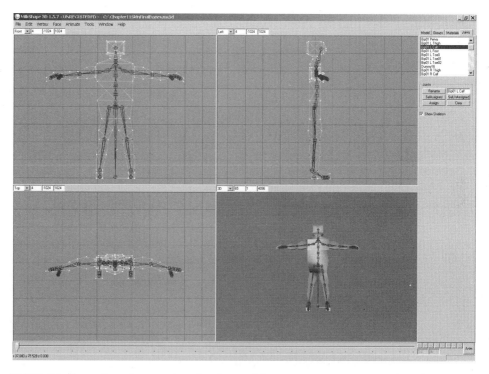

FIGURE 11.64 *The bones have been assigned to the model.*

Repeat this process for the rest of the model, assigning every bone to the appropriate areas. It is an involved process, and once you are finished, you should save it to a new filename, thus protecting your previous and current work. This will allow you to return to the model with unassigned bones if you need to.

COMPILING THE MODEL

After assigning the various bones to the model, the next step is to save the model as an SMD file. Before doing so, save it in MilkShape format to protect your work by choosing File | Export Half-Life SMD.

ON THE CD

The CD-ROM contains a directory called PlayerMDL that contains a list of animations in SMD format and a .QC file. Copy all of these files and the SMD file you exported form MilkShape into the C:\PlayerMDL directory. The next step is to compile the files into an MDL by choosing Tools | Half-Life | Compile .QC File. The QC file is located in the PlayerMDL directory and is named Player.QC. If everything has been created correctly, you will find the final model in the PlayerMDL directory. It will be named Player.MDL.

TIP

If you are really interested in model creation, take the time to download the Half-Life SDK from www.valve.com. It contains reference files and information about a wide range of models. Additionally, Appendix B, "Half-Life Model Specifications," contains information and sample .qc scripts for Half-Life models.

CHAPTER REVIEW

In this chapter, we learned how to build and skin a model using MilkShape and PaintShop Pro. We also discovered some basic information about the Half-Life model format, and how to animate it using pre-built SMD files. In the next chapter, we'll look at the DirectX 8.0 SDK, focusing on a basic framework that we can use for several projects.

CHAPTER 12
Introduction to the DirectX 8 SDK

U p to this point, the chapters in the book have involved creating graphics, music, sound effects, and 3D models. In this chapter, we will take a quick introductory look at the DirectX 8 SDK (Software Developers Kit). The entire DirectX 8 SDK is on the CD in the Applications\DirectX SDK subdirectory.

ON THE CD

INSTALLING THE SDK

There really is not much to installing the DirectX 8 SDK. Locate the SDK on the CD included with the book, and begin the installation by double-clicking the Setup.exe file. The opening screen will be displayed and will look like Figure 12.1.

FIGURE 12.1 *The first step in the installation process.*

CHAPTER 12 INTRODUCTION TO THE DIRECTX 8 SDK

Click Next, and the process will continue with the Microsoft License Agreement, an example of which is shown in Figure 12.2. Read through the document, and then click Next button.

FIGURE 12.2 *The License Agreement.*

The next step gives you the option of what type of setup you wish to perform. Unless you really need to save space, you should simply choose the Complete option as shown in Figure 12.3.

FIGURE 12.3 *You are presented with several options for different types of installations.*

After clicking Next, the Retail or Debug options appear. As you can see in Figure 12.4, this will allow you to install the retail or debug version of DirectX. Unless you have specific needs for speed, the debug version is a better choice for developers, although it is slightly slower than the retail offering.

Chapter 12 Introduction to the DirectX 8 SDK

FIGURE 12.4 *Retail or Debug installation options.*

Once you choose retail or debug, click Next, results in the Directory option screen being displayed. This screen, shown in Figure 12.5, allows you to choose a custom directory for installation. Again, unless you have specific needs, the default directory will probably be your best choice.

FIGURE 12.5 *You can choose the directory into which you install the SDK.*

If you click Next, you will see something similar to Figure 12.6. This step offers us the ability to change the name of the program folder. Like most of the previous steps, this is probably best left untouched.

FIGURE 12.6 *You should probably leave the folder name untouched.*

If you click Next, you will be presented with the last step, which allows you to go back into the Setup wizard to make changes. This window, shown in Figure 12.7, will allow you to click Back to go back into the process, or click Next to begin copying the files to your hard drive. Unless you need to review your selections, click Next to install the SDK.

FIGURE 12.7 *The setup options are complete.*

BASICS OF DIRECTX 8

Now that the SDK is installed, we can move forward to the fun part: learning DirectX 8. If you have used previous versions of DirectX in VB or within another environment, the first thing you'll probably notice is the new implementation. In earlier versions, you had access to DirectDraw for doing 2D scenes, but with version 8, Microsoft has made the decision to do away with DirectDraw. You are now forced to use 3D to do 2D. If this seems confusing, you needn't worry about it. We will discuss it thoroughly.

mode, do anything else that we need to do, and then create a loop that ultimately controls the rest of the application.

BASIC FRAMEWORK

With a small amount of the basic information out of the way, we will now focus on actually creating a basic framework for a DirectX project in VB. You should to save a copy of this project as a sort of template. Then, when you want to begin a new DirectX project, you can simply open this up and begin working almost immediately. This is perhaps the most important part of the entire DirectX process. Therefore, make sure that you understand everything in this section, as future sections and chapters of the book will assume that you do.

CREATING A NEW PROJECT

To begin, open Visual Basic and create a new Standard exe project. When you create the project, a form is automatically displayed (see Figure 12.8).

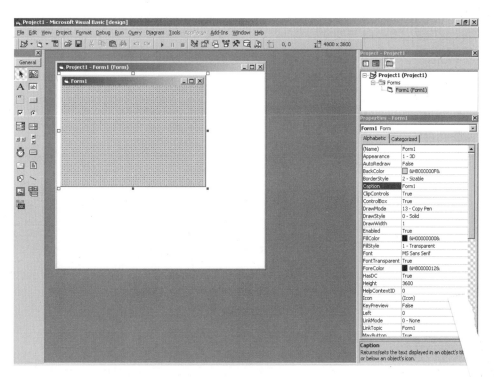

FIGURE 12.8 *A blank form is created with the new project.*

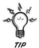

TIP *The projects should work with almost any version of Visual Basic 5 or later; in other words, Professional, Enterprise, and Learning. The source code on the CD was created with version 6 of the Enterprise edition. The code should work with VB.NET, which is in beta at the time of writing.*

The next step is to add the DirectX 8 Library to our project. Select Project | References, and from the window displayed, search for "DirectX 8 for Visual Basic Type Library." When you locate it, select the box next to it, and then click OK. Visual Basic can now access DirectX in this project.

The next step is to double-click the form, which opens the Code window in VB. The following variable declarations are required:

```
Dim Dx as DirectX8  'Entire DirectX
Dim D3D as Direct3D8  'Direct3D
Dim D3DDevice as Direct3DDevice8   'Reference to Hardware
Dim bRunning as boolean  'Running or Not
```

Next, there are a few additional variables that can be useful but are not required. They allow us to determine the current frame rate. Place these directly beneath the previous code:

```
Private Declare Function GetTickCount Lib "kernel32" () As Long  '
Framerate calculation
Dim LastTimeCheckFPS As Long  'Last time checked
Dim FramesDrawn As Long  'Number of times drawn
Dim FrameRate As Long  'Current Frame Rate
```

The next step is to initialize the DirectX objects. In our first example, we will focus on a simple Windowed mode application, which is easier to set up. Following this example, we will move forward with a full-screen example.

We need to begin this process with an Initialize function. Add the following to the Code window:

```
Public Function Initialize() as Boolean
'Return true or false
On Error Goto ErrHandler:
Dim DispMode as D3DDISPLAYMODE  'Play Mode
Dim D3DWindow as D3DPRESENT_PARAMETERS  'Viewport
Set Dx = New DirectX8  'DirectX Object
Set D3D = Dx.Direct3DCreate()  'Create  Direct3D Interface
D3D.GetAdapterDisplayMode D3DADAPTER_DEFAULT, DispMode  'Get Current Mode
D3DWindow.Windowed = 1 ' Set to Windowed Mode
```

```
D3DWindow.SwapEffect = D3DSWAPEFFECT_COPY_VSYNC 'Refresh as Monitor Does
D3DWindow.BackBufferFormat = DispMode.Format 'Use Screen Format Just
    Received
Set D3DDevice = D3D.CreateDevice(D3DADAPTER_DEFAULT, D3DDEVTYPE_HAL,
    Form1.Hwnd, _

D3DCREATE_SOFTWARE_VERTEXPROCESSING, _
                                                  _ D3DWindow)
Initialize = True 'If success set to True
Exit Function
ErrHandler:
Initialize = False 'If failed, set to false
End Function
```

If the function works correctly, a value of True will be passed; otherwise, False will be sent. We are not going to worry about the exact error that would occur at this time; we are just trying to get a basic framework together. The most interesting line in the preceding procedure is the CreateDevice call. There are several parameters in this call, and with the complete SDK installed on your system, it might be a good idea to look this up in further detail. We will take a second to look at the basic meanings of the parameters.

The standard call:

```
object.CreateDevice(Adapter As Long, DeviceType As CONST_D3DDEVTYPE,
hFocusWindow As Long, BehaviorFlags As Long, PresentationParameters As
D3DPRESENT_PARAMETERS) As Direct3DDevice8
```

- **Adapter**: Primary or Secondary adapter. We set to default, as this always represents the primary adapter. This will allow us to switch between a primary and secondary video card if needed.
- **Device Type**: Use the Hardware Abstraction Layer (HAL), reference drivers, or software rendering. We will use D3DDEVTYPE_HAL in our examples.
- **hFocusWindow**: Value used by DirectX for tracking the form. Value comes from Form.hWnd.
- **BehaviorFlags**: Sets how Direct3D engine processes textures, vertices, and lighting. Best to worst settings are D3DCREATE_PUREDEVICE, D3DCREATE_HARDWARE_VERTEXPROCESSING, D3DCREATE_MIXED_VERTEXPROCESSING and D3DCREATE_SOFTWARE_VERTEXPROCESSING.
- **PresentationParameters**: Display mode to use. We passed the current mode, or you can enter Full-Screen mode.

You can see that with many parameters, this line could cause problems. First, many graphics cards don't offer the capabilities present, especially in the BehaviorFlags parameter. If your video card doesn't support what you send to it, it could cause a problem. Therefore, we have the procedure pass False so that we know to exit instead of continuing operation. Later, we will use a process called *enumeration* to determine the settings that are available with a video card to avoid these types of potential problems.

MAIN LOOP

The next step is to set up the main loop. However, we'll first set up a rendering loop for the program. For a DirectX-based game, a rendering loop will normally follow a series of steps:

1. **Update**: Updates changes to cameras, etc.
2. **Clear**: Clear last frame.
3. **Variables**: Update any variables.
4. **Rendering**: Render image.
5. **Draw**: Draw frame.

With this in mind, the next step will be to write some code to handle this. We will create a Render subprocedure to add to our framework:

```
Public Sub Render()
D3DDevice.Clear 0, ByVal 0, D3DCLEAR_TARGET, &HCCCCFF, 1#, 0
D3DDevice.BeginScene
    'Place rendering code here!
D3DDevice.EndScene
D3DDevice.Present ByVal 0, ByVal 0, 0, ByVal 0 'Update to Screen, ByVal
   sends 0 instead of nothing
End Sub
```

This is the basic framework, so notice that we did not add any rendering code or update any variables. Later in the chapter, we will begin rendering things to the screen, and at that time, we will work on adding the appropriate code.

The next step is to create a main loop for our program. This code should normally be very well written to keep your program running as fast as possible. It might call procedures, or directly handle everything from AI to music. VB provides the Form_Load procedure, so we will begin with this:

```
Private Sub Form_Load()
Me.Show ' Show form
bRunning = Initialise() 'Call initialize which returns True or Fals
Do While bRunning
    Render 'Call Render Procedure
    DoEvents
    ' IF…Then loop to calculate Frame Rate
    If GetTickCount - LastTimeCheckFPS >= 1000 Then
        LastTimeCheckFPS = GetTickCount
        FrameRate = FramesDrawn 'FrameCount
        FramesDrawn = 0 'Reset
        Me.Caption = "FPS: ", & FrameRate ' Display FPS in caption
    End If
    FramesDrawn = FramesDrawn + 1 ' Total number of frames
Loop ' Will loop until bRunning is set to false
On Error Resume Next
Set D3DDevice = Nothing
Set D3D = Nothing
Set Dx = Nothing
Unload Me
End
End Sub
```

That's all there is to the procedure which is basically one very large loop that continues until bRunning is set to False. The DoEvents command allows Windows to "catch up"; otherwise, almost all processes would stop as the loop was being executed. Once bRunning is False, we need to clean up DirectX by setting it to Nothing. The FPS is also calculated in this sequence.

Now is a good time to save the program and execute it. When executed, the program should look something like Figure 12.9. As you can see, it is simply a window that does nothing else.

FIGURE 12.9 *The program being executed.*

At this time, the program does not appear to do much. As it stands, this is true. However, it is forming a good basis for our future work.

FULL-SCREEN MODE

Our application is currently in Windowed mode. To change it, we simply substitute this code for the window code in our Initialization procedure we built earlier. The procedure should now read as follows:

```
Public Function Initialize() as Boolean
'Return true or false
On Error Goto ErrHandler:
Dim DispMode as D3DDISPLAYMODE ' Play Mode
Dim D3DWindow as D3DPRESENT_PARAMETERS  'Viewport
Set Dx = New DirectX8 'DirectX Object
Set D3D = Dx.Direct3DCreate() 'Create Direct3D Interface
'Begin New Code
DispMode.Format = D3DFMT_X8R8G8B8
DispMode.Width = 640
DispMode.Height = 480
D3DWindow.SwapEffect = D3DSWAPEFFECT_FLIP
D3DWindow.BackBufferCount = 1 'Set 1 backbuffer
D3DWindow.BackBufferFormat = DispMode.Format
D3DWindow.BackBufferHeight = 480
D3DWindow.BackBufferWidth = 640
D3DWindow.hDeviceWindow = Form1.hWnd
'End New Code
```

```
Set D3DDevice = D3D.CreateDevice(D3DADAPTER_DEFAULT, D3DDEVTYPE_HAL,
Form1.Hwnd, _

D3DCREATE_SOFTWARE_VERTEXPROCESSING, _
                                                _ D3DWindow)
Initialize = True ' If success set to True
Exit Function
ErrHandler:
Initialize = False ' If failed, set to false
End Function
```

The first new line is DispMode.Format=D3DFMT_X8R8G8B8. This sets the color format to 32-bit color, with 8 bits reserved for each color. The following list details other options you could use:

- **A1R5G5B5**: 16-bit, 5 bits reserved for each color, 1 bit reserved for alpha.
- **A8R8G8B8**: 32-bit ARGB pixel format with alpha.
- **R9G8B8**: 24-bit RGB pixel format.
- **X1R5G5B5**: 16-bit pixel format, with 5 bits reserved for each color.
- **X8R8G8B8**: 32-bit RGB pixel format, with 8 bits reserved for each color.

You might be wondering what all of this means. Simply stated, when you want to store graphics information in memory, they need to be stored in a particular format. These formats are categorized by the amount of memory that is used to store them. There are 8 bits in a single byte, so if you have 32-bit color, it would require 4 bytes of memory for each pixel you store. In a perfect world, you would always use the highest available option, as the quality would be much better. Unfortunately, although the quality is dramatically improved, you will need a machine capable of displaying this information. Along with the format, we also set the resolution to 640 x 480 in the example. When you are dealing with a PC, you never fully know what will be present on an end user's machine. Therefore, we must have another option to determine this at runtime. We will look at a process called *enumeration* later in the chapter.

If you were to run the program at this time, you would not have a way to exit it. Therefore, we'll add a simple procedure that will exit the program if you click on it. Add the following procedure to the project:

```
Private Sub Form_Click()
    bRunning = False
End Sub
```

Now, if you were to run the program, you would be presented with something like Figure 12.10.

FIGURE 12.10 *A completely blank screen.*

While this is not very impressive, it is a necessary step toward where we ultimately want to get. In the next section, we will look at enumerating a display device, adapter, and resolution.

DISPLAY DEVICE, ADAPTER, AND RESOLUTION ENUMERATION

As shown in the previous example, when you are using DirectX, you must set specifics related to the graphics. Hard coding this data works on a single PC because you can easily determine its specific hardware. However, with the wide assortment of hardware that exists in the Windows world, it would be impossible to come up with a configuration that would ideally work with all available hardware. Additionally, this would not give end users any options to customize the program settings so that it would perform better on their machines. To get around this problem, we need to use a process called *enumeration*, which allows you to ask questions of the hardware, which in turn, responds with answers about its capabilities.

There are several pieces of information that we can get through enumeration, including the Display mode and hardware capabilities. At this time, we'll leave this to discussion only. Later, when we build our 3D game, we will use enumeration to choose a video resolution. For now, our examples will all use a hard-coded resolution of 640 x 480.

CHAPTER REVIEW

This chapter introduced you to DirectX and how to use it within VB. We began by installing the DirectX SDK, and moved forward to adding it to a VB project. Next, we created a basic framework for doing both a windowed and a full-screen DirectX application. In the next section, we'll expand on the example by adding some basic 2D graphics to it.

CHAPTER 13
Introduction to DirectX Graphics and VB

In the previous chapter, we created a basic framework for a DirectX application. This program didn't really do much, and in this chapter, we'll add some basic 2D graphics to it.

If you used previous versions of DirectX, you are probably well versed with DirectDraw, the 2D component of the earlier versions. In DirectX 8, we are forced to do everything in 3D, as DirectDraw has been removed. There have been many rumors that DirectX 9 might bring DirectDraw back into play. However, until that time, assume that we need to use basic 3D graphics for 2D graphics.

Although it is still possible to use DirectX 7, we'll stick to the original plan and use DirectX 8 for our 2D graphics. There are several reasons for this. First, it usually isn't a good idea to learn a previous technology unless you know that it will build some type of foundation for future learning. Second, if you plan to do a 3D game with DirectX 8, you will undoubtedly need to display some basic 2D graphics for items such as health meters. Therefore, even if you don't plan to do a 2D game, you'll still need to display basic 2D graphics.

BASIC 2D/3D THEORY

We begin this chapter by looking at some basic theory for 3D graphics, beginning with *vertices*. Vertices are basically a set of points that define an object. For example, if you want to define a triangular shape, it would have three vertices. Once you define each vertex, you could use Direct3D to draw a line between them, and during the process, create a triangular shape out of the three vertices. The individual vertices can also have properties such as colors, specular values for reflections, and even texture coordinates.

If you create this type of shape, you can apply a texture to it much as we did with the MilkShape model. A texture is basically a 2D bitmap image that is placed onto the polygon. The textures in DirectX need to be a power of 2; that is 2, 4, 8…64,128, and usually ending at 256. Once you apply a texture, you can display the polygon on the screen and move it around.

We only need to touch on a couple more topics before we begin developing a 2D sample with DirectX. These ideas are *transformation* and *lighting* (T&L). Vertices said to be transformed are already in 2D window coordinates. Simply put, this means that when you are in the upper left-hand corner, you are at point (0,0). Moving to the right, you are moving in the positive X direction. Otherwise, if you are moving down, you will be moving positive in the Y direction. The lighting part of this equation means that vertices are supplying their own color and are not using Direct3D lighting. Although these topics are very involved, it's only important to have a basic understanding of them at this time.

Writing Some Code

With some of the basic information out of the way, we'll move forward to build a DirectX application that displays a 2D triangle. We'll use the basic framework we created in the previous chapter to develop it and, by adding a few things, we can display the triangle shown in Figure 13.1.

FIGURE 13.1 *The triangle we are planning to display.*

We'll begin this project by opening the framework from the previous chapter in VB. The application will be developed as a windowed application, so make sure to use the correct code, as we created both a windowed and full-screen program. Once you have it open, we'll create a User Defined Typed (UDT) and constant to the project.

Before we look directly at the declarations, it's important to understand the concept of a *vertex buffer*, a Direct3D object used to store and render vertices. Vertices can be defined many different ways by specifying a custom vertex structure and corresponding custom flexible vector format (FVF). The FVF is used to describe the contents of vertices stored in a single data stream; in our case, a triangle.

```
Private Type CUSTOMVERTEX
    X As Single            'x in screen space
    y As Single            'y in screen space
    z As Single            'normalized z
    rhw As Single          'normalized z rhw
    color As Long          'vertex color
End Type
Const D3DFVF_CUSTOMVERTEX = (D3DFVF_XYZRHW Or D3DFVF_DIFFUSE)
```

FVF is used when you send data to a rendering device, as it needs to know the format that data is in. In the preceding example, the UDT specifies the format of the custom vertex type. The next step defines the FVF that describes the contents of the vertices in the vertex buffer. The constant defines an FVF that corresponds with the custom vertex type also created.

The following flags defined by the CONST_D3DFVFFLAGS enumeration describe a vertex format.

Flexible vertex format (FVF) flags:

- **D3DFVF_DIFFUSE** Vertex format includes a diffuse color component.
- **D3DFVF_NORMAL** Vertex format includes a vertex normal vector. This flag cannot be used with the D3DFVF_XYZRHW flag.
- **D3DFVF_PSIZE** Vertex format specified in point size. This size is expressed in camera space units for vertices that are not transformed and lit, and in device-space units for transformed and lit vertices.
- **D3DFVF_SPECULAR** Vertex format includes a specular color component.
- **D3DFVF_VERTEX** Same as specifying (D3DFVF_XYZ or D3DFVF_NORMAL or D3DFVF_TEX1).
- **D3DFVF_XYZ** Vertex format includes the position of an untransformed vertex. This flag cannot be used with the D3DFVF_XYZRHW flag.
- **D3DFVF_XYZRHW** Vertex format includes the position of a transformed vertex. This flag cannot be used with the D3DFVF_XYZ or D3DFVF_NORMAL flags.
- **D3DFVF_XYZB1 through D3DFVF_XYZB5** Vertex format contains position data, and a corresponding number of weighting (beta) values to use for multimatrix vertex blending operations. Currently, Microsoft Direct3D can blend with up to three weighting values and four blending matrices.

Texture-related FVF flags:

- **D3DFVF_TEX0** through **D3DFVF_TEX8** Number of texture coordinate sets for this vertex. The actual values for these flags are not sequential.

Chapter 13 Introduction to DirectX Graphics and VB

Mask values:

- **D3DFVF_POSITION_MASK** Mask for position bits.
- **D3DFVF_RESERVED0** and **D3DFVF_RESERVED2** Mask values for reserved bits in the flexible vertex format. Do not use.
- **D3DFVF_TEXCOUNT_MASK** Mask value for texture flag bits.

Miscellaneous:

- **D3DFVF_TEXCOUNT_SHIFT** The number of bits by which to shift an integer value that identifies the number of a texture coordinates for a vertex.

Form_Load

In the previous framework, we created a form_load procedure that handles most of the functions associated with our program. We'll use this procedure for the initialization of the new vertex buffers we've been discussing. The following code listing has all necessary changes made to it:

```
Private Sub Form_Load()
    Me.Show

    DoEvents
    bRunning = Initialize()
    bRunning = InitializeVertexBuffer()

    Do While bRunning
        Render
        DoEvents
        If GetTickCount - LastTimeCheckFPS >= 1000 Then
            LastTimeCheckFPS = GetTickCount
            FrameRate = FramesDrawn
            FramesDrawn = 0
            Me.Caption = "FPS: " & FrameRate
        End If
        FramesDrawn = FramesDrawn + 1

    Loop

On Error Resume Next
Set D3DDevice = Nothing
Set D3D = Nothing
Set DX = Nothing
Unload Me
End
End Sub
```

If you were to compare this listing to the one from the previous example, you would see that the only change is the addition of InitializeVertexBuffer, a function that we'll create in the next step.

To begin, we need to create the Function by adding the following lines to the Code window:

```
Function InitializeVertexBuffer() As Boolean
End Function
```

Next, we'll add some code to the function to initialize the vertices by calling the application-defined function. The following code, which can be placed between the previous lines, is the entire code needed to accomplish this:

```
Dim Vertices(3) As CUSTOMVERTEX
Dim VertexSizeInBytes As Long

VertexSizeInBytes = Len(Vertices(0))

With Vertices(0)
    .X = 50
    .y = 50
    .z = 0
    .rhw = 1
    .color = &HFF00FF00
End With

With Vertices(1)
    .X = 250
    .y = 50
    .z = 0:  .rhw = 1
    .color = &HFF00FFFF
End With

With Vertices(2)
    .X = 150
    .y = 250
    .z = 0
    .rhw = 1
    .color = &HFFFF0000
End With

Set VB = D3DDevice.CreateVertexBuffer(VertexSizeInBytes * 3, _
            0, D3DFVF_CUSTOMVERTEX, D3DPOOL_DEFAULT)
```

```
    If VB Is Nothing Then Exit Function
    D3DVertexBuffer8SetData VB, 0, VertexSizeInBytes * 3, 0,
Vertices(0)
    InitializeVertexBuffer = True
```

The With statements in the preceding code fill three vertices with the points of a triangle and specify the color each vertex will emit. The first point is at (50, 50) and emits the color green (&HFF00FF00). The second point is at (250, 50) and emits the color blue-green (&HFF00FFFF), and the third point is at (150, 250) and emits the color green. (&HFFFF0000). Each of these points has a pixel depth of 0.0 and an RHW of 1.

The next step calls Direct3DDevice8.CreateVertexBuffer and to exit the function. The lines are as follows:

```
Set VB = D3DDevice.CreateVertexBuffer(VertexSizeInBytes * 3, _
            0, D3DFVF_CUSTOMVERTEX, D3DPOOL_DEFAULT)

If VB Is Nothing Then Exit Function
```

The first two parameters for CreateVertexBuffer tell Direct3D the size and intended use for the new vertex buffer. The next two parameters specify the vector format and memory location for the new buffer. The vector format here is D3DFVF_CUSTOMVERTEX, which is the FVF that we specified earlier. The D3DPOOL_DEFAULT flag tells Direct3D to create the vertex buffer in the memory that is most appropriate for this buffer. The final parameter is the address of the vertex buffer to create.

Once you create a vertex buffer, it is filled with data from the custom vertices by calling the D3DVertexBuffer8SetData method. It is accomplished in the function with the following line:

```
D3DVertexBuffer8SetData VB, 0, VertexSizeInBytes * 3, 0, Vertices(0)
```

The first parameter of the line accepts the vertex buffer in which to place the data. The second parameter is the offset from the start of the buffer where data is set. It is given in bytes. The third parameter is the size of the buffer, in bytes. The fourth is a combination of flags that describe how to lock the buffer; in our example, it uses the default (0). The last parameter is the buffer that contains the data to place in the vertex buffer.

Now, we turn our attention back to Form_Load to Render the scene.

In the Render subprocedure, add the following declarations:

```
Dim v As CUSTOMVERTEX
Dim sizeOfVertex As Long
```

Also add the following lines of code between the D3DDevice.BeginScene and D3DDevice.EndScene:

```
sizeOfVertex = Len(v)
D3DDevice.SetStreamSource 0, VB, sizeOfVertex
D3DDevice.SetVertexShader D3DFVF_CUSTOMVERTEX
D3DDevice.DrawPrimitive D3DPT_TRIANGLELIST, 0, 1
```

Once the vertex buffer is filled with vertices, we move forward to render the display, which starts by clearing the back buffer and then calling BeginScene.

```
D3DDevice.Clear 0, ByVal 0, D3DCLEAR_TARGET, &HFF&, 1#, 0

D3DDevice.BeginScene
```

Next, we render the vertex data in a series of steps. We begin by setting the stream source that is specified by calling Direct3DDevice8.SetStreamSource. The first parameter tells the source of the data stream, and the second parameter is the vertex buffer to bind to the data stream. The last parameter is the component size measured in bytes.

Next, we instruct Direct3D to use a specific vertex shader by calling Direct3DDevice8.SetVertexShader. This can be a very complicated subject, but at this time, it's enough to understand that in many cases, the vertex shader is simply the FVF. The following line sets the vertex shader:

```
D3DDevice.SetVertexShader D3DFVF_CUSTOMVERTEX
```

You'll notice from the preceding line that there is only a single parameter for SetVertexShader, a handle to the vertex shader to use. The value for this parameter can be a handle returned by Direct3DDevice8.CreateVertexShader, or an FVF code. In our example, the FVF code defined by D3DFVF_CUSTOMVERTEX is used.

The next step is to use Direct3DDevice8.DrawPrimitive to render the vertices. DrawPrimitives has several parameters, the first of which is a flag that instructs Direct3D on the type of primitives to draw; in our case, D3DPT_TRIANGLELIST is used to specify a triangle. The second parameter is the index of the first vertex we plan to load, while the third tells the number of primitives we'll draw. Thus, a value of 1 is used in our program. Here is the code for this line:

```
D3DDevice.DrawPrimitive D3DPT_TRIANGLELIST, 0, 1
```

The last steps end the scene and then present the back buffer to the front buffer. After the back buffer is presented to the front buffer, the Client window

shows a triangle with three different colored points. These are the final two lines:

```
D3DDevice.EndScene
D3DDevice.Present ByVal 0, ByVal 0, 0, ByVal 0
```

If you were to run the program, you should now see a triangle similar to Figure 13.2.

FIGURE 13.2 *The complete program.*

EXPANDING THE PROGRAM USING THE WORLD TRANSFORMATION MATRIX

At this time, the program displays a triangle in 2D. In this part of the chapter, we'll expand the program to rotate the 2D triangle in a 3D space by using the World Transformation Matrix, which defines how to translate, scale, and rotate geometry in 3D space.

We begin by adding a few new declarations to our program:

```
Dim DX As New DirectX8
Dim D3D As Direct3D8
Dim D3DDevice As Direct3DDevice8
Dim VB As Direct3DVertexBuffer8
Dim bRunning As Boolean
```

```
Private Declare Function GetTickCount Lib "kernel32" () As Long
Dim LastTimeCheckFPS As Long
Dim FramesDrawn As Long
Dim FrameRate As Long
Private Type CUSTOMVERTEX
    x As Single         'x in screen space
    y As Single         'y in screen space
    z  As Single        'normalized z
    color As Long       'vertex color
End Type
Const D3DFVF_CUSTOMVERTEX = (D3DFVF_XYZ Or D3DFVF_DIFFUSE)
Const pi = 3.1415
```

You are probably familiar with many of the declarations on this list. We have added only a single Constant (CONST pi) and modified the CUSTOMVERTEX UDT.

We are going to take the currently displayed triangle and rotate it around the Y-axis by calling the D3DXMatrixRotationY method. We'll call this method from within a SetupMatrices subprocedure, which will be called from the Render subprocedure. Notice the SetupMatrices call in the following code, which is for the new Render subprocedure:

```
Sub SetupMatrices()
    Dim matWorld As D3DMATRIX
    Dim matView As D3DMATRIX
    Dim matProj As D3DMATRIX

    D3DXMatrixRotationY matWorld, Timer * 4

    D3DDevice.SetTransform D3DTS_WORLD, matWorld
    D3DXMatrixLookAtLH matView, vec3(0#, 3#, -5#), _
                                vec3(0#, 0#, 0#), _
                                vec3(0#, 1#, 0#)

    D3DDevice.SetTransform D3DTS_VIEW, matView
    D3DXMatrixPerspectiveFovLH matProj, pi / 4, 1, 1, 1000
    D3DDevice.SetTransform D3DTS_PROJECTION, matProj
End Sub
```

There are several new items in the preceding code. We begin with several variables. Next, we rotate the triangle around the Y-axis by calling the D3DX-MatrixRotationY method.

The next step is to call Direct3DDevice8.SetTransform. This sets the current world transformation for the Direct3D device, after which, we turn our attention to the view transformation matrix.

We begin by defining the view matrix by calling D3DXMatrixLookAtLH. The first parameter is a D3DMATRIX type that contains the returned matrix. However, the second, third, and fourth parameters define the eye point, look-at point, and "up" direction. Here, the eye is set back along the Z-axis by five units and up three units, the look-at point is set at the origin, and "up" is defined as the y-direction.

Next, we call Direct3DDevice8.SetTransform to set the current view transformation for the Direct3D device. We then move to call D3DXMatrixPerspectiveFovLH to set up the projection matrix. Direct3DDevice8.SetTransform is the next step, which sets the current projection transformation for the Direct3D device.

That's the vast majority of the changes to the program. There are a few additional items that have been altered, and can be found in the source code on the CD-ROM. You should look at the sample on the CD and alter your code to look the same. At this time, you will find that the sample, when executed, will display a rotating triangle similar to Figure 13.3.

FIGURE 13.3 *The final program with rotating triangle.*

CHAPTER REVIEW

In this chapter, we developed two samples. The first displayed a stationary triangle using DirectX in Windowed mode. The second program expanded the first by rotating the 2D triangle in 3D space.

CHAPTER 14
A DirectX Model Viewer

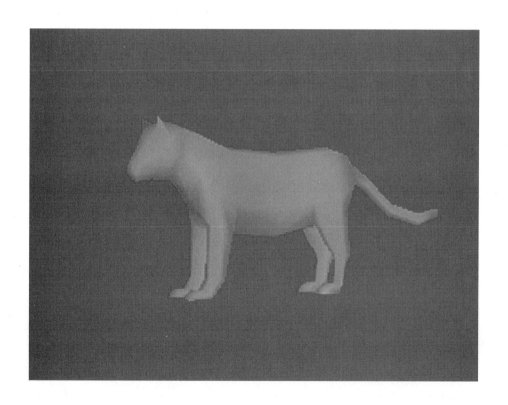

This chapter introduces you to the Retained mode of Direct3D, and builds an application that will display a DirectX binary model (.x extension) and rotate around the X-axis. Retained mode offers a simplified introduction to VB, and has been removed from DirectX 8, so we will not use it in later samples. However, because it is much easier to understand than Immediate mode, we'll use it as a introduction before moving on to the TrueVision 3D DirectX engine.

What Is Direct3D?

Direct3D is a single aspect of DirectX, which in turn is a collection of high-performance APIs written by Microsoft to produce sound, graphics animation, and multimedia. Direct3D is the three-dimensional graphics part of DirectX.

Advantages of Direct3D

While there are many advantages to Direct3D, it's important to understand the most basic. First, Direct3D provides transparent access to different hardware devices without the need to understand the intricacies of the different chipsets. As a result, applications become independent of the hardware and allow the developer to immediately know that all the drivers supporting Direct3D will support a certain set of instructions and capabilities. Applications developed using such features will work on all hardware platforms.

Direct3D also provides a standard programming interface for 3D applications, which results in applications that can be developed much easier and faster. Finally, Direct3D provides some basic protection if a hardware platform does not support a certain feature, by substituting a software equivalent implementation of the intended feature. Thus, the application can simply detect the hardware capabilities and use them; otherwise, it can render in Software mode. Obviously, software substitutions do make applications run more slowly, but that's better than not running at all.

The SDK

Before we begin the tutorial, it's important to realize the vast amount of information available to you in the DirectX SDK. The following lists some specific areas that you should visit to become more familiar with DirectX and Direct3D. The following list assumes you have installed the software to drive C using the default mssdk installation path. If you installed the SDK to another directory or hard drive, you will need to change the drive letter and root directory.

CHAPTER 14 A DIRECTX MODEL VIEWER

- **C:\mssdk\DXReadme.txt** A file that is particularly useful for navigating the rest of the CD.
- **C:\mssdk\doc\DirectX8\directX_vb.chm** This is a compiled help file containing information about DirectX 8, the most important entry on the entire CD-ROM.
- **C:\mssdk\samples\Multimedia\VBSamples** This directory contains Visual Basic samples using all the DirectX components.

DIRECT3D COORDINATE SYSTEM

There are several ways you might arrange the X, Y, and Z coordinate axes in a given three-dimensional space. Direct3D uses a system like the one that appears in Figure 14.1, where the X- and Y-axes are parallel to the computer monitor, and the Z-axis is going into the screen.

FIGURE 14.1 *The coordinate system used by Direct3D.*

With Figure 14.1 as a reference, if you imagine your position when sitting at your computer desk, relative to the point X0, Y0, Z0 in a Direct3D space, you would be at some point in space with a positive Z coordinate.

DIRECT3D MODES

DirectX 8 provides a single mode, called Immediate mode, to programmers. This mode is a high-level interface to Direct3D that can be cumbersome and confusing to a beginner. Previous versions of DirectX offered the option of using Retained mode, which was a low-level implementation. It was much easier to access and understand, especially for someone new to 3D programming. Taking this into consideration, the sample being developed in this chapter will use Retained mode, which can still be accessed by taking advantage of the backward compatibility of DirectX. As a result, we'll be using Direct3D version 7.

If you don't have any experience with Direct3D, Retained mode is definitely the easiest place to start. A great deal of the more difficult concepts are hidden from you and what's left is a much easier to use Direct3D implementation. What you learn in Retained mode can also act as a stepping stone for future work.

A trade-off that occurs with the use of Retained mode. Application frame rates will be much lower with Retained mode. This will cause a problem if you are developing a large project, but if you are after quick and easy development, Retained mode is the way to go.

The final disadvantage of Retained mode is that Microsoft has discontinued it. It remains to be seen if Microsoft will continue supporting it in future editions, although there are some persistent rumors that it will be making its way back into DirectX 9 or 10. Because the future of Retained mode is unsure, learn Retained mode and then move on to Immediate mode.

3D VOCABULARY

For our sample, you must understand some basic 3D vocabulary. The following are very simple explanations of some of the basics.

- **Camera** To do something in 3D space, you have to have a way to represent where you are. This is the sole responsibility of the camera.
- **Rotation** Rotating an object in a 3D world works very similar to a tire rotating on a car axle. Simply stated, rotation is the movement of an object around a coordinate that is referenced to the entire screen but *not* on the local object.
- **Scenes** Scenes are comprised of the many objects that you want to display, including lights, 3D objects, and backgrounds.
- **Render modes** To display the 3D information, you must render it in 2D. There are three main render modes: Wireframe, Solid, and Gourad. Wireframe displays only a set of lines and is the simplest. Solid rendering fills

the spaces between the lines with color, and Gouraud adds shading to enhance the appearance of objects.
- **Lights** A light simply does what you would expect. If you do not place a light in a scene, you will see nothing.

PROJECT FRAMEWORK

The following sections describe the different aspects in the program:

- **Declarations** Declare all variables and DirectX.
- **Form_Load** Calls all other routines to initialize DirectX.
- **InitializeDirectX** Initializes DirectDraw and Direct3D.
- **InitializeScene** Initialize cameras, objects, etc.
- **RenderLoop** Repeatedly draw objects.
- **Form_Click** End the applications.

DECLARATIONS

You need several declarations for this application. To begin, create a new project in Visual Basic and enter the following declarations.

```
Dim DX As New DirectX7
Dim DD As DirectDraw4
Dim RM As Direct3DRM3
```

The first line is particularly important, as it is from the DirectX object that you set up Direct3D and DirectDraw. Notice that New is used after DX, which simply tells Visual Basic that you want to put aside memory to use for the DirectX object you are creating. In order to use DirectX, add the DirectX 7 and DirectX 8 Type Libraries as we did in the earlier samples.

The next step is to add DirectDraw declarations, which sets the surfaces that you draw to and see. The following four entries can be added:

```
Dim PrimarySurface As DirectDrawSurface4
Dim BackSurface As DirectDrawSurface4
Dim DDPrimarySurfDescript As DDSURFACEDESC2
Dim DDCapsBack As DDSCAPS2
```

After the DirectDraw declarations, you need to add the Direct3D Retained mode declarations. The following declarations set the devices, viewport, frames, lights, and shadows; basically, they set up the entire Direct3D scene. Enter these after the DirectDraw entries:

```
Dim rmDevice As Direct3DRMDevice3
Dim rmViewport As Direct3DRMViewport2
Dim rootFrame As Direct3DRMFrame3
Dim lightFrame As Direct3DRMFrame3
Dim cameraFrame As Direct3DRMFrame3
Dim objectFrame As Direct3DRMFrame3
Dim light As Direct3DRMLight
Dim shadow_light As Direct3DRMLight
Dim shadow As Direct3DRMShadow2
Dim meshBuilder As Direct3DRMMeshBuilder3
```

Four of the final five variables are used to track the number of frames that are being displayed, while the last one, blnIsRunning, is used to stop the main rendering loop once program execution is halted. Add these final variables to the declaration section after your last entry:

```
Dim LastTimeCheckFPS As Long
Dim FramesDrawn As Integer
Dim strFramesText As String
Dim FrameRate As Long
Dim bRunning as Boolean
```

Form_Load Event

When the form loads, it calls the other routines, which in turn do the work. The following code can be entered in the Code window:

```
Private Sub Form_Load()
    Initialize
    InitializeGeometry
    Me.Show
    Render
End Sub
```

InitializeDirectX and InitializeScene prepare DirectDraw and Direct3D Retained mode for execution. We'll take a closer look at the actual procedure later in the chapter. It then displays the form and makes its final call to RenderLoop, which is the main program loop for displaying the .X file.

INITIALIZE DIRECTDRAW AND DIRECT3D

The Initialize procedure can be fairly long and complicated if this is your first exposure to 3D. You need to begin the procedure by initializing DirectDraw and getting it ready for full-screen display. You can also set up the DirectDraw surfaces.

CHAPTER 14 A DIRECTX MODEL VIEWER

Add the following code to accomplish this:

```
Sub InitializeDirectX()
    Set DD = DX.DirectDraw4Create("")

    DD.SetCooperativeLevel Form1.hWnd,DDSCL_FULLSCREEN_
    Or DDSCL_EXCLUSIVE

    DD.SetDisplayMode 640, 480, 16, 0, DDSDM_DEFAULT
    DDPrimarySurfDescript.lFlags = DDSD_CAPS Or _
    DDSD_BACKBUFFERCOUNT

    DDPrimarySurfDescript.ddsCaps.lCaps = _
    DDSCAPS_PRIMARYSURFACE Or DDSCAPS_3DDEVICE Or _
    DDSCAPS_COMPLEX Or DDSCAPS_FLIP

    DDPrimarySurfDescript.lBackBufferCount = 1

    Set PrimarySurface = _
    DD.CreateSurface(DDPrimarySurfDescript)

    DDCapsBack.lCaps = DDSCAPS_BACKBUFFER
    Set BackSurface = _
    PrimarySurface.GetAttachedSurface(DDCapsBack)
```

Once you have initialized DirectDraw, you need to do the same with Direct3D. You also need to determine if you are using a Direct3D hardware card; if not, you should use the software renderer. This is actually very easy using an IF...Then statement and checking the rmDevice result variable. Finally, you need to set the quality of the render.

Place the following code in the same procedure:

```
Set RM = DX.Direct3DRMCreate()
BackSurface.SetForeColor RGB(255, 0, 0)
Set rmDevice = _
RM.CreateDeviceFromSurface _
("IID_IDirect3DHALDevice", DD, BackSurface, _
D3DRMDEVICE_DEFAULT)
If rmDevice Is Nothing Then
    Set rmDevice = _
    RM.CreateDeviceFromSurface _
    ("IID_IDirect3DRGBDevice", DD, BackSurface,_
    D3DRMDEVICE_DEFAULT)
End If
```

```
If rmDevice Is Nothing Then
        MsgBox "Could not create a Direct3D device"
End If
rmDevice.SetQuality D3DRMLIGHT_ON Or _
D3DRMRENDER_GOURAUD
rmDevice.SetTextureQuality D3DRMTEXTURE_NEAREST
rmDevice.SetRenderMode D3DRMRENDERMODE_BLENDEDTRANSPARENCY
End Sub
```

CREATING THE SCENE

With DirectDraw and Direct3D ready to function, you need to create something to display. The InitializeScene, which if you remember is called after InitializeDirectX in the Form_Load event, is where you create the camera, set the frames, and create the viewport. The camera is being set at X0, Y0, Z–10 so that is centered horizontally and vertically, and the Z-axis is moved toward you.

The following code completes the tasks:

```
Sub InitializeGeometry()
    Set rootFrame = RM.CreateFrame(Nothing)
    Set cameraFrame = RM.CreateFrame(rootFrame)
    Set lightFrame = RM.CreateFrame(rootFrame)
    Set objectFrame = RM.CreateFrame(rootFrame)
    rootFrame.SetSceneBackgroundRGB 0, 0, 255
    cameraFrame.SetPosition Nothing, 0, 0, -10
```

Once the viewport has been created, you need to set it to 640 x 480 resolution. You can also set the position of the light at X5, Y5, Z–25 so that you will see some shadowing. The .x file needs to show up against the blue background, so you can set the light to green.

Here is the code:

```
Set rmViewport = RM.CreateViewport(rmDevice, cameraFrame,_
0, 0, 640, 480)
lightFrame.SetPosition Nothing, 5, 5, -25
Set shadow_light = RM.CreateLightRGB(D3DRMLIGHT_POINT, _
0.5, 0.5, 0.5)
lightFrame.AddLight shadow_light

Set light = RM.CreateLightRGB(D3DRMLIGHT_AMBIENT, 0, 0.5, 0)
rootFrame.AddLight light
```

Next, you need to open the .X file. In this example, you can use the Tiger.X file located in the DirectX SDK. The sub directory has been hard coded into the application. For instance, the tiger.x file is located at c:\mssdk\samples\multimedia\media\ if you installed the SDK with default settings. You would then replace app.path with the directory. Finally, you can set the position of the file at X0,Y0, Z0 so that it is in the center of the scene, and then begin the rotation.

This code finishes the subprocedure:

```
    Set meshBuilder = RM.CreateMeshBuilder()
    meshBuilder.LoadFromFile " c:\mssdk\samples\multimedia\media\
Tiger.x",_
    0, 0, Nothing, Nothing
    objectFrame.AddVisual meshBuilder
    objectFrame.SetPosition Nothing, 0, 0, 0
    objectFrame.SetRotation Nothing, 0, 1, 0, 0.25
End Sub
```

THE MAIN LOOP

The Render subprocedure is called next. This loop is responsible for continuing to display the contents of the scene until the user decides to end the application.

To begin, you need to set the variable blnIsRunning to True as a way to determine if the loop should continue. Once it is set to False, you should end the program. You need to render the scene and display some basic information to the users about what is happening, how they can exit the program, and how fast the display is being updated.

```
Sub Render()
    On Local Error Resume Next

    bRunning = True
    FrameRate = DX.TickCount()
    Do While bRunning = True
        DoEvents

        rootFrame.Move 0.05

        rmViewport.Clear D3DRMCLEAR_TARGET Or D3DRMCLEAR_ZBUFFER

        rmDevice.Update

        rmViewport.Render rootFrame
```

```
            Call BackSurface.DrawText(5, 5, "# Vertex in Object: " & _
CStr(meshBuilder.GetVertexCount), False)
            Call BackSurface.DrawText(5, 25, "FPS: " & strFramesText, _
False)
            Call BackSurface.DrawText(100, 450, "Visual Basic Direct3D _
Retained Mode – Click the Screen to Exit", False)
            PrimarySurface.Flip Nothing, DDFLIP_WAIT

            FramesDrawn = FramesDrawn + 1

            If DX.TickCount >= LastTimeCheckFPS + 1000 Then
                LastTimeCheckFPS = DX.TickCount
                strFramesText = CStr(FramesDrawn)
                FramesDrawn = 0
            End If

    Loop
End Sub
```

CLOSING THE APPLICATION

The program will function at this point, but you should not run it. If you were to do so, you would be stuck in an endless loop without a way to escape. You need to provide a simple way for the user to end the application. With the following procedure, you can use the Form_Click event to set the blnIsRunning variable to False, restore the display to the previous settings, and end the application.

You can add this procedure to the application to finish it:

```
Private Sub Form_Click()
    bRunning = False
    Call DD.RestoreDisplayMode
    Call DD.SetCooperativeLevel(Me.hWnd, DDSCL_NORMAL)
    End
End Sub
```

When you run the application, you should see something similar to Figure 14.2.

Chapter 14 A DirectX Model Viewer

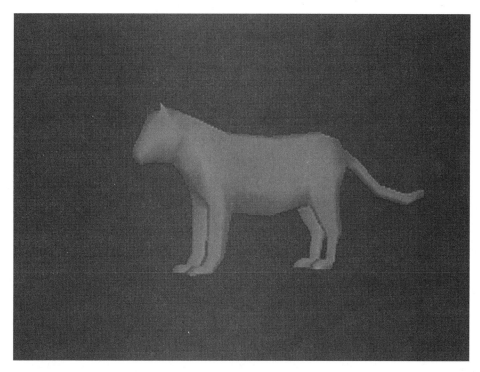

FIGURE 14.2 *The running application.*

Chapter Review

In this chapter, you learned a great deal about DirectX, and specifically Direct-Draw and Direct3D. If you plan to use Direct3D in a large application or game, you will definitely want to take the time to learn the Immediate mode functionality. The help files included in the DirectX SDK are invaluable as a learning reference. It's the only mode that Microsoft is directly supporting in version 8 and, in all probability, the lack of support for Retained mode will continue in later versions. That being said, Retained mode is a great way to learn the basics of Direct3D, and provides a quick and relatively painless solution when used in a small application.

You could easily modify this application to create a program that would display any DirectX model.

CHAPTER 15
BSP and SkyBox Designs

In this chapter, we'll look at the options available to us for creating levels for our games. For indoor levels, we'll look at the creation of Binary Space Partitions (BSPs). For outdoor levels, we'll create terrains based on a heightmap image. Later chapters in the book focus on an outdoor level, so most of this chapter will look at the way such a level can be created. However, we'll begin by looking at the basics of BSPs, and in Chapter 17, "Rendering BSP Levels," we'll create a fully functional program for rendering BSPs.

BSP

BSPs can be simply defined as a technique for organizing the 3D space represented in computer memory. It organizes the space by subdividing it. Once a space is organized using this technique, it is possible to gain dramatic rendering speed. Several commercial engines, most notably the original Quake engine, use a modification of this technique to attain their performance. BSPs are excellent options for indoor levels. Figure 15.1 shows a sample of a BSP level being rendered.

FIGURE 15.1 *A BSP being rendered.*

Chapter 15 BSP and SkyBox Designs

Besides their speed, BSP files can be an advantage because there is a tremendous amount of research material already available on the subject. Additionally, if you choose to use a known format such as the Half-Life format, you can use one of the many free editors that are available for creating these types of levels. The editors themselves are fantastic resources, but there are also countless Web sites that detail their usage with tutorials and ideas, not to mention prefabricated levels and objects that you can use.

The following list gives you the names and URLs of where you obtain more information about several of the BSP editors:

- **Worldcraft** http://halflife.gamedesign.net/resources/wc33_info.shtml
- **Quark** http://dynamic.gamespy.com/~quark/download.php3
- **QERadiant** www.qeradiant.com
- **Qoole** www.qoole.com

The editors all work in basically the same manner. The screens are usually presented similarly to MilkShape 3D with four viewports. Worldcraft is probably the most popular of the editors and is shown in Figure 15.2.

Figure 15.2 *Worldcraft looks similar to MilkShape 3D.*

OUTDOOR LEVELS

Creating outdoor levels might be a little more interesting. The typical fashion is to have your 3D engine calculate a terrain from a heightmap, a grayscale image with varying shades of gray that represent the heights that will be created by the engine. We'll be using this approach later in the book, so we'll actually create a heightmap using PaintShop Pro.

CREATING A HEIGHTMAP

To create a heightmap in PaintShop Pro, we will begin by creating a 256 x 256 image in PaintShop Pro. You can choose the size of the image by selecting File | New, and choosing the appropriate values from the New Image window as shown in Figure 15.3.

FIGURE 15.3 *The first step in creating the heightmap.*

Chapter 15 BSP and SkyBox Designs

The next step is to select Plastic from the Pattern Window (see Figure 15.4).

FIGURE 15.4 *Plastic should be selected as a pattern.*

Paint the entire image with the pattern. Next, use the Freehand tool to select an area in the image, and then choose Colors | Negative Image. Your image will look similar to Figure 15.5.

FIGURE 15.5 *The image should look something like this.*

Next, choose the Retouch tool and then choose the Smudge effect from its options. The Retouch Tools option menu is shown in Figure 15.6.

The heightmap is basically completed at this time. You can lighten or darken areas as you see fit. It's definitely not an exact science, and as a result, you might find yourself doing this in a trial-and-error fashion.

FIGURE 15.6 *The Retouch Tool menu.*

Chapter Review

This was a relatively short chapter. We looked at two types of levels that we can create: BSP or terrain-generated outdoor levels. In the next chapter, you'll be introduced to the TrueVision 3D control, a DirectX-based engine that will use the heightmap we created in this chapter to render a landscape.

CHAPTER 16

Introduction to the TrueVision 3D Engine

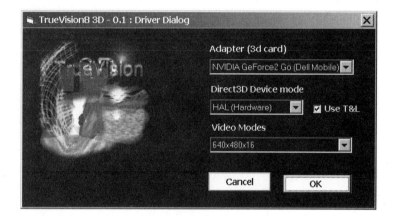

As you have seen from the limited progress in our previous examples, the development of a complete DirectX game would take a considerable amount of time if we developed everything on our own. Fortunately, there exists a complete VB and DirectX-based 3D engine called TrueVision 3D (www.truevision3dsdk.com). While we could do everything directly in DirectX, the TrueVision 3D (TV3D) engine can handle a variety of functions for us, such as rendering of 3D worlds and models, loading objects, generating landscapes, and handling cameras, to name a few. It also helps with input from keyboards, joysticks, and mice. Figure 16.1 shows the TV3D engine in action.

FIGURE 16.1 *The TV3D engine displaying a BSP file.*

Version 5 of the TrueVision Engine is included on the CD. At the time of writing, the engine is freely available for software that is to be given away, and at very limited cost for commercial products. Refer to the TrueVision site for updated information related to their new engine releases and any changes to the licensing agreement.

CHAPTER 16 INTRODUCTION TO THE TRUEVISION 3D ENGINE

BEGINNING TV3D

In order to use the TrueVision 3D engine, we must first go through a very basic installation. After the install, we must reference the engine in VB before we can use it.

INSTALLATION

TrueVision 3D is distributed as a Dynamically Linked Library (DLL). To install it, you locate the TV folder in the Applications folder on the CD-ROM. Next, copy the entire folder to your root directory (e.g., c:\). Next, open the folder and locate the TV DLL files. Highlight any DLL files you see by clicking them while holding the Ctrl key. In the current version, there is only a single DLL file, but later versions might contain multiple files. Next, drag the highlighted files to the RegSvr32.exe file located in the same directory. This will register the DLL files so that you use them in VB.

The TV3D engine was compiled with Visual Basic 6. If you do not have VB 6, you will need the VB 6 runtime DLLs. Most systems probably already have these installed, but if not, you can obtain them from www.microsoft.com.

REFERENCING THE ENGINE

After the engine has been installed, we need to reference it in VB. To begin, open VB and then create a new Standard EXE project. We are not going to develop anything in this chapter, but if you'd like to follow along in VB, you will need to open it; otherwise, you can just read through the chapter. Next, choose References from the menu, and add the DirectX 8 Type Libraries as we did in earlier chapters. Next, search the available controls until you find the TrueVision3D DX8 v5.0 engine for Visual Basic (see Figure 16.2). You should also add this to the references. If you downloaded an updated version of the engine, the DLL might be named slightly different. Click OK when you have DirectX and TV3D selected.

If you are not familiar with VB, you can find an introduction to the IDE in Appendix C, "Introduction to Visual Basic."

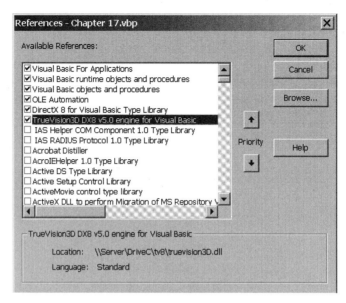

FIGURE 16.2 *The TV 3D engine should be available for reference.*

Once it is referenced, you can use the VB object explorer to view the TV3D-related classes, types, and so forth. The object browser is opened by pressing the F2 button from within the VB IDE. You can explore the engine with the object explorer built into Visual Basic.

TIP

The TV3D DLL includes all of the classes required to use the engine. The TV team has also developed a sound engine, network engine, and movie engine that are also available on their Web site. We won't be using those DLLs in our examples, so they will not be discussed.

USING TV3D IN A WINDOW OR FULL SCREEN

TrueVision works equally well in a windowed or full-screen project. Depending on our intended game, we could use TV3D in either or both types of projects.

Window

As we demonstrated earlier, a DirectX project that is going to be based in a window is different from one that will use the entire screen. One of the biggest differences between the two types of applications is in the way you handle the forms. For a full-screen project, you will want to maximize the form when it is loaded, a process you probably wouldn't do for a windowed program.

With both window and full-screen modes, you will begin your program code by defining instances of the engine classes. The following are examples of the classes that need to be created for every TV3D project:

```
Dim TV as new TrueVision8
Dim Scene as new Scene
Dim TVScreen as new Screen8
Dim Input as new InputEngine8
```

If you are planning a Windowed mode program, you will need something to render the engine to, such as a picture box. For example, if you were to add a picture box to the form in VB, it will be named Picture1 by default. Then, to initialize TV3D to run in the window, you can use a single line of code:

```
TV.Init3DWindowedMode Form1.Picture1.hWnd
```

That's really all that is needed to initialize the engine for rendering in a windowed application. If you were to run the program at this time, nothing would be created, as the engine has yet to be instructed to render anything.

Full Screen

A full-screen program uses the same process, but instead of rendering to a PictureBox control, it renders to the entire screen. You have complete control over the resolution and colors as long as your video card supports them. If you wanted to change the example we were working on to full screen, you could use the following line:

```
TVTV.Init3DFullscreen 800, 600, 16
```

The preceding code creates the TV3D engine with resolution 800 x 600 and 16-bit color. In this mode, you have complete control over the resolution and color depth, and as such, you could render to 640 x 480 or 1280 x 1240 with countless steps in between. This all depends on your video card capabilities.

If you are using Full-Screen mode, you can also use the ShowDriverDialog method of the TrueVision8 class. It displays the form shown in Figure 16.3, which allows you to pick from a list of video modes that are supported by your PC and video card. Once you select your information from the dialog box, your application will load accordingly. The following is an example of its use:

```
If (TV.ShowDriverDialog = True) then
  TV.Initialize
End If
```

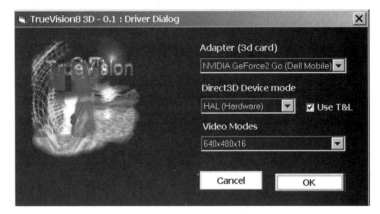

FIGURE 16.3 *The Driver dialog box in TV.*

Another option is to simply use the current resolution and color depth with the following code:

```
TV.CurrentVideoMode
```

OTHER TV3D OPTIONS

While you have seen how easy it is to initialize the engine, there are a few more advanced options you might want or need to use. These options range from ideas such as hardware Transformation and Lighting (T&L) to anti-aliasing, to automatically displaying the frames per second (FPS).

TRANSFORMATION AND LIGHTING

Using hardware T&L will ensure that the 3D card will be used for computing as much of the 3D scene as possible. This takes a tremendous load from the CPU, which can then concentrate on other activities. If your video card supports it, you can take advantage of hardware T&L with a single line of code, which should be done before the engine initialization:

```
TV.EnableHardwareTL True
```

DISPLAY FRAMES PER SECOND

You could display the FPS on the screen using DirectX, but TV3D provides a much easier way to do this. Displaying the FPS during development is important, as it will allow a developer to see how well his or her program is working. If it's too slow, a programmer could talk to the artist about removing polygons from the models, or if it's very fast, the programmer might add some special effects for added realism. There have been many studies about FPS, but for simplicity, you should try to keep your FPS above 25 and below 75. Above 25 FPS will provide good animation, and a higher number would obviously be better. On the other hand, if you are above 75 FPS, you are wasting the speed, as the human eye doesn't notice anything better than 75.

To display the FPS, you can use the following code:

```
TV.DisplayFPS = True
```

To disable the display, use the following:

```
TV.DisplayFPS = False
```

Figure 16.4 shows a screen shot of the engine with the FPS being shown.

FIGURE 16.4 *The FPS being displayed on the screen.*

LOADING CONSOLE

You have undoubtedly seen the "Please Wait" or "Loading..." messages that occur when a game is switching levels or otherwise loading data. By default, TV3D handles this for you when it is in the process of loading a map. This is fine for some uses, but if you would prefer to create your own information, you should disable this feature. The following code enables this console:

```
TV.Console = True
```

Likewise, to disable it so that you can create your own:

```
TV.Console = False
```

FULL-SCREEN TITLE

When you run an application at full screen and then use the Windows task manager to move between programs, a window title can be seen. By default, it displays information about the developer of the TV engine. Again, this might be fine for some situations, but if you would like to display your own information, you have this option with a single line of code:

```
TV.SetWindowTitle "My window Title"
```

ERROR MESSAGES

TV3D handles error messages by responding with information that instructs the user to contact the TV3D team via an e-mail address. Like the screen title, this might be fine in certain situations, but often times, the developer would prefer to have his or her own message. To do this, you should call this before you start the engine. The code is as follows:

```
TV.SetErrorInitText "My Custom Error Message"
```

CREATING A SCENE

TV3D contains a Scene class that is responsible for creating mesh objects and has a large number of effect settings built into it. You might remember the Scene 8 from the declarations we created earlier:

```
Dim Scene as new Scene
```

The preceding line is the only thing you need to use the Scene class. However, there are many optional features that might provide an effect or idea you need for your game. These options are generally related to the rendering of objects. The first option we'll look at is mip-mapping. If you ever played games like *Flight Sims*, you probably noticed the effects that occur when a texture is rendered from a distance. This doesn't cause a problem for functionality, but the appearance of a game is greatly affected. By enabling mip-mapping, you can prevent this from occurring. To do so, use the following line:

```
Scene.EnableMipMapping True
```

To disable it, you can set it to false:

```
Scene.EmableMipMapping False
```

DITHERING

If you create a scene with 32-bit colors, an older video card might experience some problems trying to display them. Dithering will help this process, as it helps the card to display the textures more closely to their original colors. To enable dithering, use the following:

```
Scene.SetDithering True
```

To disable dithering, you can use this:

```
Scene.SetDithering False
```

Rendering Modes

TV3D allows us to render a scene using different modes that allow us to render everything (TV_SOLID), wireframe (TV_LINE), or vertices (TV_POINT). You can change this mode at any time, which would allow you to render a scene with a wireframe landscape but with solid characters.

You can change the rendering mode to display vertices only with the following code:

```
Scene.SetRenderMode TV_POINT
```

To render in Wireframe mode:

```
    Scene.SetRenderMode TV_LINE
```

Finally, you can render with textures:

```
    Scene.SetRenderMode TV_SOLID
```

Figures 16.5 through 16.7 show the different rendering modes.

FIGURE 16.5 *Point Rendering mode.*

Chapter 16 Introduction to the TrueVision 3D Engine

FIGURE 16.6 *Line Rendering mode.*

FIGURE 16.7 *Solid Rendering mode.*

LIGHTING MODES

Like other aspects of the game, TV3D includes the ability to alter the lighting mode in which the scene is rendered. There are several options for TV light rendering:

- **TV_SHADEMODE_GOURAUD** The default mode. Calculated with vertices that all have their own colors. The individual faces will have multiple colors of light displayed.
- **TV_SHADEMODE_FLAT** Light calculated face by face, so it is much quicker, but isn't very good quality.
- **TV_SHADEMODE_PHONG** The highest quality. It is calculated pixel by pixel, but is very slow.

You can set the modes to Gouraud as follows:

```
Scene.SetShadeMode TV_SHADEMODE_GOURAUD
```

To change it to flat, use the following:

```
Scene.SetShadeMode TV_SHADEMODE_FLAT
```

The last option is to set it as phong:

```
Scene.SetShadeMode TV_SHADEMODE_PHONG
```

Figures 16.8 through 16.10 show the different lighting modes.

FIGURE 16.8 *Gouraud Rendering mode.*

FIGURE 16.9 *Flat Rendering mode.*

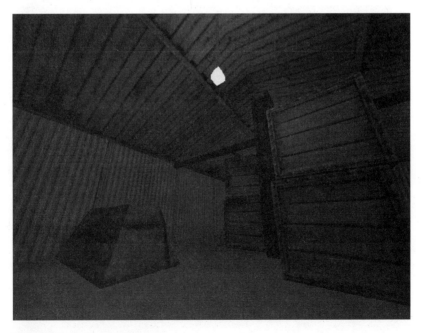

FIGURE 16.10 *Phong Rendering mode.*

TEXTURE FILTERING

In older 3D engines, textures that were displayed up close appeared very blocky, but most engines now take care of this problem. TV3D is no exception, and has a default texture filter to remove the texture blocks. You can also choose from several additional varieties, including TRILINEAR and ANISOTROPIC. Figure 16.11 shows the scene with Bilinear Filtering.

You can change this at any time by using the following:

```
Scene.SetTextureFilter TV_FILTER_ANISOTROPIC
```

FIGURE 16.11 *Scene with Anisotropic filter.*

TrueVision Feature List

This chapter has touched on some of the features of TV. However, so that you have a better understanding of what you can do with it, the following sections detail many of its features.

Main Features

- Full support of DirectX 8
- Hardware rasterization and software emulation hardware detection
- Windowed and full screen
- Multiple renderings in Windowed mode
- Driver and video mode selection window
- Z-buffer and W-buffer support (16-, 24-, and 32-bit)
- Multi video modes (16-bit and 32-bit)
- Vertex, LVertex, and TLVertex support
- Easy to use with simple functions
- Isoview rendering supported
- Hardware T&L support

Terrain Features

- 3D textured terrain generator
- With heightmap
- Empty terrain
- Huge terrains
- Visible checking
- Each 256 x 256 terrain of a landscape can be textured
- Sun and Clouds directly supported
- Water and different weather condition for landscapes
- Easy collision detection
- Sliding collision
- Terrain Get Height function from a point on the terrain
- Every chunk can have a different texture
- Multi-chunk support
- Scalable terrain
- Dynamic terrain possibility
- Advanced and normal landscape
- Possible to make chunks invisible
- Dynamic textures
- Expand texture over the whole landscape

- Detail texture
- Water with mirror
- Lensflares

FILE TYPES SUPPORT

- 3DS, X, MilkShape, 3DS ASCII loader
- MDL file (Half-Life) rendering with animation
- MD2 file (Quake 2) rendering with animation
- MD3 file (Quake 3) rendering with animation
- 3DG Level file
- BSP (Half-Life) loader and renderer (with PVS and lightmaps)
- BSP Entities parsing
- BSP3 (Quake3) maps support
- BSP3 lightmaps and PVS and Curves (Bezier patches)
- TSP TrueVision3D Map file like BSP (but faster), possible to convert from bsp
- DXE loading
- TVO TrueVision3D save and load file for landscapes, meshes, etc.
- PAK file support for storing many supported TV3D files in one file
- Wad files support
- Entities: Glass, RenderAmt, Glow, Sprite
- SPR (Half-Life Quake sprite file) support
- TVM TrueVision3D Animated object with MilkShape plug-in

GRAPHICS FORMATS

- TGA
- PCX
- JPG
- JPEG
- PNG
- GIF
- BMP
- DDS

RENDER SCENE

- Changeable view frustum and render range
- Set a default color on the background
- Different render modes
- TV_POINT

- TV_LINE
- TV_SOLID
- Dithering
- Mip-mapping (two modes)
- Render Surfaces to create more viewpoints and mirrors
- Unlimited Render hwnd screens
- Iso view rendering

SHADERS

- Pixel shader, Vertex shader for DX
- Shaders from Quake3 script file

LIGHTS

- Directional and point lights
- Materials support for VERTEXES
- Lightmaps with BSP from Half-Life
- Lightmaps generator and renderer for multigroup mesh
- Dynamical and static shadows
- Mdl lightening
- Landscape lightening

TEXTURE FACTORY

- TGA
- PCX
- JPG
- JPEG
- PNG
- GIF
- BMP
- DDS

COMPRESSED TEXTURES

- 16-bit textures
- 32-bit textures

MESHES

- Easy functions for creating 3D objects and worlds:
 AddWall 1 & 2
 AddFloor
 Add4PointFace
 AddTriangle
 CreateSphere
- Change texture position on face for addfloor, ... functions
- Enable and disable a mesh.
- Collision detection
- Create 3D text
- Easy to move vertices
- Materials support
- Child meshes supported
- Blending
- Visible checking
- Cubic/quadratic Bezier patch
- Sphere mesh collision
- Cubic environment mapping water effect

PARTICLES

- Easy CreateBillboardSystem
- Get and Set particle Position
- With Event Interval and Auto Generate mode
- Set and Get particle direction
- Many functions to change the particle style:
 Color
 Direction
 Life Time
 Speed
 All Directions Gravity
 Random Gravity
 Generate Speed
- Get Active Particle number
- Particle texture
- Custom Bounce function

CAMERA

- Camera Purchase and Follow functions
- Position (X, Y, and Z)
- Rotation (X, Y, and Z)
- Camera Position and Camera LookAt
- Free MouseLook
- Player Gravity

2D SCREEN

- 2D text with color and font
- Font with Textures and Windows font types
- Create Font function
- Surfaces
- 3DLine to draw a line from 3D position converted to 2D
- Draw on surfaces:
 Point
 Lines
 Circles
 ...and more
- Draw a texture or only a part from a texture
- Editable background texture
- Sprite(s):
 Load
 Scale
 Draw
 Rotate
- Blending for surfaces

USER INTERFACE

- DrawMessageBox to show message boxes in 3D mode

INPUT FEATURES

- Easy mouse and keyboard support
- Easy and advanced game controllers (joysticks, wheel, etc.) management
- All kinds of game controllers support
- Force feedback effects
- Mouse picking (like Direct3D Retained mode)

INTERNAL OBJECTS

- Add your own functions connected directly to the internal objects from the engine
- GetBackbuffer
- GetD3DXLibrary
- GetDevice3D
- GetDirect3D
- 3D Effects
- Billboarding (2D sprite)
- 4D Billboarding (like Doom sprite)
- Night effect (fog + background effect)
- Vertex and Table Fog
- Fade In and Fade Out (for a better transition)
- Flash (multicolor)
- Fade and flash variable speed.
- Point particles generator (explosion and others)
- Billboard particles generator (smoke, water...)
- 2D alpha-blended information
- Sky Renderer (an inverted textured cube)

MISCELLANEOUS

- AI. Path-finding node system
- Path class (for a mesh)
- Easy PAK (Quake, Half-Life) reading and extracting
- Console (full screen, or on a part of the screen)

CHAPTER REVIEW

This chapter introduced you to the invaluable TrueVision 3D DLL, a DirectX engine which will be used in the rest of the samples in the book. We touched upon some of the engine basics, such as how to reference it in a VB project, and also looked at how we could use some of its many features. In the following chapters, we will use it to develop a program that can render BSPs and a terrain generator that will ultimately be used as the basis for our First Person Shooter (FPS).

CHAPTER 17
Rendering BSP Levels

In Chapter 15, "BSP and SkyBox Designs," we looked at the process involved in creating BSP levels. In this chapter, we'll use the TV3D engine to render a BSP engine. The purpose of this chapter is twofold: it will allow us to become more comfortable with TV3D, and we'll develop a useful program that is actually our first real example.

GETTING STARTED

The first step in the creation of our project is to create a new Standard EXE project in Visual Basic. A form that is available by default when you create the project. We'll use the form to select the BSP file we want to render, and the PAK or WAD file associated with it.

First, add two Label controls to the form with the following properties:

Name	Caption
Label1	BSP
Label2	PAK/WAD

You can place them on the form and then change their captions to "BSP" and "Pak/Wad". They should be placed in an arrangement similar to Figure 17.1.

FIGURE 17.1 *The two labels on the form.*

Next, we need to add text boxes to the form and place them next to the Label controls. Figure 17.2 shows their approximate locations and sizes, along with the width and height changes we made to the form.

CHAPTER 17 RENDERING BSP LEVELS

FIGURE 17.2 *Text boxes placed next to the labels.*

The Label controls should have the following properties:

Name	Caption
txtLevel	Leave Blank
txtPak	Leave Blank

Three Button controls need to be added to the form as shown in Figure 17.3. The controls will eventually be used to open another form that we have not yet created, and to locate the BSP files and PAK files.

FIGURE 17.3 *The Button controls are added.*

Set the Button controls as follows:

Name	Caption
cmdOpen	Open
cmdBrowseLevel	Find
cmdBrowsePak	Find

The last thing we need to add to the form is a Common Dialog control. If you right-click on the Toolbox, you can select Components from the pop-up menu. The Components window, shown in Figure 17.4, will appear in which you should find Microsoft Common Dialog Control 6.0. This may be different if you are using VB 5 or VB.NET.

FIGURE 17.4 *You will find the Common Dialog control in the Components window.*

WRITING SOME CODE

Now that the form has all of the appropriate controls, the next step is to write some code. First, double-click the cmdOpen command button, which will display the Code Window and place you in the cmdOpen_Click subprocedure. Next, we need to add a new form to the project by choosing Project | Add Form. This will display the Add Form window, an example of which is shown in Figure 17.5.

CHAPTER 17 RENDERING BSP LEVELS

FIGURE 17.5 *Adding a new form to the project.*

Click the Open button and a new form will be available. Set its properties as follows:

Name	**Caption**
BSPForm	BSP Viewer

Once we have the name of the form set, we can go back to the Code window. The cmdOpen_Click subprocedure will be used to open the form once we have selected a BSP file and PAK or WAD file. The following code will open the BSPForm if there is a BSP and PAK/WAD file selected:

```
Private Sub cmdOpen_Click()
    If txtLevel <> "" And txtPak <> "" Then
        BSPForm.Show
        Me.Hide
    Else
        MsgBox "You must select a level and pak file", vbOKOnly
    End If
End Sub
```

If there aren't any files selected, a message box will appear to remind you to select the BSP file and PAK file. We also have hidden the current form after we open the BSPForm.

The next step is to use the Common Dialog controls and the remaining command buttons to display open dialog boxes, and fill in the text boxes with the resulting selected files. The following code accomplishes our objective:

```
Private Sub cmdBrowseLevel_Click()
    CommonDialog1.ShowOpen
    txtLevel = CommonDialog1.FileName
End Sub
Private Sub cmdBrowsePak_Click()
    CommonDialog1.ShowOpen
    txtPak = CommonDialog1.FileName
End Sub
```

BSP Rendering

Now that everything is completed in respect to the first form, we will move our attention to the rendering of BSP files in the BSPForm. It will be a full-screen application that will allow us to view a BSP file by moving through it with the keyboard and mouse. An example BSP file being rendered is shown in Figure 17.6.

FIGURE 17.6 *BSP file being rendered.*

Rendering Loop

Like the earlier DirectX samples, we need to create a rendering loop. We could use any of the standard VB options (Do...Loop, For...Next, etc.), but the Do...Loop option is most commonly used. You could also use a timer to create a loop, but it usually isn't fast enough for rendering in a game.

Now that we know what type of loop we are planning to use, we have to come up with some type of option for ending the loop. Otherwise, we would be stuck in an infinite loop. That is, unless we used the Task Manager (Ctrl+Alt+Del pressed simultaneously) to end the program, it would continue running. When you are working with these types of loops, it's very important to save your work often and definitely before testing it.

Before tackling the loop, we need to create our declarations. Open the Code window and add the following declarations:

```
Dim TV As New TrueVision8
Dim Scene As New Scene8
Dim BSP As New BSPTree8
Dim Inp As New InputEngine8
```

We covered these in detail in the last chapter, so won't go over them here.

We are going to use the Form_Load subprocedure for our render loop. To end the loop, we are going to use the InputEngine to test the keys that are being pressed. When the Esc key is pressed, the loop will end. In pseudocode, our loop is:

```
Do
Check keyboard, mouse input (if ESC key is pressed, then exit)
Calculate position of camera
Render
Loop
```

Now that we have a plan in place on how to implement the render loop, we need to begin writing the actual VB code. The complete code can be entered at this time:

```
Private Sub Form_Load()
Dim PosX As Single, PosY As Single, PosZ As Single, ang As Single
    Dim PosSx As Single, PosSy As Single, PosSz As Single
    Dim mx As Long, my As Long, d As Boolean

    If TV.ShowDriverDialog = False Then End
    TV.Initialize
```

```
TV.SetSearchDirectory App.Path
TV.OpenPAKFile Form1.txtPak
BSP.Load Form1.txtLevel, True, , True
TV.ClosePAKFile
PosX = BSP.GetStartPlayerPosition.x
PosY = BSP.GetStartPlayerPosition.y
PosZ = BSP.GetStartPlayerPosition.z

Do
    TV.Clear
    BSP.Render

    TV.RenderToScreen
    PosSx = PosX
    PosSy = PosY
    PosSz = PosZ
    If Inp.IsKeyPressed(TV_KEY_UP) = True Then
        PosSx = PosX + Cos(ang) * TV.TimeElapsed * 0.2
        PosSz = PosZ + Sin(ang) * TV.TimeElapsed * 0.2
    End If
    If Inp.IsKeyPressed(TV_KEY_DOWN) = True Then
        PosSx = PosX - Cos(ang) * TV.TimeElapsed * 0.2
        PosSz = PosZ - Sin(ang) * TV.TimeElapsed * 0.2
    End If
    If Inp.IsKeyPressed(TV_KEY_LEFT) = True Then
        ang = ang + TV.TimeElapsed * 0.005
    End If
    If Inp.IsKeyPressed(TV_KEY_RIGHT) = True Then
        ang = ang - TV.TimeElapsed * 0.005
    End If

    PosX = PosSx
    PosY = PosSy
    PosZ = PosSz

    Inp.GetMouseState mx, my
    If Abs(mx) > 1 Then
      ang = ang - TV.TimeElapsed * 0.001 * mx
    End If
    If Abs(my) > 1 Then
      angy = angy - TV.TimeElapsed * 0.001 * my
      If Abs(angy) > 1.52 Then angy = Sgn(angy) * 1.52
    End If
```

Chapter 17 Rendering BSP Levels

```
        Scene.SetCamera PosX, PosY, PosZ, PosX + Cos(ang), PosY +
Sin(angy), PosZ + Sin(ang)

    Loop Until Inp.IsKeyPressed(TV_KEY_ESCAPE) = True
    Set BSP = Nothing
    Set TV = Nothing
    End

End Sub
```

Most of this code should be self-explanatory. A great deal of the source code for this example was covered in the previous chapter. There are a few items that we should look at more closely, although most of them are actually very easy to grasp. First, the Input engine was used to check the status of the Up, Down, Left, and Right arrow keys and the Esc key. If one of the arrow keys is pressed, the camera is moved. If the Esc key is pressed, the loop is ended. You should also notice how we moved the camera by setting its position with the following line:

```
        Scene.SetCamera PosX, PosY, PosZ, PosX + Cos(ang), PosY +
Sin(angy), PosZ + Sin(ang)
```

There is a little math used in the code. Sin and Cos are both used to calculate positions. Also notice the use of TV.TimeElapsed in the code; this works similarly to the way we used the GetTick API call in the earlier DirectX samples.

If you test the application at this time (don't forget to save it first), you will be presented with the opening form, which allows you to set the correct BSP file and PAK/WAD file. This form is shown in Figure 17.7.

FIGURE 17.7 *The first form is displayed.*

If you open a BSP and corresponding PAK file, and then click OK, the BSP will be rendered to the screen and you can move around with the arrow keys and mouse. Additionally, if you press the Esc key, you will end the execution of the program. The rendering should be full screen and appear something like Figure 17.8.

FIGURE 17.8 *Full-screen BSP rendering.*

Chapter Review

In this chapter, we built a complete application capable of rendering BSP files. In the next chapter, we'll build a Half-Life model viewer that will be able to display all of the animations in the model. We'll also include the capability to rotate and zoom the models.

CHAPTER 18
Half-Life Model Viewer

In this chapter, we'll build a program to view Half-Life models, the format we are using throughout the book. The program will be capable of viewing Half-Life models by sorting through the available animations. It will display the animations, number of frames, and allow us to zoom and rotate our model. Figure 18.1 shows the final program with a model loaded.

FIGURE 18.1 *The Half-Life model viewer.*

Getting Started

We'll begin this project much like most VB applications by creating a Standard exe project. A form is created by default. You can change the properties on the form to match Figure 18.2.

FIGURE 18.2 *The properties for the form.*

After the properties on the form have been altered, you will need to add several controls to the form. The following list details the controls and their positions on the form:

Control Type	Name	Caption	Left	Top
Command Button	cmdOpen	Open	110	110
ComboBox	Combo1		2400	215
PictureBox	Picture1		110	650
CheckBox	Check1	Rot X	650	5800
CheckBox	Check2	Rot Y	1750	5800
Label	Label1	Label1	3650	5800
Label	Label2	Frames:	2900	5800

You also need to alter the width and height of the PictureBox to 5000, and you can visually resize or position the other controls as needed so that they look similar to Figure 18.3.

FIGURE 18.3 *The form with most of the finished controls.*

Chapter 18 Half-Life Model Viewer

You have to place a Common Dialog control on the form as well; however, its size and position are not factors as it is hidden at runtime. The control can be found in the Components window, which is displayed by pressing Ctrl+T or right-clicking on the Toolbox and selecting Components from the pop-up menu.

Writing Some Code

Now that the controls are all in place, we will write the code. First, add the following declarations to the Code window:

```
Public TV As New TrueVision8
Public Scene As New Scene8
Public Actor As New Actor8

Dim Info As MDLModelInfo

Dim RotationX As Single, RotationY As Single, LastX As Single, LastY As Single
Dim ScaleZ As Single
```

Many of the declarations will be familiar to you from previous examples. Most of the others are self-explanatory or will be discussed as we use them. We'll begin with the Form_Load subprocedure, which will start with the initialization of the TV3D engine. Next, we'll set the background color and then show the form. The next step will be to set the ScaleZ variable to 1. This variable will be used to change the zoom level of the model. Then, we'll clear the picture box and set up our Do...Loop. Here is the code for the procedure:

```
Private Sub Form_Load()
        TV.Init3DWindowedMode Form1.Picture1.hWnd
        Scene.SetSceneBackGround 0, 0, 0.1
        Me.Show
        ScaleZ = 1

On Error Resume Next
Do
        DoEvents
        TV.Clear

If Not Actor Is Nothing Then
        Actor.Render
End If

TV.RenderToScreen
Loop
End Sub
```

At this time, our program will render properly, but has nothing to render. We'll change this by working with the cmdOpen_Click subprocedure. First, we should set up the CommonDialog control to display only Half-Life MDL format files. We'll then show the CommandDialog and, once a file is selected, we'll set the Actor to the filename of the CommonDialog control. The Actor was declared earlier and is used to load models into the TV3D engine. The next step is to set the position of the camera and scale the model so that we can see it upon loading.

Once an MDL has been loaded, we should set the animation speed to 1, and then store a list of its animations in Combo1.

```
Private Sub cmdOpen_Click()
    CommonDialog1.DialogTitle = "Open Half-Life Model"
    CommonDialog1.Filter = "Model File (*.MDL)|*.MDL"
    CommonDialog1.ShowOpen
    If CommonDialog1.FileName <> "" Then
    Actor.Load CommonDialog1.FileName
    Scene.SetCamera 0, 50, -140, 0, 50, 0

    Actor.SetScale 2, 2, 2
    Actor.SetAnimation 1
    Actor.SetSpeed 1

    On Error Resume Next
    Info = Actor.GetModelInfo
    Combo1.Clear
    For i = 1 To Info.NumSequences
    Combo1.AddItem Info.Sequences(i - 1).Name
    Next i
    Combo1.ListIndex = 0
    End If
End Sub
```

Now the animations are loaded into the ComboBox and the model is being displayed. The next thing we need is to change the animations by using Combo1. This only takes two lines of code:

```
Private Sub Combo1_Click()
    Label1.Caption = CStr(Info.Sequences(Combo1.ListIndex).NumFrames)
    Actor.SetAnimation Combo1.ListIndex
End Sub
```

Chapter 18 Half-Life Model Viewer

The only thing left to do with the project is take care of rotating the model and zooming in and out. We can use the Picture1_MouseDown and Picture1_MouseMove events for this. The MouseDown is the easier of the two. It will actually be a placeholder for storing our mouse position when we click Picture1. Here is the code:

```
Private Sub Picture1_MouseDown(Button As Integer, Shift As Integer, X As Single, Y As Single)
        LastX = X
        LastY = Y
End Sub
```

The MouseMove subprocedure is a little more difficult. First, we need to track the position from the old position, which was stored in the variables LastX and LastY in the MouseDown subprocedure. Next, we check to see which CheckBoxes are selected and then rotate the model accordingly. For instance, if Check1 is selected, it will only rotate around the X-axis. This is the same for the Y-axis or both of them. This will only occur if the left button is clicked. If the right button is clicked, the model should zoom in and out depending on the position of the mouse. If it is left of the center of Picture1, which is 2500, then it should zoom out; otherwise, if it is to the right of the center, it will zoom in.

```
Private Sub Picture1_MouseMove(Button As Integer, Shift As Integer, X As Single, Y As Single)
If Button = 1 Then
        fx = X - LastX
        fy = Y - LastY
        LastX = X
        LastY = Y
If Check1 And Not (Check2) Then RotationX = RotationX + fx * 0.05
If Check2 And Not (Check1) Then RotationY = RotationY + fy * 0.05

If Check1 And Check2 Then
      RotationX = RotationX + fx * 0.05
      RotationY = RotationY + fy * 0.05
If X < 2500 Then y * 0.05
End If

Actor.SetRotation RotationX, RotationY, 0
End If
```

```
        If Button = 2 Then
        ScaleZ = ScaleZ - 0.1
        Else
        ScaleZ = ScaleZ + 0.1
        End If

        If ScaleZ < 1 Then ScaleZ = 1
        If ScaleZ > 10 Then ScaleZ = 10
        Actor.SetScale ScaleZ, ScaleZ, ScaleZ
        End If
        End Sub
```

The only other thing we have remaining is to set the engine equal to "nothing" when we exit the application, which we can do in the Form_Unload subprocedure. The following code finishes the program:

```
    Private Sub Form_Unload(Cancel As Integer)
            Set TV = Nothing
            End
    End Sub
```

If you run the application, you should see something like Figure 18.4.

FIGURE *The application as displayed on start.*
18.4

If you open a Half-Life model, it will be displayed in the viewer. A sample of this functionality is shown in Figure 18.5.

FIGURE 18.5 *The model being displayed.*

If you pull down the combo box, you will see a list of available animations located in the file, as shown in Figure 18.6.

FIGURE 18.6 *The drop-down list displays the available animations.*

Finally, you can zoom in and rotate the model. The model in Figure 18.7 is zoomed out and rotated.

Chapter 18 Half-Life Model Viewer

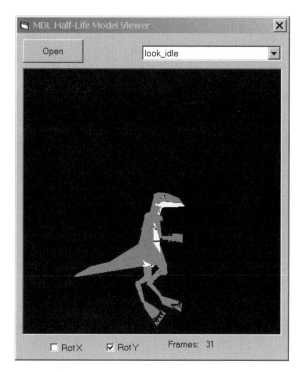

Figure 18.7 *A rotated and zoomed model.*

Chapter Review

In this chapter, we used the DirectX-based TV3D control to build a Half-Life model viewer. You can test the functionality of this program by using the model we created earlier in the book. In the next chapter, we'll use TV3D and PaintShop Pro to render a terrain, the first step in our game.

CHAPTER 19
Terrain Rendering and FPS Shooter

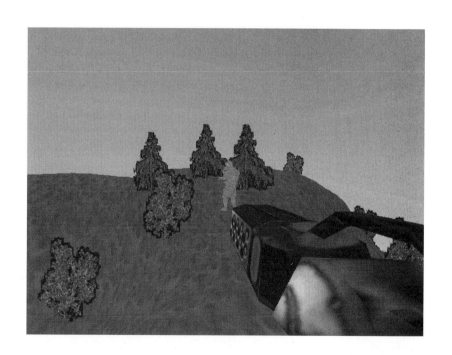

In the previous two chapters, we used the TV3D engine and DirectX to load BSP files and Half-Life models. In this chapter, we'll expand on what we learned to render a terrain and display a model on the terrain. We'll also add sound and music to the level and, when finished, this project will look like Figure 19.1.

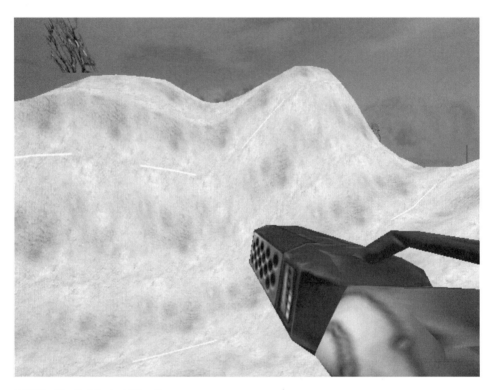

FIGURE 19.1 *The finished application.*

Getting Started

We'll begin this chapter like the others. First, create a new Standard EXE project in Visual Basic. Next, reference the DirectX 8 for Visual Basic Type Library and the TrueVision3D engine (see Figure 19.2).

FIGURE 19.2 *References for our project.*

The next step is to open the Components Window (Ctrl+T or right-click on the toolbar) and locate the Windows Media Player control. We'll use this to play the music we created with ACID. You can place it anywhere on the form, as we'll hide it from being displayed.

Next, open the Code window. We'll begin this project with the Declarations and Form_Load event. Many of these will be familiar to you at this time because of the earlier chapters. The code is as follows:

```
Private Sub Form_Load()
    Dim Width As Long, Height As Long
    Dim L As New LightEngine8
    Dim treeTex(2) As Texture8
    Dim x As Single, y As Single, z As Single
    Dim Trees(100) As Mesh8
    Dim Scr As New Screen8
    Dim mx As Long, my As Long
    Dim FileName As String

    MediaPlayer1.FileName = App.Path & "\gamemusic.wav"

    TV.ShowDriverDialog
    TV.DisplayFPS = True

    TV.Initialize

    TV.GetVideoMode Width, Height, 0

    TV.SetSearchDirectory App.Path

    HumanoidHealth = 100

    TexFactory.LoadTexture "grass.bmp", "terrain"

    Scene.SetSceneBackGround 0, 0, 0
    Scene.SetViewFrustum 90, 1024

    TexFactory.LoadTexture "down.jpg", "Up"
    TexFactory.LoadTexture "left.jpg", "Left"
    TexFactory.LoadTexture "up.jpg", "Down"
    TexFactory.LoadTexture "right.jpg", "Right"
    TexFactory.LoadTexture "front.jpg", "Front"
    TexFactory.LoadTexture "back.jpg", "Back"

    Scene.SetSkyTexture GetTex("Front"), GetTex("Back"),
GetTex("Left"), GetTex("Right"), GetTex("up"), GetTex("down")

    Land.SetFactorY 2
    Land.GenerateHugeTerrain "height.jpg", TV_PRECISION_LOW, 8, 8, 0,
0, True
```

```
    MatFactory.CreateMaterial "terrain"
    MatFactory.SetAmbient GetMat("terrain"), 0.7, 0.7, 1, 1
    MatFactory.SetDiffuse GetMat("terrain"), 1, 1, 1, 1
    MatFactory.SetEmissive GetMat("terrain"), 0, 0, 0, 1

    L.CreatePointLight Vector(512, 200, 512), 1500, 5, 5, 5, 1

    Land.SetTextureScale 2, 2
    Land.SetTexture GetTex("Terrain")
    Land.SetMaterial GetMat("terrain")

    Set treeTex(1) = TexFactory.LoadTexture("tree.jpg", , , , RGBA(0, 0, 0, 1))
    Set treeTex(2) = TexFactory.LoadTexture("tree2.jpg", , , , RGBA(0, 0, 0, 1))

    For i = 1 To 60
        x = Rnd * 2048
        z = Rnd * 2048
        y = Land.GetHeight(x, z) + 5
        Set Trees(i) = Scene.CreateBillboard(treeTex(Int(Rnd * 2) + 1), x, y, z, 90, -120)
        Trees(i).SetPosition x, y + 35 * 3, z
        Trees(i).ComputeSphere
    Next i

    Weapon.Load "v_weapon.MDL"
    Humanoid.Load "Humanoid.mdl"

    Weapon.SetAnimationName "idle"
    Weapon.SetSpeed 1

    Humanoid.SetAnimationName "idle"
    Humanoid.SetScale 1, 1, 1
    Humanoid.SetSpeed 1
    HumanoidPos = Vector(500, 200, 500)
    Humanoid.SetPosition HumanoidPos.x, HumanoidPos.y + 60, HumanoidPos.z
    Humanoid.SetRotation -90, 0, 0
```

```
        Set Flash =
Scene.CreateBillboard(TexFactory.LoadTexture("flash.bmp", _
                , , , TV_COLORKEY_BLACK), 0, 0, 0, 10, 10, "Flash", _
True, _
                D3DBLEND_SRCALPHA, D3DBLEND_ONE)

        PosX = 500
        PosZ = 500

        Do

        TV.Clear

        Scene.RenderSky

        Land.Render
        Humanoid.Render

        TV.Start2D

        Scene.RenderAllMeshes

        Weapon.Render

        Walk = False

        If Inp.IsKeyPressed(TV_KEY_UP) = True Then
            Walk = True
            PosX = PosX + Cos(ang) * TV.TimeElapsed * 0.09
            PosZ = PosZ + Sin(ang) * TV.TimeElapsed * 0.09
        End If

        If Inp.IsKeyPressed(TV_KEY_DOWN) = True Then
            Walk = True
            PosX = PosX - Cos(ang) * TV.TimeElapsed * 0.09
            PosZ = PosZ - Sin(ang) * TV.TimeElapsed * 0.09
        End If

        If Inp.IsKeyPressed(TV_KEY_LEFT) = True Then
            ang = ang + TV.TimeElapsed * 0.005
        End If

        If Inp.IsKeyPressed(TV_KEY_RIGHT) = True Then
            ang = ang - TV.TimeElapsed * 0.005
        End If
```

Chapter 19 Terrain Rendering and FPS Shooter

```
    Inp.GetMouseState mx, my, b1

    If Abs(mx) > 1 Then
        ang = ang - TV.TimeElapsed * 0.001 * mx
    End If

    If Walk = True Then
        If OldStep < TV.TickCount - 400 Then
            OldStep = TV.TickCount
            step = Int(Rnd * 4) + 1
                If Not SoundInit(App.Path & "\Step1.wav") Then
                    Sound.Play DSBPLAY_DEFAULT
                End If
        End If
    End If

    If Abs(my) > 1 Then
        angy = angy - TV.TimeElapsed * 0.001 * my
        If Abs(angy) > 1.52 Then angy = Sgn(angy) * 1.52
    End If

    PosY = Land.GetHeight(PosX, PosZ) + 60
    WeaponCheck

    Scene.SetCamera PosX, PosY, PosZ, PosX + Cos(ang), PosY +
Sin(angy), PosZ + Sin(ang)

    Scr.DrawCircle Width / 2, Height / 2, 10, 20, &HFF00FF00
    Scr.DrawLine Width / 2, Height / 2 - 5, Width / 2, Height / 2 + 5,
&HFF00FF00
    Scr.DrawLine Width / 2 - 5, Height / 2, Width / 2 + 5, Height / 2,
&HFF00FF00

    TV.RenderToScreen

    PosY = Land.GetHeight(PosX, PosZ) + 3

    HumanoidChange

    Loop Until Inp.IsKeyPressed(TV_KEY_ESCAPE) = True

Set TV = Nothing
MediaPlayer1.Stop
End
End Sub
```

There are a few items that you should look at in more detail. First, the creation of the landscape takes place in this procedure, along with the playing of the music files. Additionally, there are textures being loaded that make up the various aspects of the terrain, trees, and so forth. The main loop also takes place in this subprocedure. This is all very similar to the previous examples, so you should be able to understand most or all of what is happening with a quick glance. We created the terrain heightmap earlier in Chapter 15.

CREATING THE TEXTURES

We need to create the textures, and PaintShop Pro is a great choice for this. We'll create the grass textures for the level, which uses the same approach as the others. First, open PaintShop Pro and create a new file. From the New Image window, select 1000 x 1000 (see Figure 19.3).

FIGURE 19.3 *The New Image window.*

Once the image is available, you need to choose the grass pattern for the Foreground pattern and paint the entire image with the pattern. The image should now look like Figure 19.4.

FIGURE 19.4 *The first step in creating the image.*

Next, draw a selection in the center of the image about one-fourth the size (see Figure 19.5).

FIGURE 19.5 *A selection of the image.*

Now we can choose Selections | Convert to Seamless Pattern. We are not yet finished, but as you can see in Figure 19.6, we are getting close.

CHAPTER 19 TERRAIN RENDERING AND FPS SHOOTER

FIGURE 19.6 *We are almost finished with this texture.*

The only additional requirements are to resize the image to 256 x 256 and then save it to your directory. You could do more refinement of the texture, but this is very quick and easy. The other textures and graphics files used in the example are created in the same manner.

The Form_Load procedure also loads front, back, left, right, top, and bottom textures that make up the "SkyBox" for the level. These textures are very simple, but as you'll see at the end of the chapter, improving them can make for a much better level.

DIRECTSOUND AND MOVEMENTS

There are only two more things to set up. First is the movement of the humanoid model, which occurs in the HumanoidChange subprocedure. The model will basically compare itself to your position, and if it is within 40 units, it will pick a random direction in which to move. When you are first placed on the terrain, the humanoid model will be placed in your exact location. Therefore, when you run the application, you will need to give it a moment to begin moving.

```
Sub HumanoidChange()
    Dim Dist As Single
    Dim p As D3DVECTOR

    If HumanoidHealth < 0 Then
        If OldAI < TV.TickCount - 900 Then
            Humanoid.SetAnimationName "lying_on_back"
        End If
    Else

    Dist = VModulus(VSubtract(Vector(PosX, PosY, PosZ), HumanoidPos))

    If Dist < 40 Then
        HumanoidDest = Vector(Rnd * 1024, 0, Rnd * 1024)
        Change = True
    End If

    Scene.SetCollisionPrecision Dist

    If Change = True Then
        HumanoidDir = VNormalize(VSubtract(HumanoidDest, HumanoidPos))
            If HumanoidDir.z > 0 Then
                angle = Rad2Deg(Atn(HumanoidDir.x / HumanoidDir.z))
            Else
                angle = Rad2Deg(Atn(HumanoidDir.x / HumanoidDir.z)) + 180
            End If
        Humanoid.SetRotation 0, 90 + angle, 0
        HumanoidWalk = True
        Humanoid.SetAnimationName "run"
    End If

    If HumanoidWalk = True Then
        p = VAdd(HumanoidPos, VScale(HumanoidDir, TV.TimeElapsed * 0.09))
        HumanoidPos = Vector(p.x, 0, p.z)
        If Int(p.x / 4) = Int(HumanoidDest.x / 4) And Int(p.z / 4) = Int(HumanoidDest.z / 4) Then
            HumanoidWalk = False
            Humanoid.SetAnimationName "idle"
        End If
    End If

    HumanoidPos.y = Land.GetHeight(HumanoidPos.x, HumanoidPos.z) + 32
    Humanoid.SetPosition HumanoidPos.x, HumanoidPos.y, HumanoidPos.z
    End If
End Sub
```

Chapter 19 Terrain Rendering and FPS Shooter

If you look back at the loop in Form_Load, it will check the status of the weapon. The weapon will fire when the left mouse button is clicked. This procedure will check to see if there is a collision between the weapon and the model, and if so, it will subtract a random number from the health of the model. It will also play the shot.wav file from the application directory when the weapon is fired.

```
Sub WeaponCheck()
    Dim FP As D3DVECTOR
    Static Shot As Boolean
    Dim bone As Integer

    Weapon.SetScale 0.2, 0.2, 0.4
    Weapon.SetPosition PosX, PosY, PosZ
    If angy <> 0 Then
        arcc = Atn(Sin(angy))
    End If

    Weapon.SetRotation 0, 180 - ang * 180 / 3.14, -arcc * 180 / 3.14

    If b1 <> 0 And Shot = False Then
        FP = VAdd(Vector(PosX, PosY, PosZ), VScale(Vector(Cos(ang), -1, Sin(ang)), 5))
        Flash.SetPosition FP.x, FP.y, FP.z
        Flash.SetDeathTime 70
        Flash.Enable True
        Weapon.SetAnimation 1
        OldWeapon = TV.TickCount
        Shot = True
    End If

    If Shot = True And TV.TickCount - OldWeapon > 300 And tested = False Then
        If Not SoundInit(App.Path & "\shot.wav") Then
            Sound.Play DSBPLAY_DEFAULT
        End If
        tested = True

        Humanoid.Collide Vector(PosX, PosY, PosZ), Vector(PosX + Cos(ang), PosY + Sin(angy), Sin(ang) + PosZ), TV_TESTTYPE_MDL_HITBOXES, bone

        HumanoidHealth = HumanoidHealth - Rnd * 50
```

```
        If HumanoidHealth <= 0 And dying = False Then
            Humanoid.SetAnimationName "die_simple"
            dying = True
            OldAI = TV.TickCount
            Humanoid.SetAnimationLoop False
        End If
    End If

    If Shot = True And TV.TickCount - OldWeapon > 900 Then
        Weapon.SetAnimationName "idle"
        Shot = False
        tested = False
            If HumanoidHealth > 0 Then
                Humanoid.SetAnimationName IIf(HumanoidWalk = True,
"run", "idle")
            End If
    End If

End Sub
```

The playing of the shot.wav file occurs when the ShotInit function is called with App.Path & "\shot.wav". It uses DirectSound to play the wav file.

```
Function SoundInit(SoundFile) As Boolean

    Set DS = DX.DirectSoundCreate("")

    If DS Is Nothing Then GoTo SoundInitFailed

    DS.SetCooperativeLevel hWnd, DSSCL_NORMAL

    Set Sound = DS.CreateSoundBufferFromFile(SoundFile, SoundDesc)

    If Sound Is Nothing Then GoTo SoundInitFailed

SoundInitFailed:
    SoundInit = False
End Function
```

That's really all there is to the basics of the game. If you run the program at this time, you will see something like Figure 19.7. You could improve the game dramatically by creating several humanoid models and improving the textures. For example, Figure 19.8 shows the same level, but with a snow texture and an improved set of Sky Box textures.

FIGURE 19.7 *The level is finished.*

FIGURE 19.8 *The same level rendered with an improved set of textures.*

 Depending on the version of the engine you are using, the images that you use to make up the trees and other 2D effects might need to be flipped, mirrored, or otherwise altered so that it renders accordingly.

Chapter Review

We covered most of the items needed to create a complete game, including the music, sound effects, programming, and graphics. We put all of these elements together to create a playable game level. In the final chapter, we'll look at several other options for game developers that offer a much easier route to game creation.

CHAPTER 20
Alternative Development Environments

While the previously mentioned programming languages seem to offer the most, there are a few additional choices when it comes to game programming. They range from programs very similar to Visual Basic, and others designed specifically for game programming.

MACROMEDIA DIRECTOR

Authoring tools such as Macromedia Director have long been used for the development of games. Many current and past commercial games have been developed using these types of programs. Director, which is arguably the leading development tool in this area, has several strong features that make it a possibility for the right type of game project. First, it is cross-platform capable, which is a big factor for certain projects. There are also many *Xtras* (a term for Director add-in controls) available that increase the productivity of Director applications.

The newest release of Director, now in version 8.5, enhances this already popular program, which can be seen in Figure 20.1. It includes a complete 3D engine courtesy of Intel's Internet 3D graphics software, which offers adaptive geometry and rendering. The algorithms of the software rendering engine enable 3D content to scale to the user's machine. It includes support for DirectX and OpenGL hardware acceleration. Of particular interest to game developers is a third-party Xtra that will enhance the capabilities of the 3D engine with the addition of Havok's real-time interactive physics.

Director uses a language called Lingo to add custom programming to a project. Because of the popularity it has gained throughout the years, there are many third-party books and training resources for Director, making it a possibility for certain types of project.

MULTIMEDIA FUSION/JAMAGIC

Similar to Director in that it is an authoring tool of sorts, Multimedia Fusion, or MMF as it is commonly known, is ideally suited for designing 2D arcade styles of games. It does include support for ActiveX controls although it is severely limited in this capacity due to what appears to be compatibility problems. The package contains everything you would possibly need for 2D games without any programming. Instead, it uses an event-based system for defining actions, an example of which is shown in Figure 20.1.

Chapter 20 Alternative Development Environments

FIGURE 20.1 *The event-based system offered by Multimedia Fusion.*

Multimedia Fusion is a good alternative to the scripting types of authoring software such as Macromedia Director. Instead of writing code, you use a sometimes complicated but effective IDE interface. Its performance can sometimes be a problem, but it is a very good tool for beginners or those looking for quick and easy prototyping for 2D content. Clickteam, the maker of Multimedia Fusion, has also been working diligently on Jamagic, their next-generation programming tool. Unlike Multimedia Fusion, it will offer a 3D engine and support for a scripting language that is similar to JavaScript. Although not available at the time of this writing, it looks very promising.

3D GAME STUDIO

Another authoring system, 3D Game Studio offers the ability to create 2D and 3D computer games. As its name implies, it was designed primarily as a game development environment, a point that is very important, as 3D Game Studio has been optimized for the development of games. It includes several modeling and level-building tools as shown in Figure 20.2. 3D Game Studio uses a JavaScript-style programming language with an integrated 3D engine and 2D engine. It also includes a Visual C++ interface along with a map and model editor. 3D Game Studio has a nice mix of features for either the beginner or experienced game programmer.

FIGURE 20.2 *The level editor that ships with 3D Game Studio.*

Chapter 20 Alternative Development Environments

3D RAD

3D RAD is perhaps the easiest to use authoring tool of any mentioned here, although it is probably not the best choice for commercial quality games. It offers several interesting features, including pre-built objects that can be used in a program without the need to alter it. For example, you can place one of the 3D car models into a scene and the model will already have basic movement capabilities and collision information. An example of the models is shown in Figure 20.3. Unfortunately, the models are very generic, the movements are really too simple for a commercial game, and the 3D rendering needs some speed and quality improvements. This program is best suited for a beginner, and if a few items are changed, it could offer a complete solution for 3D games.

FIGURE 20.3 *The built-in models of 3D RAD make building a scene a painless process.*

DarkBASIC/3D Game Maker

DarkBASIC is a programming language that allows you to write games for Direct X and Direct3D. It's a very easy program for beginners and includes a complete IDE. The interface takes a little time to get used to, but overall, it is a good program and worthy of consideration, especially for beginners. In recent development news, it appears that DarkBASIC hasn't been getting much attention from the developers. It's probably a byproduct of the release of their new product called the 3D Game Maker. This tool, shown in Figure 20.4, is one of the easiest game programming tools available at this time. While you lose some of your control over the environment, you can create several types of games by following a series of wizards.

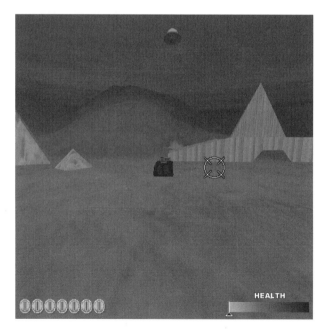

FIGURE 20.4 *The 3D GameMaker is extremely easy to use.*

BLITZBASIC3D

The newcomer to this field, BlitzBasic3D might offer the most compelling solution for developers with BASIC language experience. The folks at Blitz have been in the business for a long time, with their first game programming tools released on the Amiga. Recently, Blitz has offered BlitzBasic, a 2D game programming environment that still exists. If you're looking for a platform or 2D arcade programming environment, it is full of features. This takes the already popular 2D program and expands it to include support for 3D. Along with A5, BlitzBasic3D is the only other tool to support popular 3D game formats such as MD2. You should definitely check this one out.

CHAPTER REVIEW

In this chapter, we looked at several additional programming environments that might be options for inspiring game developers. They are all very well done and offer a tremendous amount of power, and when you factor in their ease of use, they make ideal learning tools. Appendix D, "Links to Game Programming Sites," provides links to these types of Web sites along with newsgroups and learning resources for game developers. Good luck with your projects!

APPENDIX A
Design Document

Design Document

First Person Shooter

Developed by ABC Gaming Company

Document written by John Doe
Version # 1.20
September 25, 2001
Copyright 2001 by ABC Gaming. All Rights Reserved.

Copyright (C) 2001 Company ABC. All rights reserved.

Design History

This is version 1.20 of the document originating on January 15, 2001.

Version 1.10

You can use version 1.10, 1.20, etc.

1. Changed platforms for game. Added Mac OSX.
2. Graphics are now 32 bit.

Version 1.20

The story has been rewritten.

1. Details of story now changed.
2. Enemy character is now a humanoid model.

Game Overview

Type of Game

This game is a 3D shooter with ...

Game Ideas

This game has been in the process of creation for many years. The idea has been tossed around for the past five and has been revised many times. We felt that it was the proper time for such a release.

Location

The game takes place on an uninhabited island. You are surrounded by rocky ledges and water as far as the eye can see.

Players

You will control the main character in the story from a First Person perspective. You will begin the game with a rifle, and additional weapons are available throughout the level.

Main Objective

Your objective is to get off the island.

Game Overview

This game takes a slightly different approach to the development of First Person Shooters in that instead of blasting your way through a level destroying everything in sight, you must also figure out a way to get off the island.

Copyright (C) 2001 Company ABC. All rights reserved.

Features

General Features

- Large terrains
- 3D graphics
- 32-bit color
- Several types of enemies

Multiplayer Features

- N/A
- Might implement in version 2.0

Editor

- No world editor at this time but planned for version 2.1.
- Free levels on the Net.

The Game World

Overview

An island that is uninhabited and without an obvious means of escape.

Key Locations

- There is a cave on the south side of the island that contains health kits.
- The creek that runs throughout the island is the quickest way to travel.
- There is a boat at the bottom of the lagoon. A repair kit is also inside it.

Objects

- A boat for getting off the island.
- Food such as bananas that give you energy.
- Old health kits from a ship wreck.
- Weapons.

Graphics

Rendering/3D Engine

The renderings will be 3D with polygonal models based on the Half-Life model format. It will be an FPS view without the capability to move the camera in any way. The game uses the TrueVision 3D engine that is based on DirectX 8.

3

Copyright (C) 2001 Company ABC. All rights reserved.

Game Characters

Main Character

There is only one main character in the game.

Enemies

There will be several enemies that you will encounter:
- Mummy
- Dracula
- Etc.

Weapons

Types

There are several types of weapons on the island including a rifle, handgun, machine gun and laser gun.

Musical and Sound Effects

Music

The game will use wav files created with ACID.

Sound Design

The sound effects include basic information about the weapons being fired and the foot steps when walking.

Appendix ABC

Any additional information. Ideas include:

User Interface

Character Rendering and Animation

APPENDIX B
Half-Life Model Specifications

.QC SCRIPTS

.qc scripts are simple text files that can be edited in Notepad, and are needed to compile a model. They tell MilkShape where the mesh, textures, and animations are.

COMPONENTS OF THE .QC SCRIPT

First is a partial list of some of the .qc script commands:

$modelname <path>

This tells MilkShape where to put the compiled model.
 Example: $modelname "C:\model\monster"

$cd <path>

This directs MilkShape to start in this folder when looking for files. It is the same as DOS' "change directory" command.
 Example: $cd "C:\model\monster"

$cdtexture <path>

This tells MilkShape where the textures are if they are in a separate folder from the mesh.
 Example: $cdtexture "C:\model\monster\textures"

$scale

This resizes the model. To reduce the size, make it less than 1; to increase the size, make it more than 1.
 Example: $scale 1.2

$origin <X> <Y> <Z>

This offsets the origin of the model so, for example, its feet are really on the ground. This is an easy fix if it wasn't done correctly when the model was made. It can also be put throughout the .qc file to offset a model or animation. It is mostly used for player models and weapons.
 Example: $origin 0 0 36

$body <smd name> [reverse]

This is the reference .smd file for the model, the basic model with a skin.
 Example: $body studio "monster"

$bodygroup <groupname> {smd groups}

This lets your model have interchangeable parts.

Appendix B Half-Life Model Specifications

$texturegroup <groupname>
This lets your model have interchangeable skins.

$include <.qc filename>
This tells MilkShape to include another .qc file in the compile.
 Example: $include "C:\model\monster\model_shared.qc"

$hbox <group #> <bone> <X> <Y> <Z> <X> <Y> <Z>
These define hit boxes, which are invisible boxes around each bone used to determine where the model is being shot.

Example Scripts

Weapon Used in Game

```
$modelname "C:\Temp\v_weapon.mdl"
$cd "\Temp\"
$cdtexture "\Temp\"
$cliptotextures
$scale 1.0
// 1 attachments
$attachment 0 "Gauss Master" 17.000000 -1.000000 0.000000
// 0 bone controllers
// 4 hit boxes
$hbox 0 "Gauss Master" -7.870000 -5.000000 -5.450000 16.980000 3.700000 2.680000
$hbox 0 "Spinner" -3.020000 -1.750000 -2.480000 0.000000 2.550000 2.480000
$hbox 0 "Bip01 L Arm2" 0.000000 -2.800000 -1.730000 11.680000 3.020000 4.000000
$hbox 0 "Bip01 L Hand" 0.000000 -0.870000 -1.940000 3.890000 1.030000 1.790000
$bodygroup body
{
studio "gauss_gun"
}
$bodygroup body
{
studio "gauss_hand"
}
// 9 sequences
$sequence idle "idle" loop fps 15
```

```
$sequence idle2 "idle2" loop fps 15
$sequence fidget "fidget" fps 30
$sequence spinup "spinup" loop fps 30
$sequence spin "spin" loop fps 30
$sequence fire "fire" fps 30
$sequence fire2 "fire2" fps 30
$sequence holster "holster" fps 45
$sequence draw "draw" fps 60
```

PLAYER SCRIPT

```
$modelname "C:\PlayerMDL\player.mdl"
$cd "\PlayerMDL\"
$cdtexture "\PlayerMDL\"
$cliptotextures
$scale 1.0
$bodygroup body
// 77 sequences
$sequence look_idle "look_idle" loop fps 14 ACT_IDLE 2
$sequence idle "idle" loop fps 14 ACT_IDLE 1
$sequence deep_idle "deep_idle" loop fps 12 ACT_IDLE 4
$sequence run2 "run2" LX loop fps 40 ACT_RUN 1
$sequence walk2handed "walk2handed" LX loop fps 26 ACT_WALK 1
$sequence 2handshoot "2handshoot" fps 20 ACT_RANGE_ATTACK1 1
$sequence crawl "crawl" LX loop fps 22 ACT_CROUCH 1
$sequence crouch_idle "crouch_idle" loop fps 12 ACT_CROUCHIDLE 1
$sequence jump "jump" fps 30 ACT_HOP 1
$sequence long_jump "long_jump" LX fps 24 ACT_LEAP 1
$sequence swim "swim" loop fps 14 ACT_SWIM 1
$sequence treadwater "treadwater" loop fps 14 ACT_HOVER 1
$sequence run "run" LX loop fps 31
$sequence walk "walk" LX loop fps 31
$sequence aim_2 "aim_2_blend1" "aim_2_blend2" loop fps 14 blend XR -45
45
$sequence shoot_2 "shoot_2_blend1" "shoot_2_blend2" loop fps 14 blend
XR -45 45
$sequence aim_1 "aim_1_blend1" "aim_1_blend2" loop fps 14 blend XR -45
45
$sequence shoot_1 "shoot_1_blend1" "shoot_1_blend2" loop fps 14 blend
XR -45 45
$sequence die_simple "die_simple" fps 22 ACT_DIESIMPLE 1 { event 2001 9
}
$sequence die_backwards1 "die_backwards1" fps 26 ACT_DIEBACKWARD 4 {
event 2001 13 }
```

APPENDIX B HALF-LIFE MODEL SPECIFICATIONS

```
$sequence die_backwards "die_backwards" fps 30 ACT_DIEBACKWARD 1 {
event 2001 15 }
$sequence die_forwards "die_forwards" fps 26 ACT_DIEFORWARD 1 { event
2001 8 }
$sequence headshot "headshot" fps 24 ACT_DIE_HEADSHOT 4 { event 2001 22
}
$sequence die_spin "die_spin" fps 30 ACT_DIE_HEADSHOT 1 { event 2001 16
}
$sequence gutshot "gutshot" fps 26 ACT_DIE_GUTSHOT 1 { event 2001 22 }
$sequence ref_aim_crowbar "ref_aim_crowbar_blend1"
"ref_aim_crowbar_blend2" loop fps 12 blend XR -45 45
$sequence ref_shoot_crowbar "ref_shoot_crowbar_blend1"
"ref_shoot_crowbar_blend2" fps 24 blend XR -45 45
$sequence crouch_aim_crowbar "crouch_aim_crowbar_blend1"
"crouch_aim_crowbar_blend2" loop fps 12 blend XR -45 45
$sequence crouch_shoot_crowbar "crouch_shoot_crowbar_blend1"
"crouch_shoot_crowbar_blend2" fps 24 blend XR -45 45
$sequence ref_aim_trip "ref_aim_trip_blend1" "ref_aim_trip_blend2" loop
fps 12 blend XR -45 45
$sequence ref_shoot_trip "ref_shoot_trip_blend1"
"ref_shoot_trip_blend2" fps 18 blend XR -45 45
$sequence crouch_aim_trip "crouch_aim_trip_blend1"
"crouch_aim_trip_blend2" loop fps 12 blend XR -45 45
$sequence crouch_shoot_trip "crouch_shoot_trip_blend1"
"crouch_shoot_trip_blend2" fps 16 blend XR -45 45
$sequence ref_aim_onehanded "ref_aim_onehanded_blend1"
"ref_aim_onehanded_blend2" loop fps 12 blend XR -50 35
$sequence ref_shoot_onehanded "ref_shoot_onehanded_blend1"
"ref_shoot_onehanded_blend2" fps 16 blend XR -50 35 { event 5011 0 "21"
}
$sequence crouch_aim_onehanded "crouch_aim_onehanded_blend1"
"crouch_aim_onehanded_blend2" loop fps 12 blend XR -50 35
$sequence crouch_shoot_onehanded "crouch_shoot_onehanded_blend1"
"crouch_shoot_onehanded_blend2" fps 16 blend XR -50 35 { event 5011 0
"21" }
$sequence ref_aim_python "ref_aim_python_blend1"
"ref_aim_python_blend2" loop fps 12 blend XR -50 35
$sequence ref_shoot_python "ref_shoot_python_blend1"
"ref_shoot_python_blend2" fps 16 blend XR -50 35 { event 5011 0 "31" }
$sequence crouch_aim_python "crouch_aim_python_blend1"
"crouch_aim_python_blend2" loop fps 12 blend XR -50 35
$sequence crouch_shoot_python "crouch_shoot_python_blend1"
"crouch_shoot_python_blend2" fps 16 blend XR -50 35 { event 5011 0 "31"
}
```

```
$sequence ref_aim_shotgun "ref_aim_shotgun_blend1"
"ref_aim_shotgun_blend2" loop fps 12 blend XR -45 45
$sequence ref_shoot_shotgun "ref_shoot_shotgun_blend1"
"ref_shoot_shotgun_blend2" fps 15 blend XR -45 45 { event 5021 0 "51" }
$sequence crouch_aim_shotgun "crouch_aim_shotgun_blend1"
"crouch_aim_shotgun_blend2" loop fps 12 blend XR -45 45
$sequence crouch_shoot_shotgun "crouch_shoot_shotgun_blend1"
"crouch_shoot_shotgun_blend2" fps 15 blend XR -45 45 { event 5021 0
"51" }
$sequence ref_aim_gauss "ref_aim_gauss_blend1" "ref_aim_gauss_blend2"
loop fps 12 blend XR -45 45
$sequence ref_shoot_gauss "ref_shoot_gauss_blend1"
"ref_shoot_gauss_blend2" fps 15 blend XR -45 45
$sequence crouch_aim_gauss "crouch_aim_gauss_blend1"
"crouch_aim_gauss_blend2" loop fps 12 blend XR -45 45
$sequence crouch_shoot_gauss "crouch_shoot_gauss_blend1"
"crouch_shoot_gauss_blend2" fps 15 blend XR -45 45
$sequence ref_aim_mp5 "ref_aim_mp5_blend1" "ref_aim_mp5_blend2" loop
fps 12 blend XR -45 45
$sequence ref_shoot_mp5 "ref_shoot_mp5_blend1" "ref_shoot_mp5_blend2"
loop fps 20 blend XR -45 45 { event 5001 0 "40" }
$sequence crouch_aim_mp5 "crouch_aim_mp5_blend1"
"crouch_aim_mp5_blend2" loop fps 12 blend XR -30 40
$sequence crouch_shoot_mp5 "crouch_shoot_mp5_blend1"
"crouch_shoot_mp5_blend2" loop fps 20 blend XR -30 40 { event 5001 0
"40" }
$sequence ref_aim_rpg "ref_aim_rpg_blend1" "ref_aim_rpg_blend2" loop
fps 12 blend XR -45 40
$sequence ref_shoot_rpg "ref_shoot_rpg_blend1" "ref_shoot_rpg_blend2"
fps 18 blend XR -45 40
$sequence crouch_aim_rpg "crouch_aim_rpg_blend1"
"crouch_aim_rpg_blend2" loop fps 12 blend XR -45 40
$sequence crouch_shoot_rpg "crouch_shoot_rpg_blend1"
"crouch_shoot_rpg_blend2" fps 18 blend XR -45 40
$sequence ref_aim_egon "ref_aim_egon_blend1" "ref_aim_egon_blend2" loop
fps 12 blend XR -45 35
$sequence ref_shoot_egon "ref_shoot_egon_blend1"
"ref_shoot_egon_blend2" loop fps 18 blend XR -45 35
$sequence crouch_aim_egon "crouch_aim_egon_blend1"
"crouch_aim_egon_blend2" loop fps 12 blend XR -45 45
$sequence crouch_shoot_egon "crouch_shoot_egon_blend1"
"crouch_shoot_egon_blend2" loop fps 18 blend XR -45 45
$sequence ref_aim_squeak "ref_aim_squeak_blend1"
"ref_aim_squeak_blend2" loop fps 12 blend XR -45 45
```

Appendix B Half-Life Model Specifications

```
$sequence ref_shoot_squeak "ref_shoot_squeak_blend1"
"ref_shoot_squeak_blend2" fps 14 blend XR -45 45
$sequence crouch_aim_squeak "crouch_aim_squeak_blend1"
"crouch_aim_squeak_blend2" loop fps 12 blend XR -45 45
$sequence crouch_shoot_squeak "crouch_shoot_squeak_blend1"
"crouch_shoot_squeak_blend2" fps 14 blend XR -45 45
$sequence ref_aim_hive "ref_aim_hive_blend1" "ref_aim_hive_blend2" loop
fps 12 blend XR -45 45
$sequence ref_shoot_hive "ref_shoot_hive_blend1"
"ref_shoot_hive_blend2" fps 15 blend XR -45 45
$sequence crouch_aim_hive "crouch_aim_hive_blend1"
"crouch_aim_hive_blend2" loop fps 12 blend XR -45 45
$sequence crouch_shoot_hive "crouch_shoot_hive_blend1"
"crouch_shoot_hive_blend2" fps 15 blend XR -45 45
$sequence ref_aim_bow "ref_aim_bow_blend1" "ref_aim_bow_blend2" loop
fps 12 blend XR -45 45
$sequence ref_shoot_bow "ref_shoot_bow_blend1" "ref_shoot_bow_blend2"
fps 16 blend XR -45 45
$sequence crouch_aim_bow "crouch_aim_bow_blend1"
"crouch_aim_bow_blend2" loop fps 12 blend XR -45 45
$sequence crouch_shoot_bow "crouch_shoot_bow_blend1"
"crouch_shoot_bow_blend2" fps 16 blend XR -45 45
$sequence deadback "deadback" fps 10
$sequence deadsitting "deadsitting" fps 10
$sequence deadstomach "deadstomach" fps 10
$sequence deadtable "deadtable" fps 10
```

APPENDIX C
Introduction to Visual Basic

Although this book centers on a game development project, it is important to have at least a basic understanding of the Visual Basic environment. This appendix introduces you to Visual Basic and guides you through the creation of your first Visual Basic program. Topics that you'll be exposed to include the basics of the Visual Basic language, variables, the built-in components, the ingredients that make up a basic application, and the Integrated Development Environment (IDE).

The vast majority of screen shots and information pertain to the Visual Basic 6 IDE. However, this appendix addresses the differences in the Visual Basic 6 and Visual Basic .NET IDEs, and includes information on how to open and convert version 6 projects to .NET.

For those of you already familiar with Visual Basic, feel free to skip this introduction. However, if you are a beginner to intermediate programmer, this chapter will build a solid foundation onto which you can base your future Visual Basic learning.

The Integrated Development Environment

The Visual Basic IDE might be the single biggest reason for VB's vast popularity. It provides everything you need to develop applications in an easy-to-use-and-learn graphical user interface (GUI, pronounced Gooey).

As with many Windows applications, there are several ways to open Visual Basic. First, and probably the easiest, is accessing it through the Start menu—the exact path required to access this shortcut is dependent upon your installation and might differ on individual machines. Another option is to create a shortcut on your desktop, which will execute Visual Basic by double-clicking on it. In addition, because Visual Basic sets up default associations when it is installed, you can also run it by double-clicking on a variety of files with Visual Basic extensions, including vbp, frm, and bas.

APPENDIX C INTRODUCTION TO VISUAL BASIC

When you open Visual Basic, you are presented with an opening screen that will appear very much like Figure C.1. For most of the projects in this book, you will be creating Standard exe files, so you should click Open or press Enter. This standard type of project will create a standard Windows executable program that can be run outside of the IDE.

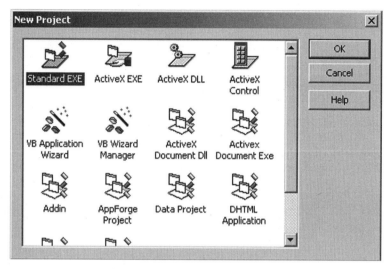

FIGURE C.1 *The New Project window is displayed when Visual Basic is started.*

As you can see in Figure C.2, the Visual Basic IDE is fundamentally a collection of menus, toolbars, and windows that come together to form the GUI. Five main windows appear in the default Visual Basic IDE, along with the menu toolbar, menu bar, and title bar.

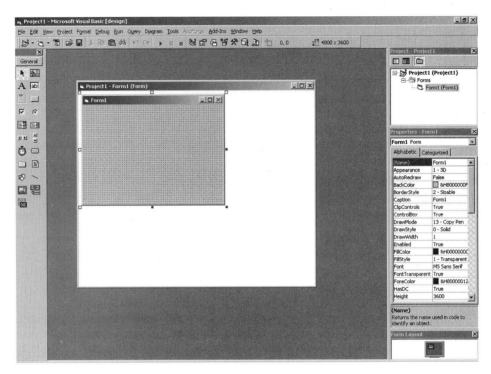

FIGURE C.2 *Visual Basic offers an IDE that is both powerful and easy to use.*

If you have ever used VB5, the version 6 IDE will look very similar to you. In fact, they are so close that you can probably begin without looking at any additional documentation. If you have used Visual Basic version 4 or earlier, the IDE might take some getting used to, as Visual Basic 5 and 6 have been changed to a Multiple Document Interface (MDI) application. If you are new to Visual Basic, the IDE can seem a little daunting at first glance. However, this will quickly fade away as you begin to become comfortable with each part.

THE MENUS

As you can see in Figure C.3, the Visual Basic IDE contains a menu bar and title bar that appear very similar to most Windows applications. The title bar serves as a quick reminder of what you are doing inside the IDE. For example, unless you changed something, the title bar should currently read "Project 1 – Microsoft Visual Basic [design]."

APPENDIX C INTRODUCTION TO VISUAL BASIC

FIGURE C.3 *Menu and title bars provide information similar to most Windows programs.*

The menu bar provides functions that you would expect from any standard Windows application. For example, the File menu allows you to Load and Save projects, the Edit menu provides Cut, Copy, and Paste commands that are familiar to most Windows users, and the Window menu allows you to open and close windows inside the IDE. Each menu option works like any other Windows application, so they do not need any real introduction. You should not be overly concerned with all of the options at this time, because we will be spending some time on them later in this appendix and throughout the book.

THE TOOLBARS

The Visual Basic toolbars generally duplicate the options and functions available in menu options. Although this might seem like duplication, the menus provide a quick and easy way to access options that can often be several clicks away.

STANDARD TOOLBAR

The standard toolbar shown in Figure C.4 is also comparable to the vast majority of Windows applications. It provides shortcuts to many of the commonly used functions provided by Visual Basic. Along with the standard toolbar, Microsoft has provided several additional built-in toolbars that can make your job a little easier. To add or remove any of the toolbars, you can right-click on the menu bar, or you can select Toolbars from the View menu.

FIGURE C.4 *Toolbars provide shortcuts to many of the common functions.*

INDIVIDUAL TOOLBARS

The individual toolbars include the Debug, Edit, and Form toolbars. The Debug toolbar, shown in Figure C.5, is used for resolving errors in your program and provides shortcuts to commands that are found in the Debug menu.

FIGURE C.5 *Shortcuts in the Debug toolbar are helpful when finding errors in your program.*

THE EDIT TOOLBAR

Figure C.6 shows the Edit toolbar, which can be useful when you are editing code and setting breakpoints and bookmarks. This toolbar contains commands that can be located in the Edit menu.

FIGURE C.6 *The Edit toolbar offers a variety of time-saving features.*

THE FORM EDITOR TOOLBAR

The Form Editor toolbar (see Figure C.7) includes most of the commands in the Format menu, and is useful only when you are arranging controls on a surface of a form.

FIGURE C.7 *The Form Editor toolbar displays buttons specific to form editing features.*

Whether you decide to display these toolbars is purely a matter of personal taste, as the functions they provide are generally available in menu options. Several factors, such as your screen size and resolution, might make their use impractical.

You can create a custom toolbar or customize the appearance of the built-in toolbars. First, right-click on any toolbar, and then select the Customize option. From the Customize window that appears, click New and type a name for the new toolbar. The name will appear in the Toolbar list, and after making sure that its check box is selected, click the Commands tab, which displays a list of available menu commands. From the list of categories and commands, select the options you would like to have on your toolbar. The changes are automatically saved, so continue placing options on the toolbar until you are finished and then simply close the window. You can now use your toolbar like any other.

THE WINDOWS

In addition to the menus and toolbars, there are several windows that you need to become familiar with in order to get a basic grasp of the Visual Basic IDE. The Form window displays the basic building block of Visual Basic applications. The Toolbox window displays some of the built-in Visual Basic controls. You can set properties of the components and forms in the Properties window. Finally, the Project Explorer displays the objects that make up the project you are working on, and you can position and view the forms with the Form Layout window.

THE TOOLBOX

The Toolbox, shown in Figure C.8, is probably the window that you will become familiar with the quickest, as it provides access to all of the standard controls that reside within the Visual Basic runtime itself. These controls, know as intrinsic controls, cannot be removed from the Toolbox and include the following options:

FIGURE C.8 Standard controls as well as ActiveX Controls are displayed in the Toolbox.

- **Pointer** The pointer is the only item in the Toolbox that is not a control. You can use it to select controls that have already been placed on a form.
- **PictureBox** You use the PictureBox to display images in several different graphics formats, such as BMP, GIF, JPEG, and others.
- **Label** The Label control is used to display text information that does not have to be edited by an end user. It is often displayed next to additional controls to label their use.
- **TextBox** You use TextBox controls for user input. It might be the most widely used control.
- **Frame** A Frame control is typically used for containing other controls and dividing the GUI. Controls placed within the frame cannot be displayed outside of it, and if the frame is moved on the form, the controls are moved with it.

- **CommandButton** Much like the TextBox, CommandButtons are used for input on almost every frame. They are used as standard buttons for input, such as OK or Cancel.
- **CheckBox** If you need the capability to select True/False or Yes/No, the CheckBox control is the one to use.
- **OptionButton** The OptionButton is similar to the CheckBox in that it offers the capability to select an option. However, an OptionButton is most often used when a group of options exists and only one item can be selected. All additional items are deselected when a choice is made.
- **ListBox** This control contains a list of items allowing an end user to select one or more items.
- **ComboBox** ComboBox controls are similar to a ListBox, but they only provide support for a single selection.
- **Scrollbars** The HScrollBar and VScrollBar controls let you create scroll bars, but are used infrequently because many controls provide the capability to display their own scroll bars.
- **Timer** The Timer control is an oddity when compared to other controls in that it is not displayed at runtime. It is used to provide timed functions for certain events.
- **DriveListBox**, **DirListBox**, **FileListBox** These controls can be used individually, but many times are used together to provide dialog boxes that display the contents of drives, directories, and files.
- **Shape**, Line The Shape and Line controls are simply used to display lines, rectangles, circles, and ovals on forms.
- **Image** You can think of the Image control as a lighter version of the PictureBox control, and although it doesn't provide all of the functionality that the PictureBox does, it consumes fewer resources. Therefore, you should use this control when possible.
- **Data** The Data control is a component that allows you to connect one or more controls on a form to fields in a database.
- **OLE** The OLE (Object Linking and Embedding) control can host windows belonging to other executable programs. For example, you can use it to display a spreadsheet generated by Microsoft Excel, or a Word document.

Some of the intrinsic controls are used more frequently and you are likely to become acquainted with them much faster. The TextBox, Command Button, and Label controls are used in almost all Visual Basic developed applications. While some are very important, others might provide functionality that can be replaced by far superior controls. For example, you probably should not use the Data control, as it cannot be used with ActiveX Data Objects (ADO) data sources.

Additional controls, known as ActiveX controls (sometimes referred to as OCX controls or OLE custom controls), provide additional functionality and can be added to the Toolbox for use in a project. These components are provided by many third-party companies or might be provided by Visual Basic itself. Many times, these controls provide extended functionality that makes them much more powerful than the intrinsic controls. That being said, the built-in varieties offer a few advantages that cannot be overlooked. For example, if you use a third-party control, you will need to distribute it with your application, while the intrinsic controls are included with the Microsoft Visual Basic runtime file.

FORM WINDOW

You need to have a place to assemble your controls, and this is the function of forms. As you can see in Figure C.9, the forms you work with are displayed inside the Form Designer window. When they are displayed in this way, you can place and manipulate controls.

FIGURE C.9 *During development, the Form Designer window displays the form you are working on.*

APPENDIX C INTRODUCTION TO VISUAL BASIC

CODE WINDOW

Every form has a Code window, which is where you write the code for your program. The Code window can be opened in a variety of ways such as double-clicking on a form or choosing Code from the View menu. Figure C.10 displays a sample Code window.

FIGURE C.10 *Visual Basic code is written in the Code window.*

PROJECT EXPLORER

The Project Explorer is shown in Figure C.11 and is provided to help you manage projects. The Project Explorer is a hierarchical tree-branch structure that displays projects at the top of the tree. The components that make up a project such as forms descend from the tree. This makes navigation quick and easy, as you can simply double-click on the part of the project you would like to work on. For example, if you have a project with several forms, you can simply double-click the particular form you want to view. It provides a quick and easy means of navigation.

FIGURE C.11 *You will quickly realize the usefulness of the Project Explorer.*

 You can display the Project Explorer at any time by pressing the F4 key.
TIP

You can also use the Code window icon displayed at the upper-left side of the Project Explorer window by highlighting a particular form with a single click. Once you have a particular form highlighted, you can display the code associated with it by clicking on the Code window icon.

The Project Explorer also provides additional functions, such as the capability to add new forms or code modules. You can add a form to a project by right-clicking on an open area of the Project Explorer window, and selecting Add from the pop-up Context menu shown in Figure C.12.

PROPERTIES WINDOW

The Properties window is used for the configuration of the controls you place on a form as well as the form itself. All of the standard Visual Basic controls have properties, and the majority of ActiveX controls do as well. As you can see in Figure C.13, the window displays the available properties for an individual control or the forms on which they are placed. These properties can be changed as you design an application, or you can alter them in code.

APPENDIX C INTRODUCTION TO VISUAL BASIC

FIGURE C.12 *Pop-up menus make available countless valuable features in the IDE.*

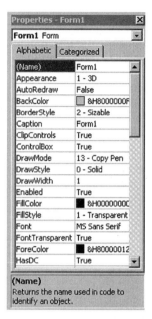

FIGURE C.13 *The Properties window allows you to adjust properties for many Visual Basic objects.*

FORM LAYOUT WINDOW

Figure C.14 shows the Form Layout window. Its only purpose is to allow you to set the position of forms when they are actually being executed during runtime. The process is very simple. You select the position of the form by moving it on the small "screen" that represents your desktop. Keep in mind that the placement of your form in the Form Layout window does not affect its position during runtime execution.

FIGURE C.14 *You can change the position of executed forms in the Form Layout window.*

Changes in Visual Basic.NET

Visual Basic.NET is the next generation of Visual Basic and has been completely reengineered by Microsoft. As you can see in Figure C.15, Visual Basic.NET introduces some changes to the IDE and new Windows Forms and Web Forms. The product was developed from the ground up, and is not just an upgrade to Visual Basic 6.

FIGURE C.15 *The new IDE in Visual Basic.NET resembles earlier versions.*

Upgrading Version 6 Projects to Visual Basic.NET

Because of the new changes associated with Visual Basic.NET, you will need to upgrade your code before it can be used. Fortunately, most of the time, this is very easy, as it happens automatically when you open a Visual Basic 6 project in Visual Basic.NET. An Upgrade Wizard, shown in Figure C.16, steps you through the upgrade process and creates a new Visual Basic.NET project. The existing Visual Basic 6 project is left unchanged. If you have Visual Basic version 5 projects, it is best to upgrade them to 6 before moving on to 7.

APPENDIX C INTRODUCTION TO VISUAL BASIC

FIGURE C.16 *The Upgrade Wizard makes it easy to convert version 6 projects to Visual Basic.NET.*

When your project is upgraded, the language is modified for any syntax changes and your Visual Basic 6.0 Forms are converted to Windows Forms. Depending on your application, you might need to make minor changes to your code after it is upgraded. Many times this can be necessary, because certain features either are not available in Visual Basic.NET or the features have changed significantly enough to warrant manual changes.

Once your project is upgraded, Visual Basic.Net provides an "upgrade report" to help you make changes and review the status of your project. The items are displayed as tasks in the new Task List window, so you can easily see what changes are required, and navigate to the code statement simply by double-clicking the task. Many times, the document recommendations simply represent good programming practices, but they also identify the Visual Basic 6 objects and methods that are no longer supported.

WORKING WITH BOTH VISUAL BASIC 6.0 AND VISUAL BASIC.NET

The Visual Basic.NET and Visual Basic 6.0 IDEs can be used on the same computer and can even execute simultaneously. Additionally, applications written and compiled in Visual Basic.NET and Visual Basic 6.0 can be installed and executed on the same computer. Although the projects in this book were written for Visual Basic 5 or 6, they should work equally well with either Visual Basic 6 or Visual Basic.NET.

A Quick Project

Now that you have an understanding of the Visual Basic IDE, you can put the information to work with your first Visual Basic project. The first step to any application is to draw the user interface.

The User Interface

The user interface is probably the first step in developing an application. Start the Visual Basic IDE using one of the methods mentioned previously, and select Standard EXE project from the first window that appears.

The next step is to place controls on the default form that appears. You can use two separate approaches to do this. First, you can simply double-click on one of the intrinsic Visual Basic controls that appear in the toolbar, which will place a single instance of the control on the Form.

Another way you can place controls on the Form begins by clicking the tool in the Toolbox. You then move the mouse pointer to the Form window, and the cursor changes to a crosshair. Place the crosshair at the upper-left corner of where you want the control to be, press the left mouse button, and hold it down while dragging the cursor toward the lower-right corner. As you can see in Figure C.17, when you release the mouse button, the control is drawn.

FIGURE C.17 *You can place controls on a form in several different ways.*

You do not have to place controls precisely where you want them, because Visual Basic provides the necessary tool to reposition them at any time during the development process. To move a control you created with either process, you click the object in the Form window, drag it, and release the mouse button when you have it in the correct location. You can resize a control very easily as

well, by clicking the object so that it is in focus and the sizing handles appear. These handles, shown in Figure C.18, can then by clicked and dragged to resize the object.

For a first project, begin by placing a TextBox and a CommandButton on the form, and position them so that they look something like the TextBox in Figure C.19.

FIGURE C.18 *Handles are useful for positioning and resizing objects.*

FIGURE C.19 *Beginnings of a GUI.*

The next step is to double-click the CommandButton, which will bring up the Code window and show you something similar to Figure C.20.

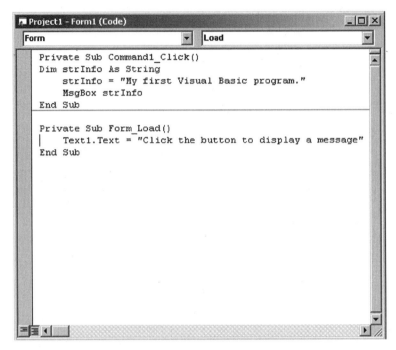

FIGURE C.20 *When you double-click an object on a Visual Basic form, it opens an event in the Code window.*

Your cursor should be flashing beneath the Private Sub Command1_Click() line. Type the following lines into your application:

```
Private Sub Command1_Click()
Dim strInfo as String
    StrINfo = "My first Visual Basic program."
    Msgbox strInfo
End Sub
```

From the drop-down menu located at the top left of the Code window, select Form. A From_Load event is created for you automatically. Enter the following code and continue reading for an explanation:

```
Private Sub Form_Load()
    TextAC.Text = "Click the button to display a message"
End Sub
```

ON THE CD

The companion CD-ROM contains all of the code. You can use it or type in the projects as you go.

THE CODE EXPLANATION

That is all we need for this application. Although this project is very simple, you are going to be introduced to a few items that you would not necessarily need for this type of application, but are being presented in order to get you started in Visual Basic development. The first of these extras are variables, which are used by Visual Basic to hold information needed by your application. There are only a few simple rules you should keep in mind when using variables: they should be less than 40 characters, they can include letters, numbers, and underscores (_), they cannot use one of the Visual Basic reserved words (e.g., you cannot name a variable Text), and they have to begin with a letter.

Let us look carefully at what the code does. The "Private Sub Command1_Click()" tells Visual Basic to run this line of code when someone clicks on the CommandButton you created called CommandAC. When they do, the lines of code you typed in are executed. The "End Sub" simply informs Visual Basic that it is time to stop running the code. These lines were created automatically for you when you double-clicked on the Command1 button in a previous step.

The Form_Load event was created automatically for you when you selected Form from the drop-down menu in the Code window. Inside the event, you added a line that sets the text box equal to "Click the button to display a message." Like the Command1_Click event, the code is run only when something occurs, which in this case is the form being loaded when the program runs.

To use a variable in Visual Basic, you should declare it with the Dim statement. The first line of code that you entered creates a new variable of type String called strInfo. The next line assigns the text string "My First Visual Basic Program" to the variable, and the final line uses the Visual Basic command Msgbox to display the MessageBox.

RUNNING THE PROGRAM

You can execute the program from within Visual Basic by clicking the Start button. You should see a window that appears something like Figure C.21.

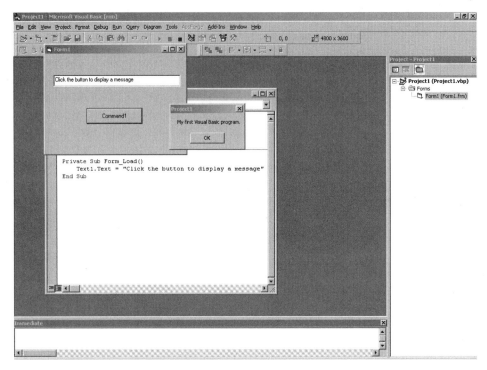

FIGURE C.21 *Your first program running inside the IDE.*

You can close it like any Windows program, or click Stop button within the Visual Basic IDE.

You have created your first program. You can save it if you like, by choosing Save from the File menu. When saving a project, it is best to create a new directory in which you can store all the files necessary for the project. In this way, you keep the files in one easy-to-manage area without the risk of another project corrupting the source code or data.

Complete Code Listing

The following code is the complete listing:

```
Private Sub Command1_Click()
Dim strInfo As String
    strInfo = "My first Visual Basic program."
    MsgBox strInfo
End Sub
Private Sub Form_Load()
    TextAC.Text = "Click the button to display a message"
End Sub
```

APPENDIX D

Links to Game Programming Sites

WEB LINKS

SNOK GAME PROJECT
http://tihlde.org/~torbjorv/snok/
A 3D snake game, complete with source code.

JAVA GAME DEVELOPMENT CENTER
www.electricfunstuff.com/jgdc/
Java game development.

GAMEINSTITUTE
www.gameinstitute.com/
Online courses.

DELPHI GAMER/DEVELOPMENT
www.savagesoftware.com.au/DelphiGamer/indexf.php
A site dedicated to Delphi game development.

FILIPE'S PAGE OF GAME PROGRAMMING
www.mindlick.com/programming/
Various tutorials.

2D GAME PROGRAMMING
www.2dgame.nl/
Good 2D site.

DAMBERG.DE GAME PROGRAMMING
www.damberg.de/
A VB game programming site.

LUCKY'S VB GAMING SITE
http://rookscape.com/vbgaming/
One of the best!

THE NEXUS
www.thenexus.bc.ca/
Another excellent VB site.

APPENDIX D LINKS TO GAME PROGRAMMING SITES

AMIT'S GAME PROGRAMMING SITE
www-cs-students.stanford.edu/~amitp/gameprog.html
Information on path finding, and more.

GAME DEVELOPER'S CONFERENCE
www.gdconf.com/
Home of the GDC—not much else to say.

DARWIN3D GD SECTION
www.darwin3d.com/gamedev.htm
A collection of useful articles from *Game Developer* magazine.

JAVA GAME DEVELOPMENT CENTER
www.electricfunstuff.com/jgdc/
Source code, theory, and other resources related to Java development.

GAME DESIGN WEB SITES
www.cs.queensu.ca/~dalamb/Games/design/gameDesignSites.
This is simply a collection of game development resources on the Internet.

MR-GAMEMAKER.COM
www.mr-gamemaker.co.uk/
Mr-GameMaker.Com features tutorials on topics related to game development, including some hard-to-find D3D information.

CFXWEB
http://cfxweb.planet-d.net/
CFXWeb is a game programming and demo news site. It is updated quite often and features some good tutorials, links, and other related features. Definitely worth a look.

GOLGOTHA SOURCE CODE
www.jitit.com/golgotha/
When Crack.com went under, they released the source code to their project, Golgotha. The entire game engine, art, and so on are available for download.

GAMASUTRA
www.gamasutra.com/
Gamasutra is *Game Developer* magazine's Web site.

Mad Monkey
www.madmonkey.net
Mad Monkey focuses on the independent gaming scene. There, you will find information on projects currently in the works, programming tutorials, message forums, and much more.

Game Programming Megasite
www.perplexed.com/GPMega/index.htm
Tutorials and information.

Pawn's Game Programming Pages
www.aros.net/~npawn/
Rex Sound Programming Engine.

The New Game Programmer's Guild
http://pages.vossnet.de/mgricken/newgpg/
Large Web ring for development sites.

GameProgrammer.com
www.gameprogrammer.com/
Mostly old information.

GameDev.Net
www.gamedev.net
Articles, news, links, and more.

Game Development Search Engine
www.game-developer.com/
Search engine for game developers.

Linux Game Development Center
http://sunsite.auc.dk/linuxgames/
As the name says, mostly Linux materials.

flipCode
www.flipcode.com
Another highly recommended site!

APPENDIX D LINKS TO GAME PROGRAMMING SITES

NEWSGROUPS

LANGUAGE GROUPS

comp.lang.asm.x86
x86 assembly language.

comp.lang.c
The C programming language.

comp.lang.c.moderated
Not much traffic, but good.

microsoft.public.vb
VB language.

microsoft.public.vb
VB language and DirectX.

microsoft.public.vb.winapi.graphics
Graphics and VB.

borland.public.delphi
Delphi language.

borland.public.delphi.graphics
Delphi graphics.

macromedia.director.lingo
Director information.

GRAPHICS GROUPS

comp.graphics.algorithms
BSP trees to texture mapping.

AI GROUPS

comp.ai.games
This newsgroup has useful info.

Game Groups

rec.games.programmer
Probably the most popular general newsgroup.

rec.games.design
Designing games.

APPENDIX

About the CD-ROM

The CD-ROM includes all of the necessary tools (with the exception of a compiler) to write the programs that are developed in the book. It also includes full color images of all the figures in the book, and the source code and executable files for the sample projects.

CD Folders:

- **FIGURES:** The full color version of all the figures in the book.
- **2D:** Sample textures.
- **3D Models:** The MilkShape 3D created models.
- **Design Document:** A design document template/sample.
- **Music and SFX:** Music and Sound Effects.
- **SOURCE:** Arranged by chapter and includes the source code and executable files for every sample in the book.
- **Applications:**
 - DirectX 8 SDK: The first program available on the CD-ROM is the Microsoft DirectX 8 Software Developers Kit. Located in the DirectX 8 SDK sub-directory, it is the full version of the SDK and is needed for the DirectX model viewer program developed in the book. Once installed, it includes samples and documentation.
 - PaintShop Pro 7.0: Located in the Applications sub-directory and is used for 2D graphics and textures. (Evaluation Copy)
 - MilkShape 3D 1.5.9: MilkShape is located in the Applications / MS3D155 sub-directory. It is used for the creation of 3D models and characters. (Evaluation Copy)
 - TrueVision 3D Engine 5.5: The engine is an ActiveX control that is in the Applications/TV8 sub-directory and is used as the basis for programming a 3D game and Half-Life model viewer. (Evaluation Copy)
 - Sonic Foundry ACID 2.0d: Used to create music and is located in the Applications sub-directory. (Evaluation Copy)
 - Cool Edit 2000: Located in the Applications sub-directory and used to create sound effects. (Evaluation Copy)

System Requirements:

Minimum System Requirements
Pentium® or comparable processor
32 MB RAM
75 MB free hard disk space
256-color display adapter at 800 x 600 resolution

Appendix E About the CD-ROM

CD-ROM Drive
Windows® 95/98/NT4/2000/ME/XP
 VISUAL BASIC 6 OR HIGHER
Recommended System Configuration
500 MHz or better processor
128 MB of RAM
32 bit color display adapter at 1024 x 768 resolution or better

Installation:

To use the programs on the CD-ROM, your system should match at least the minimum system requirements. The image files that are used in the development of projects are mostly in JPEG and PaintShop Pro format while the chapter figures are TIFF files.

Index

.NET, 28
 framework, 29
.qc scripts
 Components, 336
 text files, 336
16-bit color, 267
2D
 artwork-like textures, 4
 bitmap image, 232
 content, 323
 graphic image skinned, 5
 graphics, 232
 Screen TrueVision, 281
 Sketch, 74
2D, 3D graphics tools, 5
32-bit color, 227, 271
3D Studio Max (3ds max)
 TrueSpace; Maya, 5
3D
 engine, 20, 24
 First Person Shooter
 (FPS), 10
 Game Maker, 326
 Game Studio, 324
 graphics, 4, 232
 humanoid model, 164
 modelers, 5, 32
 modeling tools, 5
 RAD, 325

rendering, 325
space, 46, 239
 organizing, 256
viewport, 83, 186
vocabulary, 246
worlds, 264
8Pack
ACID, 147
ACIDPlanet, 152
ACID, 147, 307
 Loops, 147
 project file, 147
 specific, 128
 Track List Multi-Function
 area, 122
 window, 121
ACIDize files, 128
ActiveX, 322
 controls, 28, 352
 Data Objects (ADO), 351
Adapter, 223, 228
Add Form window, 286
Add Noise
 filter, 108
 window, 103
AI programmers, 3
Airbrush
 PaintShop Pro, 67
Altering the Interface
 ACID, 122

AMD, 25
Amiga, 327
Amplitude Ruler
 Cool Edit, 141
Animate menu, 55
animated files, 210
animation, 164, 269, 294
 Basic, 210
 sequences, 53
 tools, 52
animators, 5
ANISOTROPIC, 276
anti-aliasing, 269
API (application program-
 ming interface), 16, 18,
 244
Application
 Applications directory, 58
 closing, 252
 frame rates, 246
artificial intelligence (AI), 3
artist, 4, 11
Assembly, 24
Assembly language, 25
Assign button, 95
audio components, 4
Audio personnel, 11, 16,
 17
autodetected type, 148
back buffer, 238

375

Background
 artists, 5
 information, 12
 layer, 70
 noise, 153
basic 3D shooter, 154
basic component, 46
Basic language, 27, 327
basic template, 10
Beat Ruler
 ACID, 124
Beatmapper Wizard
 ACID, 148
BehaviorFlags, 223
 parameter, 224
Beta testers, 6
Bezier curves, 72
Bilinear Filtering, 276
Binary Space Partitions
 (BSPs), 256
bitmap, 32
 object, 58
BlitzBasic3D, 327
BMP format, 74, 105
box, 44
BSP
 editors, 257
 engine, 284
 file, 257, 285, 287, 291
 rendered, 288
 Form, 288
 levels, 284
built-in textures
 PaintShop Pro, 101
Button controls, 285
bytes, 237
C language, 25
 Additional Information;
 Advantages, 25
C++, 26
 libraries, 26
Camera
 3D vocabulary, 246
 TrueVision, 281
CD libraries, 153

Center of Mass
 Scale tool, 50
center point options, 51
character 11
 artist, 5
 heros, 13
Charles River Media, 29
chipsets, 244
Clickteam, 323
Client window, 238
client-server system, 18
Code
 Explanation, 361
 library, 20
 Listing, 363
 modules, 354
 window, 248, 286, 287,
 289, 307, 353
 window icon, 354
 writing, 233, 286
 VB, 222
color format, 227
Color palette, 110
 PaintShop Pro, 66
combo box, 299, 301
command button, 359
 cmdOpen, 286
Common Dialog control,
 286, 288, 298
Component window, 286,
 297, 307
composition, 139, 148
Compressed Textures
 TrueVision, 279
concept drawings, 18
Constant (CONST pi), 240
controls
 VB, 296
convey actions, 153
Cool Edit, 158
Cool Edit 2000, 32, 143
 Syntrillium, 132
Cool Edit Pro, 114
copyright information, 148

Cos
 code, 291
CreateDevice, 223
CreateVertexBuffer, 237
Creating
 mood, 12
 SFX, 153
 Textures, 98, 100
 Wood Texture, 107
crosshair, 358
cross-platform capable, 322
current frame rate, 222
custom toolbar, 349
custom vertex type, 234
custom vertices, 237
cut scenes, 5
cylinder, 44
DarkBASIC
 programming language,
 326
data stream, 238
declarations, 289
Declarations, 247, 307
Delphi, 29
Dennis Ritchie, 25
descriptive, 13
design document, 3, 10,
 11, 12, 18, 19
Designing textures, 98
development cycle, 6
development team, 7
 meetings, 11
Device Type, 223
Diffuse button, 110
digital clay, 5
digital form, 153
digital recorder, 153
Dim statement, 361
Direct3D, 220, 237, 326
 advantages, 244
 Coordinate System, 245
 hardware card, 249
 lighting, 232
 Retained mode declara-
 tions, 247

INDEX

space, 245
DirectDraw, 220, 232
DirectSound, 220, 318
DirectX, 8, 24, 27, 28, 322, 326
 application, 233
 Basic, 220
 Library, 222
 objects, 222
 programming, 32
 project, 267
 basic framework, 221
 SDK, 214, 244
 Type Librarie, 247
DirectX-based game, 224
Display Device, 228
Display Range Bar
 Cool Edit, 141
display vertices only
 Rendering Mode, 272
Dithering, 271
Draw tool
 PaintShop Pro, 72
Dropper tool, 66
Duplicate Object, 87
Duplicate Selection, 54, 184
Dynamically Linked Library (DLL), 265
Edit menu, 54
Edit toolbar
 Visual Basic, 348
elements
 movement, 6
empty project, 148
Engine or graphics programmers, 3
enumeration, 224, 228
Eraser
 PaintShop Pro, 66
Error Messages, 271
 TV3D, 271
Example Scripts, 337
Export Half-Life SMD, 212

extrude, 32, 76
 tool, 51, 168
extruding, 46
extrusion, 190
 resize methods, 193
eye point, 241
Face tool, 32
faces, 46
 menu option, 55
fader, 126
File menu, 53
File Types Support
 TrueVision, 278
Fill tool
 PaintShop Pro, 101
final game project, 32
final MDL file, 210
first draft, 16, 17
First Person Shooter (FPS), 2, 63, 164
Flatten, 55
flexible vector format (FVF), 233
 flags, 234
Flight Sims, 271
Flood Fill tool
 PaintShop Pro, 68
Form Editor toolbar
 Visual Basic, 348
Form Layout window, 349, 355
Form Load, 235, 248
Form Window, 352
Form_Load
 event, 307
 subprocedure code, 297
frames per second (FPS), 3, 13, 269
 display, 269
FPS clone
 Quake, 17
Freehand tool, 259
Front viewport, 173

Full-Screen
 mode, 268
 program, 267
 project, 266
 Title, 270
FVF, 233, 234, 237, 238
game
 type of, 18
Game artists, 5
game
 concepts, 3
 design, 24
 development, 24
 environment, 324
 formats, 32
 idea, 10
 market, 20
 overview, 17
 category, 12
 Storyline, 12
 play multiplayer, 17
 proposal, 19
 programmers, 3, 153
 programming, 24
generating landscapes, 264
Genesis3d
 skeletal animations, 32
geometric primitives, 42
geo-sphere, 43
GetTick API, 291
Gourad, 274
 render mode, 246
graphical user interface (GUI) Gooey, 344
graphics
 animation, 244
 application, 47
 editor, 58
 elements, 4
 files, 315
 Formats
 TrueVision, 278
 information, 227
grayscale image, 258

grid, 150
Group tab, 94, 99, 110
 MilkShape, 198
Half-Life
 skeletal animations, 32
 format, 164, 257
 humanoid model, 164
 MDL format, 298
 model, 301
 model format, 32
 models, 32, 294
hardware, 5
 manufacturers, 25
 platforms, 244
 T&L
 code, 269
Hardware Abstraction
 Layer (HAL), 223
heightmap, 258, 260
heroes, 13
hFocusWindow, 223
home education sales, 20
horizontal scroll bar
 Time Ruler, 125
Horizontal Zoom
 Cool Edit, 140
humanoid, 195
 model movement, 315
 models, 318
 Change subprocedure, 315
IDE interface, 323
Ignore Backfaces, 170, 173, 183
Immediate mode, 246
individual components, 11
individual toolbars
 Visual Basic, 348
Initialization procedure, 226
Initialize
 DirectX, 248
 function, 222
 procedure, 248
 Scene, 248, 250

Input engine, 289, 291
Input Features
 TrueVision, 281
Integrated Development Environment (IDE), 344
Intel, 25
 Internet 3D graphics software, 322
intelligence level, 13
Internal Objects
 TrueVision, 282
intrinsic
 controls, 349, 351
 Visual Basic, 358
Jamagic, 323
Java
 programmers, 29
JavaScript, 323
 programming language, 324
Joint tool, 52
joints, 52
Just In Time
 compilers, 29
key member, 7
keyframes, 53
Label controls
 properties, 284, 285
landscape, 312
Layer
 menu, 104
 palette, 71
layout, 12
lead game designer, 2
lead programmers, 19
Learning Visual Basic with Applications, 29
legalities, 11
level meters
 Cool Edit, 143
 configuration menu, 143
levels
 game, 12
 rough layout, 12

Light Streaks, 203
Lights
 3D vocabulary, 247
 TrueVision, 279
Line In/Line Out
 sound cards connections, 156
Line tool, 104
Lingo
 language, 322
Linux, 29
Loading Console, 270
look-at point, 241
loop-based music, 32, 114
low-level editing, 32
low-polygon modeling, 32
Mac sales, 20
Macromedia Director, 322
Main Features
 TrueVision, 277
main loop, 224, 251, 312
market analysis, 11
Mask values, 235
material, 106
Material tab, 106, 110, 205
Media Explorer
 ACID, 123
memory location, 237
Menu Navigation, 15, 16
menus, 53
Merge, 53
mesh editing tool, 47
mesh model, 210
mesh objects, 271
Meshes
 TrueVision, 280
Mete Ciragan, 32
Mic (microphone), 157
 sound cards connection, 156
Microsoft, 27, 244, 356
Microsoft Common Dialog Control 6.0, 286
MIDI file
 music, 16

INDEX

MIDI/Game Port
 connector, 155
 sound cards connection, 156
MilkShape, 74, 105, 210, 336
 basic features, 42
 built-in shaders, 110
 export models, 54
 Installation, 33
 mesh editing tools, 46
 model, 88, 232
 primitive objects, 42
 registering, 36
 screen, 176
MilkShape 3D, 32, 74, 164, 257
 Interface, 38
mini-disc recorder, 155
mip-mapping, 271
Mirror commands, 55
mirroring, 183
Miscellaneous
 TrueVision, 282
Model, 264
 displayed on terrain, 306
 Compilation, 212
 Texturing, 198
model loaded, 294
Model tab, 46, 76
modeling operations, 32
MouseMove subprocedure, 299
move
 mesh editing tool, 49
Move tool, 49
moveable objects, 5
movie engine, 266
movie script, 10
MP3
 file, 16
 format, 148, 152
 player, 29
Multimedia Fusion, (MMF), 322

multimedia work, 27
multiplayer game, 18
Multiple Document Interface (MDI), 346
multiple platforms, 20, 25
multiple tracks
 moving, 126
Music, 16
 creating, 148
 effects, 146
 files
 playing, 312
 historians, 147
 samples, 147
musician, 4
NARAS (National Academy of Recording Arts and Sciences), 146
network engine, 266
new character, 10
New Image window, 312
New Raster Layer, 202
new vector layer, 74, 104
number of frames, 294
object-oriented
 approaches, 26
 programming (OOP), 25, 26
OCX controls, 352
OLE custom controls, 352
one-shot events, 150
Open button, 287
Open Image box, 205
OpenGL, 28, 322
operating systems, 25
optimizing the code, 3
Origin
 Scale tool, 50
Other Visual Media
 Grammy Category, 146
outdoor levels, 258
paint program, 29
Paint tool, 150
Paintbrush tool, 66

PaintShop Pro (PSP), 32, 58, 68, 70, 105, 200, 258, 312
 file format, 70
PAK
 file, 284, 285, 287
 WAD file, 291
pan drop-down control, 126
Particles
 TrueVision, 280
Pattern Window, 259
PC sales, 20
PDA, 153
 using, 155
peak amplitude, 143
peer-to-peer system, 18
phong, 274
Picture Tube
 PaintShop Pro, 67
 tool, 68
PictureBox, 296
 control, 267
pitch-shift, 128
pixel, 70, 227
placement of enemies, 12
platform independent, 25, 29
play testers, 6
Playback
 mode, 143
 volume, 158
Player Script, 338
PlayerMDL, 212
 directory, 212
plot, 10
PocketFuel, 148
PocketPC, 155
polygon, 5, 232, 269
 counts, 4
portable recorder, 153
positions
 VB, 296
positive Z coordinate, 245
pre-built objects, 325

preconstructed project, 152
preliminary sketch, 5
PresentationParameters, 223
pressure-sensitive tablet, 65
primitive, 32
 object, 81
producer, 6, 11
product
 alpha, 21
programmers, 16, 17
programming, 24
 language, 24, 322
 C#, 24
Project Explorer, 353
Project Framework, 247
properties, 287
 tab
 ACID, 128
 window, 354
proprietary language, 29
publisher, 11
Quake
 engine, 256
 model formats, 32
raster
 editing tools, 70
 image, 70
 layers, 66
 PaintShop Pro, 71
Record
 how to, 154
 mode, 143
Recording
 Controls window, 157
 Device
 using, 155
 Sounds, 153
Referencing the Engine TV3D, 265
Regroup button, 200
Remap button, 206

render, 238, 267, 298
 terrain, 306
 everything
 Rendering Mode, 272
loop, 289
modes
 3D vocabulary, 246
Scene
 TrueVision, 278
subprocedure, 251
rendering, 264, 267
 code, 224
 loop, 248, 289
 Modes, 272
 objects, 271
RenderLoop, 248
required resources, 21
resize the image, 315
resolution, 267
 dependent, 70
 Enumeration, 228
Retained mode, 244, 246, 254
Retouch tool, 260
Reverse Vertex Order, 55
rmDevice, 249
road map, 10
rotate, 46, 51
 mesh editing tool, 49
 model, 302
Rotation
 3D vocabulary, 246
royalty-based system, 147
royalty-free license, 147
sales figures, 20
scale, 50, 75
 mesh editing tool, 49
 tool, 190
scaling, 46
Scene class
 TV3D, 271
Scenes
 3D vocabulary, 246
scheduling information, 21

SDK
 Installation, 214
SDK directory, 245
Seamless Pattern, 314
select data, 142
Select tool, 47
Selection tool, 49
set of maps, 12
Shaders
 TrueVision, 279
Show Skeleton option, 198, 210
simple illustration, 15
Sin
 code, 291
single byte, 227
single player game, 18
skeletal animation, 32
 system, 164
Sketches, 14
Sky Box, 315
 textures, 318
SMD file, 212
Smoothing, 94
Smudge effect, 260
Snap Together, 55
Software Developers Kit, 214
software project, 3
software renderer, 249
Solid
 render mode, 246
Sonic Foundry ACID, 32, 114
Sonic Foundry run ACID-Planet.com
 music loops, 147
sound card, 155, 157, 220
sound effects, 4, 11, 16, 17, 20, 32, 146, 153, 155
sound engine, 266
Sound programmers, 3
Sound Type table
 How to Record, 154

INDEX

source code, 291
sphere, 43
sports simulation, 12
standard CD audio
 format, 147
Standard EXE project, 221
 Visual Basic, 284
standard toolbar
 Visual Basic, 347
standard VB options, 289
Status Bar
 Cool Edit, 143
storyboard, 3
storybook, 12
strength, 13
Style and Texture tools
 PaintShop Pro, 66
sub directory, 251
Syntrillium's Cool Edit
 2000, 131
Syntrillium's Cool Edit Pro,
 114
system-level programs, 25
tapered effect, 160
target audience, 11
team oriented, 11
team's development
 experiences, 20
technical details, 18
technical risks, 20
template, 202
Template
 Creating, 200
 Painting, 203
tempo, 124
Terrain Features
 TrueVision, 277
terrain-generated, 261
text-based information, 16
Texture, 32, 312, 318
 artists, 5, 6
 creation, 58 312
 coordinates, 232
 Filtering, 276

Texture Coordinate
 Editor, 206
Texture Factory
 TrueVision, 279
Texture-related FVF flags,
 234
Texturing Models, 150
texturing process, 90
third-party 3D engines, 27
three-dimensional
 graphics, 244
three-dimensional space,
 245
Time Display Fields
 Cool Edit, 142
time readout, 143
Time Ruler
 ACID, 124
Time window
 Cool Edit, 140, 143
timeline, 124
time-stretch, 128
Tool Options palette
 PaintShop Pro, 65
Tool programmers, 4
Toolbar
 PaintShop Pro, 64
 groupings
 Cool Edit, 140
 Visual Basic, 347
Tools menu, 55
Track List, 125, 150
Track View
 ACID, 123
Transformation, Lighting
 (T&L), 232, 269
Transport
 Cool Edit, 140
 toolbar
 Cool Edit, 144
TRILINEAR, 276
TrueVision 3D (TV3D), 264
 DirectX engine, 244
 engine, 307
 Feature List, 277

TrueVision8, 268
turn edge, 32
TV light rendering, 274
TV.TimeElapsed
 code, 291
TV3D, 284
 engine, 297
UDT, 234
up direction, 241
Upgrade Wizard, 356
User Defined Typed
 (UDT), 233
user interface, 16, 63, 358
 Cool Edit, 139
 TrueVision, 281
User Point
 Scale tool, 50
values for reflections, 232
Valve created skeleton, 164
variable, 222, 361
VB, 220, 265, 295
 code, 289
 programmer, 27
 programming language,
 28, 29
VB 6
 Visual Basic, 24
vector
 drawing; editing, 70
 Drawing Tools, 70
 format, 237
 images, 70
 Layer, 66, 104
 PaintShop Pro, 71
 object, 58
Vector-based images, 70
Vertex, 32, 75, 232
 buffer, 233, 235
 button, 47
 data, 238
 menu, 55
 Mirror Left, Right, 185
 shader, 238
vertical views, 44

Vertical Zoom
 Cool Edit, 144
vertices, 46, 47, 232
 moving, 173
 Rendering Mode, 272
video cards, 220, 267
 capabilities, 267
video game industry, 146
video resolution, 229
view matrix, 241
viewport, 250
 controls, 41
 individual, 38
Virtual Machine, 29
virtual world, 3
Visual Basic, 24, 27, 221, 322
 development, 361
 environment, 344
 IDE, 344, 349, 358
 learning, 344
 project, 358
 Type Library, 222, 307
 .NET, 356
Visual C++, 324
volume drop-down
 control, 126

WAD file, 284
WAV file
 music, 16
 format, 152, 155
Waveform
 Display
 Cool Edit, 141, 142
 select data, 142
 Playback, 158
 Record, 158
 View, 141
Web Forms, 356
Window
 project, 267
windowed application, 267
Windowed mode program, 267
Windows
 CE-based PDA, 155
 Forms, 356
 Media Player, 307
wireframe
 Rendering Mode, 272
wizards, 326
World Transformation
 Matrix, 239
Worldcraft, 257

X, Y, and Z
 coordinates, 49
 input boxes, 51
X86 machines, 25
XPress version
 ACID, 119
Xtras
 Director add-in
 controls, 322
y-direction, 241
Z-axis, 241, 250
Zoom Controls
 ACID, 125
zoom in
 model, 302